The Painter Speaks

Also published in
Contributions to the Study of Art and Architecture

The Craftsperson Speaks: Artists in Varied Media Discuss Their Crafts
Joan Jeffri, editor

)

The Painter Speaks

ARTISTS DISCUSS THEIR EXPERIENCES AND CAREERS

EDITED BY

Joan Jeffri

INTRODUCTION BY
Judith M. Burton

Sponsored by the Research Center for Arts
and Culture, Columbia University

Contributions to the Study of Art and Architecture,
Number 2

Greenwood Press
WESTPORT, CONNECTICUT • LONDON

Library of Congress Cataloging-in-Publication Data

The Painter speaks : artists discuss their experiences and careers /
 edited by Joan Jeffri ; introduction by Judith M. Burton.
 p. cm — (Contributions to the study of art and
 architecture, ISSN 1058-9120 ; no. 2)
 Sponsored by the Research Center for Arts and Culture, Columbia
 University.
 Includes bibliographical references and index.
 ISBN 0-313-28915-8 (alk. paper)
 1. Painting—Vocational guidance—United States. 2. Painters—
 Training of—United States. 3. Painting—United States—Marketing.
 4. Painters—United States—Interviews. I. Jeffri, Joan.
 II. Columbia University. Research Center for Arts and Culture.
 III. Series.
 ND205.P35 1993
 759.13—dc20 92-46395

British Library Cataloguing in Publication Data is available.

Library of Congress Catalog Card Number: 92-46395
ISBN: 0-313-28915-8
ISSN: 1058-9120

First published in 1993

Greenwood Press, 88 Post Road West, Westport, CT 06881
An imprint of Greenwood Publishing Group, Inc.

Printed in the United States of America

The paper used in this book complies with the
Permanent Paper Standard issued by the National
Information Standards Organization (Z39.48-1984).

10 9 8 7 6 5 4 3 2 1

CONTENTS

ACKNOWLEDGMENTS

The Research Center for Arts and Culture gratefully acknowledges the contributions of the Andrew W. Mellon Foundation and the New York Foundation for the Arts, which provided resources for the project's research and development, its own Administrative Committee and Advisory Board members, the artists and related experts for their thoughtful guidance, and the members of the staff who carried the project through to completion.

Joan Jeffri, Director
Zoe Friedman, Project Coordinator
Toby Boshak, Research Coordinator
Dr. Robert Greenblatt, Computer Consultant
Mary Greeley and Ruth Loomis, Interviewers

PREFACE

The interviews in this book were chosen from fifty personal narrative histories of painters and "related experts"—curators, dealers, art historians, critics, museum directors, and managers—from all over the United States. Besides forming an important resource of their own, they constitute an integral part of the Artists Training and Career Project, a study of the training and career choices and patterns of painters, craftspeople, and actors conducted by the Research Center for Arts and Culture at Columbia University. Painters are at the heart of this second volume culled from the study, which complements the first, *The Craftsperson Speaks: Artists in Varied Media Discuss Their Crafts* (Greenwood, 1992). They have been asked through the interviews and a detailed questionnaire sent to a random sample of 2,000 painters nationwide (garnering a 47 percent response) to describe in systematic ways the impact of training and career choices on their work, their requirements for doing their work over time, and their career development and satisfaction.

Areas of investigation used first in the interviews and later in the questionnaire have been developed through the creation of a multistage "validation sequence" from early childhood through mature careers. Questions move from initial influences through education, training, and preparation to career entry, peers and colleagues, marketplace judgments, critical evaluation and public response, to career satisfaction and maturity. They also seek information on background and current activity.

By eliciting information about the kinds of validation as well as the

kinds of resistances the painter meets, the Research Center for Arts and Culture (RCAC) will begin to be able to describe the training and career development of painters; will contribute to a growing literature on careers that includes research in the scientific, legal, medical, and law enforcement professions but is sadly lacking in the arts; will provide important information for advocates and funders; will give training institutions a better idea of the points of greatest need for training; will give arts service organizations information about appropriate assistance for painters and when such assistance is most helpful; and will document the position of the painter as an integral member of society.

Also, these interviews will provide pleasurable reading as they humanize a process and a search. Space does not permit us to publish all the interviews, but all the audio tapes are housed at the Oral History Collection of Columbia University and permission to hear them may be secured there. Data and information from the survey can be obtained directly from the Research Center.

Each published interview begins with a brief biography of the main markers in the painter's life and ends with information on where the work itself can be viewed, including corporate and public holdings. Professional affiliations and honors are appended as relevant. One illustration of the artist's work is provided with each interview, courtesy of the painter.

We have tried to represent painters demographically, ethnically, and equally by gender as much as possible in this volume. We have encompassed a wide age range and have targeted painters in three broad career stages—emerging, established, and mature. During the study we have been advised formally by two groups, one of "related experts" and one of painters themselves, to help us keep our work relevant to the needs and realities of the field.

From this small sampling and from the larger body of interviews, particular comments and insights have stayed with us. Societal pressures and a decidedly Western view of the artist were expressed by one expert: "What makes you think that you can . . . dabble in your interest when ninety-five percent of the world has to work to make a living, and why do you think, because you're committed to pursuing your dream, that somebody should support you?" Our interviews found artists like Sam Gilliam saying, "It's not enough just to side with artists—because artists can be wrong, too." In relation to their art, artists went back again and again to their own personal traditions. Santa Fe artist Dan Namingha talked about the whole change in perception of Native American painting in the 1960s away from its former association with a kind of flatness and its treatment almost as an artifact. Elias Rivera mentioned the experience of learning

painting at New York's famous Art Students League, while Keiko Hosokawa sold tickets to horse races to support her painting, which she described not "as something I want to do, something I *have* to do." From self-described "blue-collar painters" to those supported by their loved ones, those interviewed revealed the hunger, the search, as critic Peter Frank said, "for knowledge, for interpretation, for discourse."

Like craftspeople, painters' first investment is in the work itself and their own satisfaction with it. Our data bear this out, showing that three-fourths of our survey respondents were satisfied or very satisfied with "doing the work" and their own personal satisfaction with it. Teachers seem to have had substantial influence on painters, both negative and positive. Sixty-one percent of our respondents said teachers provided them with "early validation"; comments also cited teachers whose influence was decidedly negative, as Chuck Close describes his own experience here.

Throughout our interviews, it became increasingly clear that problem solving was at the core of many painters' lives. Sometimes peers played an important role; other times artists described a condition of intense isolation. Age, of course, also plays a part. As Sally Haley said, "I'm eighty-two. I'm my own peer!"

The interviews were conducted by Research Center Project Coordinator Zoe Friedman, staff members Toby Boshak, Mary Greeley, and Ruth Loomis, and myself. I am most grateful for their good work and conscientious interviewing. They were aided by Ron Grele of the Columbia University Oral History Collection, who gave everyone important pointers in technique. The introduction that follows was written by Judith M. Burton, Coordinator of the Program in Art and Art Education at Teachers College and a valued participant in our think tank of related experts. I greatly appreciate her hard work and obvious love of the material.

This work would not have been possible without the substantial aid of the Andrew W. Mellon Foundation and the continuing support of the New York Foundation for the Arts. Even more so, it would not have been possible without the cooperation of painters and experts nationwide, who have given generously and willingly to make this project happen.

<div align="right">Joan Jeffri</div>

INTRODUCTION

Judith M. Burton

The Congress shall have Power . . .
To promote the Progress of Science
and useful Arts.
(Article 1, Section 8, U.S. Constitution)

We still find it difficult to say what an artist does exactly. However, from colonial days of the traveling limner, there have always been individuals who draw and paint pictures, who make sculptures and create designs, all of which give shape and meaning to American daily life. But the notion persists that the artist is a strange being, an out-of-time bohemian whose work processes are mysterious and whose talents and abilities are God-given rather than laboriously honed. The image looks better, perhaps, on the frenzied Pollock than the double-breasted Magritte.

Many are puzzled about what artists do, for rarely if ever are jobs advertised for them, and apart from their visibility as teachers or visiting artists in schools and museums, the lay public harbors the idea of the artist as a special person, ensconced in a studio, alone. Yet the scope of activities and professional possibilities offered to artists has broadened considerably in this century. New technologies and mass production have changed dramatically the work of artists and propelled them into extended professional outlets. While many artists still paint easel pictures or create drawings and sculptures, many others have developed skills and special-

izations that have gained them entry into the new worlds of film, television, video, theater design, and the whole field of commercial and industrial design. The lay public may be more than mystified by what artists do, but the results of their activities have come to embrace aspects of daily living that would have been unthinkable to our colonial forebears.

Art began in the American colonies amid conditions that existed in none of the European homelands. Instead of settled, civilized societies, there were colonists from many countries inhabiting tiny, straggling villages along the Eastern Seaboard of a continent no European had yet crossed. Early settlers had little wealth and almost no leisure time, and their life-style and religion called for little adornment. Yet into these inhospitable surroundings came the traveling limners, men trained in heraldry, sign painting, and engraving, who, from the beginning, were pressed into service as portrait painters. Such men had for their prototypes remembered images from their homelands and whatever objects, artifacts, or paintings their compatriots had brought with them to their new lives. Typical of their naive and direct art is the anonymous equestrian portrait of Nicholas Stuyvesant (1666, New York Historical Society). Depicting what looks more like a squashed hobbyhorse, this painting calls to mind the dramatic rearing horse in Rembrandt's *Rider* (1659, National Gallery, London) and reminds us, perhaps with some surprise, that when the Stuyvesant portrait was made Rembrandt was still alive.[1] We are also reminded through journal accounts of the time that throughout the colonial period enslaved black artists practiced an array of skills, including those of sign painter and portraitist. While much of the artistry of this time is lost, it was nonetheless in the hands of the untutored limners, white and black, that the first truly American vernacular style was born.

While these artisans of the New World plied their trade along the thinly settled Eastern Seaboard, the Indian cultures of the as yet undiscovered North American continent enjoyed active and strong traditions of painting and crafts. The cultural heritage of the Indian nations derived from a long and ancient evolution in which paintings, pottery, and weaving expressed the deepest beliefs and aspirations of the people. Depicting a reverence for ancestral traditions, the ceremonial, and the relationship among man, nature, and the universe, Indian art represented a level of cultural cohesion and sophistication that surpassed that of their unknown compatriots to the east. These truly indigenous American artists have been largely ignored by art historians, and perception of their work has at best been filtered through stereotypical cultural lenses shaped by European classicism. Thus it would not be until the late twentieth century, nearly four centuries after the traveling limner had set in motion the artistic tradition of the "new"

American, that ethnographers, folklorists, and American Indian artists themselves would set before the public the long and rich heritage to which they were heir.

Meanwhile it was a long time before home-based American training was available to aspiring artists and even longer before it was available to black, Native American, and women artists, who were for a long time regarded as outcasts of the profession and given little opportunity to practice it. Early documents record that very few "painters" either came to, or resided on, this side of the Atlantic. Most portraits remained in the hands of artisans turned artists who, in their flat, linear styles and penetrating observations, left us an indelible picture of both sitters and style. Painters strove above all to capture likeness with as much fidelity to detail as possible, and their efforts were valued for some very down-to-earth and prosaic reasons. Early colonists, it seemed, sent their portraits to faraway loved ones as tokens of enduring physical presence and in hopes that such likenesses would ensure a kind of material mortality.[2]

Later artists came to these shores with skills acquired in European academies, and increasingly, American artists turned their gazes to Europe and European role models. Such models were elusive, however, and had to be imagined, for they could be seen only secondhand in the form of copies or engravings. When, in the late eighteenth century, Charles Wilson Peale, painter, founder of America's first museum, and friend of Benjamin Franklin, named his sons Rembrandt, Raphael, and Rubens, not one work by these great names had yet crossed the Atlantic. For any thorough study, artists had to venture to the academies of Europe, to London, Paris, and Rome. In the colonies, professional standards were represented by a few artists of European origin like John Smibert and native-born painters like Robert Feke who, with their followers, worked out of studios in Boston, Philadelphia, and New York.

Among the artists active at this time was the portraitist Sara Peale, niece to Charles Wilson Peale, who was, by all accounts, the first professional woman painter to make her living through her craft. Black artists such as the portrait painter Scipio Morehead of Boston and the landscape artist Joshua Johnston of Baltimore, who also practiced professionally, are credited with considerable bodies of work executed mostly for white patrons. However, in spite of small steps in the direction of professionalism, the majority of the best colonial artists continued to be self-taught.

Out of the general colonial tradition of "face painting" came the first of a line of gifted native-born painters who were to find acclaim in Europe. John Singleton Copley was largely self-taught, although he aspired to the sophistication of the British School whose work he knew through engrav-

ings. Dissatisfied with provincial Boston, Copley embarked for Europe the year before the outbreak of the Revolutionary War. In London Copley was to create some of the most impressive historical works and forceful portraits of the age. A lack of teachers from whom to learn and great paintings to see cramped the style of other American artists, who, like Benjamin West and Gilbert Stuart, also made the journey to Europe. West settled in London, became court painter to archenemy George III, and was elected second president of the fledgling Royal Academy. Given small encouragement at home, this first generation of expatriates finally broke with the tradition of portrait painting, turning their insistent gazes to wider classical, historical, and religious themes. Many young artists trained in West's studio; full of European confidence, they returned to their native shores to change forever the public's notions of what art could be.

Broadly speaking, two events changed the role and perception of the professional American artist in society in the eighteenth century. The first was the Revolutionary War, which gave American painters heroic themes from their own history and immediate experience. Artists like John Trumbull and Charles Wilson Peale, returning from their training in the salons of Europe, brought with them the grand neoclassical style well suited to the creation of large canvases depicting agitations of battle and recording the dramatic political scenarios of an emergent democracy.[3]

The second event was the discovery of the land itself, of the vastness of nature. The first indigenous school of professional landscape painting was founded on the banks of the Hudson River in New York State and found expression in the romantic imaginations of painters like Thomas Cole, who captured the American wilderness in all its mystery and grandeur. The idea of a "new world" stretching westward quickly captured the imagination of pioneer explorers and artists alike, and as the continent was opened up, new kinds of painting and drawing emerged, partly reportorial and partly artistic. The great oratorial landscapes of Frederick Church and Albert Bierstadt brought to the American public for the first time the power and hugeness of the Rocky Mountains, Yosemite, the Grand Canyon, the volcanoes of Mexico, and the Amazon jungle. The wide horizons of the wilderness and mountains provided artists with virgin subject matter of a kind that had little precedent in Europe. By the early years of the nineteenth century, the depiction of nature in all its wonder and strangeness had become the overriding passion and preoccupation of American artists—epitomized, perhaps, by the many renditions of Niagara Falls.[4]

The character of the American land, its spaciousness and changing light, also attracted professional artists whose visions were much more intimate and personal. The lucid seascapes and lonely harbors painted by Fitzhugh

Lane and Martin Heade, the portrayals of rural life epitomized by Sydney Mount's own Long Island farm community, and George Bingham's Missouri boatmen and trappers offered an authentic vision of both down-home pioneer life and the newly settled agrarian democracy. More intimate still was the precise and careful study of fauna, flora, and Plains Indians that found expression in the works of artists such as George Caitlin and John James Audubon. Above all, whether the vision of American land and life was vast or intimate, painters of the time believed that art was primarily the representation of a God-given external world; the nobler the subject matter, the worthier the picture. The best art was conceived to depict nature with an absolute fidelity to facts. American art may have found new themes in the land and its people and history, but it continued to cherish its own traditions of close observation and realism.

With the rise of Jacksonian Democracy came a new national consciousness in which deference to Europe gave way to the belief that America was the greatest nation on earth. National pride and self-interest were thus well served by the dramatic, poetic images created by professional painters and writers of the period. Indeed the nostalgia that underpinned much professional painting was also captured by writers of the time, in, for example, *Tom Sawyer*, *Huckleberry Finn*, and *Little Women*. Many painters and writers were self-taught and had been brought up on the farms and among the people that provided the background for their works. For the most part, early nineteenth-century American patrons shared these agrarian roots, and the visual celebration of land and life thus provided artist and buyers with a bond, with a nostalgic escape from the growing complexity and ugliness of an emergent city life. To satisfy the growing demand for art of all sorts, for history pictures as well as scenes of the countryside, harbors, and towns, a growing army of itinerant painters, including newly enfranchised black artists, plied their trade throughout the eastern part of the country. For the last time for more than a century, American patrons were to be proud and anxious to buy American art.

Industrial and economic changes precipitated by the aftermath of the Civil War gradually turned the nation into a commercial-manufacturing power. The emergence of a new breed of self-made industrial barons was accompanied by a renewed search for trappings of power and influence. Almost inevitably the gaze turned back to Europe, to palaces and châteaus, which soon appeared in mock profusion across the New World. Art ransacked from European collections formed the basis for new personal collections and for the establishment of the museums that opened to the public between 1860 and 1890. This showcasing of European art and its evident attractiveness to wealthy collectors did much to inspire young

painters to seek training abroad. Thus by the second half of the nineteenth century, it was almost taken for granted that to be a successful professional artist meant to study in Europe, in one of the great academies of Düsseldorf, Munich, and Paris. This wanderlust extended also to black artists like David Bustill Bowser and Robert Duncanson, who journeyed with the support of wealthy patrons. There, in a more cosmopolitan and less racially prejudiced climate, they studied and exhibited alongside their white contemporaries. At one point the French painter Jean Louis Gerome had ninety American students enrolled in his studio, including Thomas Eakins.[5]

As the nineteenth century came to a close, American artists returned fresh from Europe with new methods and a sense of European profession- alism. However many returning artists were to experience an inhospitable reception, for there was little use for their new bravura techniques, melodramatic visions, and penchant for contemporary subject matter, including studies from the nude, which were heavily frowned upon. While the nation continued to accumulate new wealth at an unprecedented rate, American collectors continued to prefer original European masterpieces in the Beaux Arts tradition to the work of local painters, even those shaped by European training. Many professionals trained in the academies and ateliers of Europe found they could not marry their newfound skills to the American way of life and simply packed their bags and left. The rawness of life at home jarred with the sophistication of Paris and London.

Two painters who managed to bridge the gap between the two cultural worlds in these years were Winslow Homer and Thomas Eakins. Both painters drew upon the quiet observation of fact that had become a characteristic of American painting and combined this with new interplays of light and dark and technical fluidity in the handling of paint learned in Europe. Both captured a feel for the life around them: for Eakins, working in Philadelphia, this involved individual personalities, for Homer, working in Maine, the elemental interplays of man and nature. Beyond their austere visions of American life, however, both painters reflected a more world- wide movement toward a new naturalism in painting. While neither appealed to American patrons of the time, they nonetheless provided a homespun backdrop to the artistic innovations that were to sweep the country from abroad during the next century.

For those aspiring painters who did stay at home during the closing years of the nineteenth century, training could be found in the newly opened academies or university departments of fine and applied arts. With new monies available and a growing conception of humanistic education, studio programs of painting, sculpture, and design flourished. In New

York alone, students could find training at New York University, the National Academy of Design, and the Art Students League. Beyond this, accredited reputations attracted students further afield to the Pennsylvania Academy of Fine Arts, the Cincinnati Art Academy, and the School of the Boston Museum of Fine Arts. Yet, in spite of solid homegrown studio art programs, the veneer of parochialism clung to those students who attended them, and, for the most part, their doors remained closed to women, Native Americans, and black artists. Paris remained the mecca, and the fear was that those who stayed at home would have little contact with the new movements of Impressionism and Postimpressionism, then all the rage.

The American painter who was to live most of his life in Europe and whose thinking was to exert a most profound effect on the course of twentieth-century art was James McNeil Whistler, a contemporary of Degas and Manet. Whistler created an art of simplified forms and harmonic tones which played a crucial role in the evolution from literal naturalism to the abstractionism of the modern era. However Whistler's notion that "art was art" and not narrative would take almost half a century to take hold in the minds of professional American artists and their patrons. Other artists like John Singer Sargent and William Merrit Chase were captivated by the new style of direct painting being explored by European artists, and later other expatriates such as Mary Cassatt, John Twatchman, and Childe Hassam were to be excited by the possibilities of exploring outdoor light and changing visual effects.

Back home, removed from the heady heights of Parisian innovation, the ranks of trained artists began to swell, and finding work for everyone became problematic. Many painters found work as teachers in the new art schools in New York, Pennsylvania, Cleveland, and Boston. Other professionally trained artists such as Frederick Remington and W. C. Wyeth worked as engravers and illustrators for magazines like *Harpers* and *Vanity Fair*, which were finding for the first time that visual dramatization sold copy. Among the emerging community of black artists, the pen-and-ink illustrations of John Henry Adams, Laura Wheeler Waring, and Hilda Wilkerson created for periodicals like *Crisis*, *Opportunity*, and *The Messenger* became vastly popular, attracting audiences for what was becoming a new and distinctive artistic voice. Indeed there was a growing belief among liberal intellectuals that art was a universal language, one that could give meaning to the lives of underprivileged factory workers and farmhands as well to the lives of industrial barons. Mail-order art schools sprang up across the nation, sponsored by the newly formed *Federal Illustrator* which also promoted national art competitions and local exhibitions open to all.[6] State fairs were also held up and down the

Eastern Seaboard, those of Jamestown and Charleston becoming famous for the opportunities they provided talented, young black painters to exhibit and sell their work.

The nation's growing wealth and expanding consciousness of art stimulated unprecedented public building schemes that gave work to muralists and monumental sculptors. The lavish decorations for the Chicago World's Fair of 1893 ushered in a golden age of academic public art. However many professional artists, particularly those influenced by the modern movements in Europe, began to react to what they saw as domination by academic, conservative taste. In what would become a growing effort to bring the more contemporary work of a new generation of American painters to the public, professional artists began to band together to stage exhibitions and promote their achievements.

By 1878 the painters Thomas Eakins, Frederick Church, and Alden Weir had already formed the Society of American Artists with the intention of promoting annual exhibitions. However, ten years later, the increasing size and perceived mediocrity of the society's shows prompted a group of professional artists, including many like Childe Hassam and John Twatchman who practiced the methods of the French Impressionists, to break away and hold exhibitions of their own in New York City. Known as the "group of ten," these American painters shared what critics termed a "sympathetic taste," characterized by subjects drawn from the native tradition of landscape and American life imbued with the new plein air regard for light and atmosphere infiltrating from Paris.

As the twentieth century opened, the American art scene was about to be invaded from abroad by two forces: realism and modernism. Within twenty or so years, these changes would affect the lives, professional aspirations, and practices of almost every artist. The first invasion, led by Robert Henri, turned from the now much-criticized academic idealism to contemporary life as subject matter. Relishing low and high life in equal measure, painters created a form of genre painting that looked not to the Impressionists for inspiration but back to the naturalism of Hals, Rembrandt, and Velázquez. Their portrayals of realistic, everyday subject matter, like the work of Eakins and Homer before them, made them seem radical to the established art world attuned to the prim works of National Academy representatives, who immediately labeled them "apostles of ugliness."[7]

Abroad European and expatriate American artists looked further into the future, beyond the bounds of Cartesian rationalism and what was regarded as industrial dehumanization. In France and Germany they turned away from Impressionism, from the preoccupation with surface appear-

ance, to probe the feelings, sensations, and meanings lurking behind everyday appearances. The nonrational replaced the rational, instinct replaced reason, and the senses became valued guides to self-awareness. Never before had so many young American artists been at the forefront of international art movements. As Postimpressionism gave way to Cubism, Abstractionism, Surrealism, and Constructivism, American painters were part of the forward thrust.

When young painters such as Maurice Prendergast and Marsden Hartley finally returned from Europe, they found a still inhospitable cultural climate. In spite of the efforts of Henri, Twatchman, and their groups, America's phenomenal material growth had not been matched by artistic awareness. Banding together to circumvent the continuing conservatism of large national art shows, young artists continued to promote their own exhibitions, culminating in the Armory Show of 1913. This first grand-scale showing of contemporary European and American art attracted huge crowds in New York, Chicago, and Boston.[8] The nature of the public's perception of the show was largely shaped by responses to the Duchamp painting *Nude Descending a Staircase*: "a success by scandal."[9] However the show had a serious didactic intention, namely, to reveal the roots of modern art in nineteenth-century traditions; the hope was that established authority could be lent to the avant-garde. With only about eight works by European masters of the nineteenth century on display, however, the public understandably overlooked this intention.[10] People were dismayed by the works of Cézanne, Van Gogh, Gauguin, and Matisse, feeling, not for the first nor the last time, that perhaps the art world had conspired to fool them with meaningless invention.

For both the new modernists and the traditional realist painters, there were increasing outlets for showing work in the large national exhibitions, in smaller galleries like the Whitney Studio Club in New York, and in branches of the public library in New York, as well as in other such venues in cities across the country. Exhibition curators, gallery directors, and the critics who swarmed to public showings now began to exert considerable influence over the forms and directions of professional artists' work. One such force was New York's Gallery 291, opened by photographers Alfred Stieglitz and Edward Steichen in 1905. At first devoted to the new art of photography, the gallery became the mecca of the modern movement in America. Heavily influenced by the paintings of Kandinsky, Picasso, and Braque, Gallery 291 and, in its later incarnations, The Intimate and An American Place, brought to a largely uninterested public the work of contemporary artists from Europe and America. The gallery championed liberated thought and vision over stylistic uniformity and sustained young

artists through years of depression and much critical scorn.[11] New possibilities also opened to black artists active in New York, Washington, and Chicago. Major exhibitions were dedicated to talented young artists, bringing to public attention for the first time the works of such painters as Palmer Hayden, Robert Lewis, and James Wells.

Other steps were also afoot to support the work of professional artists and bring it to the public's attention. By 1910 the National Committee of Fine Arts had been established to advise the president on, among other things, the design, selection, and location of public monuments. However the prevailing taste of the United States Government still remained heavily classical and conservative; officialdom was largely unaffected by the artistic furor on its own doorstep. Thus it was left to private collectors to begin the task of accumulating art commensurate with the country's leading political and economic position in the world. By 1920, Gertrude Vanderbilt Whitney had opened her own Museum of American Art, Katherine Deier had formed her collection of modern art, later to be given to Yale University, and Mrs. John D. Rockefeller had spearheaded plans for the opening of a museum of modern art in New York. MOMA opened its doors to the public in November 1929, with Alfred Barr as its first director and sole employee. As the 1930s opened, America boasted 167 art museums, representing a startling increase of over 50 percent in ten years. What became known as the "museum movement" was largely financed by industrialists like Henry Clay Frick, Andrew Carnegie, and Paul Mellon, who believed in returning some of their wealth to the public whence it came—in the form of culture.

With museum and large group exhibitions becoming ever more prevalent and controversial, American art and artists renewed a sense of professional pride last felt in the middle years of the eighteenth century. To some extent this enthusiasm was bolstered by the sheer numbers of Europeans who flocked to the United States in the years between the two world wars. Accredited professional painters such as Kirshner, Nolde, Chagall, Dali, Ernst, Mondrian, and Tanguy joined younger American artists such as Pollock, Guston, Motherwell, Gottlieb, Kline, Newman, and Rothko. In Harlem, under the watchful, philosophical gaze of W. E. B. DuBois and with the support of philanthropic institutions like the Harmon Foundation and the New York Public Library, artists such as Charles Alston, Aaron Douglas, and Hale Woodruff claimed attention. Many black artists were at variance with European traditions and cultural trends and turned increasingly to African idioms, thus stimulating open discussion of the role of racial content in art. Gathered together in New York City, long the outpost of the art world, black and white artists, through their distinctive voices

and divergent aesthetics, almost inexorably moved the nation one step further toward becoming the undisputed center of the art world, wresting professional influence and control from Europe.

The Depression of the 1930s called a summary halt to all the ferment. The country once seen as invincible was suddenly thrown into havoc as the failure of the stock market called into question cherished values. The economy was believed to have been undermined by foreign corruption, and the art world, steeped as it was in Eropean styles and ideas, was similarly suspect. Not only this, but artists were seen to have sold out to the new commercialism of the postwar years; many liberal-minded intellectuals actually regarded the Depression as a blessing which saved art from destructive market forces!

As the Depression bit hard, artists who had traditionally stood at the periphery of society now shared the lot of almost ever other worker. Vigorous arguments were presented to the president and federal government in support of public employment of the type recently given to the young muralists Rivera, Orozco, and Sigueiros by the Mexican government.[12] The original idea was to help needy artists while at the same time using their talents to document the aspirations and achievements of the American people. President Roosevelt had financially supported artists when governor of New York, but he exerted little influence over his officials in the Treasury Department. The fear was that public sponsorship of artists would be extended to "modernists," whose art was viewed as "experimental" and "ephemeral" and not at all consistent with what officialdom saw as the stability and purpose of the nation.

With the government dragging its feet, professional artists, such as the unemployed artists group formed in 1933 and later the Artists Union, brought pressure to bear. In response the Public Works of Art Project was officially sanctioned by the government; created to provide relief support, it started operations in December 1933. The PWAP employed nearly four thousand artists, including many young black painters, sculptors, and printmakers and, in a rare act of recognition, some seventy Plains Indians. In four and a half months, 15,663 works of art were created, ranging from murals and easel paintings in oil and watercolor to etchings and woven blankets. Over four hundred murals were installed across the country from New Haven to Cleveland, Dallas, Iowa City, and San Francisco. The government appeared satisfied with its five-month trial of relief support for artists and coverage was extended in August 1935 under the Works Project Administration in the form of the Federal Art Project.

The FAP extended relief to a spectrum of artists, craftsmen, designers, photographers, and art teachers; almost 5,500 individuals were employed.

Beyond the provision of a small income, the Project aimed directly at cultivating the work of artists and helping to preserve their skills. Indeed many artists hitherto forced by circumstances to practice on a part-time basis could now work full-time. Delivered from the forces of an unpredictable marketplace, many young artists matured at their own pace and in their own ways. Painters such as Baziotes, Beardon, Guston, de Kooning, Pollock, Rothko, Gorky, Gottlieb, and Woodruff, whose careers were made vulnerable by the Depression, could not only work and evolve but bring their art to the attention of the public. Of the seventy-seven art museums that opened between 1938 and 1941, thirty-one did so with the direct cooperation of WPA artists' support. FAP artists were also successful in national competitions held in Virginia, Pennsylvania, and Chicago, and scores won Carnegie fellowships allowing them to teach at colleges and universities across the land.[13]

Organized on a state-by-state basis with local sponsorship augmenting federal grants, most professional artists found themselves working in either the mural or easel painting divisions of the FAP. The latter allowed artists to work at home or in central workshops, and required them to produce one canvas for ninety-six hours of work, or one oil every six weeks, one watercolor every three weeks. In exchange for their work, artists were paid between $85 and $100 a month and were given the opportunity to exhibit their work in the WPA Federal Art Gallery in Washington. For some artists materials were hard to come by during the worst years of the Depression, and they were forced to supply their own from meager stipends. However as an unexpected outcome of the relief program, artists were invited by corporate sponsors to test new materials. It was during the later years of the Depression that synthetic resins such as acrylic, non-cracking size for canvases, new techniques for painting directly on freshly plastered walls, and the use of screen printing for artistic purposes were developed and marketed. Thus by an almost perverse twist of fate, the federal government, long the champion of the conservative-academic tradition and the corporate sector, gave momentum to the careers of young modernists and handed them more flexible materials and techniques with which they would change forever the nation's ideas about art.

As the Depression gave way to the war years, so funding was increasingly diverted. Under pressure to justify artistic relief, the government viewed the FAP with diminishing enthusiasm. The House Committee on Un-American Activities saw an unwelcome and growing trend toward the left in the social themes espoused by artists in their work and public statements. Accusations of radicalism and even communism abounded; there was a feeling that artists should not be publicly supported in what

was seen as destructive and unjustifiable political activity.[14] At the local level, the project was seen to have pandered to the lowest aesthetic taste and degenerated to a level where artists serviced sponsors rather than the public at large. Artists selected at the local level were thought not always to have been of the best, and quantity of artistic production had taken the place of quality. The argument that the government was morally obligated to support the arts in times of both war and peace fell on deaf ears. The many moves to extend the FAP and create a permanent Bureau of Fine Arts floundered in the face of unprecedented political and journalistic debate, which, in the main, saw governmental funding for the arts to be destructive to freedom, innovation, and experimentation. Since the public itself could not agree on whether support of the arts was a legitimate and desirable factor of government, the question of compatibility between bureaucracy and the creative spirit remained unresolved. Funding was finally withdrawn from the FAP in 1943.

Emerging from the Depression and World War II, American modernist painters were still relegated to the cultural backwoods. Many accredited painters of the time, like Grant Wood and John Stuart Curry, made representational art, continuing the long tradition of recording aspects of American life, particularly the growing world of mid-America. While the realists were not unaware of the formal discoveries and styles of the modernists, they believed such innovations could be accommodated within existing representational styles. Such beliefs were articulated by the great painter-teachers of the period, by Kenneth Hayes Millar, John Sloan, and Reginald Marsh.

However the social and political upheavals of the 1930s and 1940s gave new and urgent impetus to the long tradition of social commentary in American art. The Depression in the United States and fascism abroad had brought home to artists that social and political factors affected everyone, sometimes dramatically. The new painters of the American scene began to emphasize the seamy, prejudiced, tawdry, and squalid in a land once pictured for its nobility, grandeur, and hope. From the horror-laden images of George Gross to the biting satire of Jack Levine to the more quietly humanistic observations of Ben Shahn and Jacob Lawrence, artists began to capture an irony and philosophical content which was quite distinct. Other painters, who remained within the realist tradition, also turned from the fruits, flowers, and figures of the past toward the new technological landscape that was changing the face of American life. Striking for their austerity and precision, the works of Bellows, Demuth, and Sheeler gave powerful meaning to the idea of a dehumanized urban wasteland. Perhaps in no other nation at this time were so many artists bringing a moral

conviction into their art, portraying what they thought wrong with their own country—an example of the growing democratization of expression unique to American art.

As the second half of the twentieth century got underway, the new wave of abstract artists began to exert influence. While born out of European Dada and Surrealism, the Abstract Expressionists learned to speak loudly and clearly through American voices. The new "culture of modernism" emerged from a confluence of influences: European masters who had fled Nazism joining forces with the generation of young American painters emerging from the Depression years in New York. Mistrustful of the "illusions" of realist painting, this new breed of professional painters espoused the belief that free, untrammeled movement of hand across paper or canvas produced forms at the behest of the unconscious.[15] Artists such as Mark Rothko strove to uncover the key to the expression of universal images and feelings both tragic and timeless produced by the free reign of energies normally censored by the culture.

Other painters of the Abstract Expressionist group began to espouse commitments that harked back to Whistler half a century earlier; they concentrated on the physical and tactile sensations of the medium itself, of color, line, surface, and texture. Artists stressed the primacy of gesture, of the "act of painting," and claimed for the outcome no referential intent. Painting, it was argued, no longer referred to events outside itself but to itself only, to the world of the canvas. The new avant-garde found in abstractionism a fixed point of reference in a world they saw as beset by economic, social, cultural, and political confusions. Their focus was held constant and made highly public through the writing and influence of two critics, Clement Greenberg and Harold Rosenberg, and émigré teachers such as Hans Hofmann, who gave to the movement its rationale and aesthetic underpinnings.[16] Both critics and teachers made the consciousness of "flatness, color field, and gesture" the leitmotifs, or beacons, that came to guide painterly intent.[17]

Abstract Expressionists saw themselves as a group of pioneers in an aesthetic wilderness, expressing not so much a style of painting as an agreed upon philosophical, gestural intent. While Mark Rothko explored light, color, and the expression of basic human emotions, Jackson Pollock focused on the rhythms and energies created by the interplay of paint and surface. Willem de Kooning caught semi-anthropomorphic images within the flow of monumental gesture, and Barnett Newman worked toward creating illusions of boundless space. Thanks to the strenuous efforts of art critics and journalists, public interest was excited, not to say outraged, and many Abstract Expressionists were swept to international fame.

Photographs of his work in new art magazines such as *Art in America*, *Art Forum*, and *Art News* helped "Jack the Dripper," as Pollock was called, become known to millions who had never set foot in a commercial gallery or museum. Artists themselves were not above self-promotion. They gathered in watering places such as New York's Cedar Tavern bar and later the "21" Club, where attitudes were incubated and arguments often erupted onto the streets as they fought over their work, loves, and lives.[18]

What became the art boom of the post war years was set in motion by the growth of a new breed of middlemen: dealers, collectors, advisers, gallery owners, and critics. Epitomized by the sometimes dubious wheelings and dealings of Bernard Berenson half a century earlier, the art stardom of the later 1950s was underwritten by an army of new tastemakers. Alfred Barr at MOMA, Peggy Guggenheim and her *Art of this Century* exhibit, and the blue-chip sales of the Sidney Janis, Betty Parsons, and Marlborough Fine Art galleries introduced the work of modern artists to the buying public. A nod from the critics Greenberg or Rosenberg was enough to send a growing army of curators and collectors scrambling for investments. It became fashionable to collect fine art, and as corporations such as IBM and Chase Manhattan more heavily invested in the art market, prices began an upward swing. All the activity in buying newness created expanded possibilities for professional artists. For the first time ever, it became possible to envision a career in art just as in any other profession. Bolstered by the economy, aspiring artists flocked to studio training; the swelling demand precipitated an expansion of university and college programs in art and art education across the country.

Giving shape to the art market were the changing commitments of those who actually made art, many of whom, like Al Heid, received their artistic training through the postwar G.I. Bill. By far the most significant event of the last thirty years was the response of 1960s painters to their modernist forebears, who reacted with some coldness to the notion of "art for art's sake" and argued for matter-of-factness. Painting, it was stressed, was no more important, or sacred, than any other human endeavor. Rejecting all forms of social criticism and philosophical posturing, Pop Art burst onto the scene along with the Beatles and Rolling Stones. So-called by the critic and painter Lawrence Alloway in 1958, Pop Art was in fact part and parcel of the enduring tradition of American realist painting, prizing cool objectivity and subjects from everyday life. But in a move that gave breadth to their professional stretch, young painters began to appropriate media images as sources for their art. In turn the media appropriated the artistic images and put them to work for consumer gain. Epitomized by the soup cans of Andy Warhol, the comic strips of Roy Lichtenstein, and the flags

of Jasper Johns, Pop painters drove a fine and controversial line between art and life, between the commercially superficial and the artistically substantive.[19]

One of the truly significant events of the last half century has been the freedom movement set in motion during the 1960s. The awakening of passions and consequent struggles were reflected in, and amplified by, new artistic visions and voices. Basic themes drawn from African folk traditions and urban ghetto experiences were captured by painters like Hale Woodruff, Romare Beardon, and Sam Gilliam. Their works capture the anguish and hope of people in the flow of self-discovery and fight for full legitimization. Also caught up in this tide of events, women and Latin American artists increasingly found discrete public voices. Women artists, once victims of a cultural apartheid, found public appreciation, and the works of Lee Krasner, Georgia O'Keeffe, Louise Nevelson, Louise Bourgeois, and their younger contemporaries Helen Frankenthaler, Elizabeth Murray, Jenny Holzer, and Faith Ringgold are commonly found in museums and galleries. Latin Americans such as Jorge Vega, Carlos Osorio, and Manuel Vega banded together to form the Taller Alma Boricua, a group that gave artistic voice to the pro-independence movement of the Puerto Rican community. More recently Asian-American artists such as Amy Cheng and Tomie Arai reveal a contemplative introspection that harks back to the folk past of their cultures.

The main characteristics of American art today are its sheer diversity and geographical spread. Contemporary art includes individuals—even whole schools—representing radically divergent viewpoints, styles, and techniques. Pluralism is the product of a democratic society, and perhaps as nowhere else on earth have artists found multiple stages. The struggle for voice and identity that has shaped much of the art of recent years has brought into a sometimes difficult coalition the art of Asian, African, Latino, Native American, and women artists. To add to this mix, the art of the past is also undergoing a renaissance, and in the words of Peter Allen's song, "Everything that is old is new again," or seemingly so. Above all perhaps, whatever the period or style, American art has not failed to hold up the mirror to American life and challenge its values and aspirations.

Economic good fortune has made possible unheard of expansion in American art. Federal, state, corporate, and private monies have offered professional artists unprecedented opportunities to work and develop their styles. Artists have been provided with support for travel, teaching, and the development of special projects and exhibitions. The sheer diversity of the buying public has allowed them to be more productive and earn

more than ever before. As a consequence perhaps, in 1988 the federal tax law gave a specific definition of the term "artist."[21] The internationalism of the art market has inspired an influx of European and Japanese buyers and brought to public attention the work of a new wave of European painters: Auerbach, Bacon, Baselitz, Beuys, Freud, Keifer, Penc, Chia, and Clemente. American painters have shared equal billing at the great international art fairs of Cologne, Basel, and Venice. To accommodate the new appetite for buying, successful artists have had to work at a pace that would have astonished their Federal Arts Project forebears. Twenty or thirty years ago, artists could expect to hold a one-person exhibition every two years. In the 1980s American artists frequently held, or were represented in, six or seven exhibitions a year.

The sheer rapaciousness of the art market has a darker side. The great auction houses like Sotheby's and Christie's sell modern and ancient art at prices that rival the national budgets of small countries.[22] Often great works once available to public view disappear into private collections; similarly reputations are inflated into overnight success stories, placing enormous burdens on the shoulders of inexperienced artists. With a primary appeal to the ultrarich, the value of art nowadays is almost entirely set by the marketplace and, like junk-bond trading, is constantly amenable to collapse.[23] In the words of Robert Hughes, "When you're hot, you're hot; when you're not, you're not." It is estimated, furthermore, that 60 percent of all *Fortune* 500 companies now collect art for cultural enlightenment and self-interest. Art, it is argued, lends dignity and credibility to corporate power, the more so when great masterpieces hang in pride of place in boardrooms or are used in advertising campaigns.[24]

Voices of the past, of pre-Depression critics who believed that professional artists had blunted their cutting edge for consumer gain, now find sympathetic contemporary echoes. Peter Berger, among others, has frequently argued that in the present economy, a truly progressive art form, one that reintegrates lived experience, is quite impossible. There is a widespread concern that institutionalization by market forces neutralizes artistic content and stabilizes a status quo vision of society. Indeed even when radical new voices and styles emerge to challenge this stasis, they no longer violate cultural norms so much as become new and exciting commodities to be absorbed within them. In a very real sense, professional artists at the closing years of the century have been brought into direct and uncomfortable conflict with the very structures that sustain them. The new task espoused by many artists is to enter the as-yet-uncharted space opened up by the economy and reestablish an avant-garde that looks with precision

and critical honesty at the dominant reality—a task professional painters in America have a long tradition in honoring.

A FINAL WORD

It is at the crossroads of individual and cultural histories that artists reshape the way reality is envisioned. If we are to chart the way forward with care and responsibility, if we are to move beyond the vagaries of instant art, instant culture, then to know where we have been is essential. For as Karl Marx once wrote, "Historical events and personalities enact themselves first as tragedy and then, in their repetition, as farce!" Knowing where we have been and who we are is to recognize that we have it in our own hands to make the future in a more careful mold. A more detailed look at the many occupations in which artists now serve provides a panorama against which more informed education can take place, higher goals set, and new opportunities forged. Artists also need to build bridges to their public, to help raise consciousness and not consign the fate of their efforts to those who manipulate images simply for commercial gain. In our uncertain, multifaceted world, artists have a particular responsibility and a particular challenge to help us envision anew both ourselves and our surroundings through their endeavors.

NOTES

1. In the main, early limner artists who plied their trade along the Eastern Seaboard came from Holland or England, where they may well have seen the paintings and drawings of the masters either in the original or copies. Thus early folk paintings were enriched by what was remembered of foreign styles, poses, and techniques.

2. The desire to perpetuate personal likeness has its roots in the dawn of art history, and in this, early settlers were no different from their ancient forebears. Portraiture was one of the staples of English and Dutch painting at the time, and of special appeal to the image-conscious, growing middle classes who, with accumulating wealth, aspired to the symbols of the upper levels of society.

3. John Trumbull made his career out of depicting American history. He did many portraits of famous people and completed four large wall paintings of Revolutionary battle scenes for the rotunda of the Capitol in Washington, D.C.

4. John Trumbull, John Vanderlyn, and Samuel Morse are among the best known documenters of what was to become a perennial subject for American painters.

5. Goodrich, Lloyd. *Three Centuries of American Art*. New York: Whitney Museum of American Art, 1966.

6. Information about mail-order art training was circulated on match book order blanks. Interested candidates simply filled out the application blank, and their first training information was shipped to them. Students completed work, sent it back for comment, and by return post received their next training package. See Funk, Clayton.

more than ever before. As a consequence perhaps, in 1988 the federal tax law gave a specific definition of the term "artist."[21] The internationalism of the art market has inspired an influx of European and Japanese buyers and brought to public attention the work of a new wave of European painters: Auerbach, Bacon, Baselitz, Beuys, Freud, Keifer, Penc, Chia, and Clemente. American painters have shared equal billing at the great international art fairs of Cologne, Basel, and Venice. To accommodate the new appetite for buying, successful artists have had to work at a pace that would have astonished their Federal Arts Project forebears. Twenty or thirty years ago, artists could expect to hold a one-person exhibition every two years. In the 1980s American artists frequently held, or were represented in, six or seven exhibitions a year.

The sheer rapaciousness of the art market has a darker side. The great auction houses like Sotheby's and Christie's sell modern and ancient art at prices that rival the national budgets of small countries.[22] Often great works once available to public view disappear into private collections; similarly reputations are inflated into overnight success stories, placing enormous burdens on the shoulders of inexperienced artists. With a primary appeal to the ultrarich, the value of art nowadays is almost entirely set by the marketplace and, like junk-bond trading, is constantly amenable to collapse.[23] In the words of Robert Hughes, "When you're hot, you're hot; when you're not, you're not." It is estimated, furthermore, that 60 percent of all *Fortune* 500 companies now collect art for cultural enlightenment and self-interest. Art, it is argued, lends dignity and credibility to corporate power, the more so when great masterpieces hang in pride of place in boardrooms or are used in advertising campaigns.[24]

Voices of the past, of pre-Depression critics who believed that professional artists had blunted their cutting edge for consumer gain, now find sympathetic contemporary echoes. Peter Berger, among others, has frequently argued that in the present economy, a truly progressive art form, one that reintegrates lived experience, is quite impossible. There is a widespread concern that institutionalization by market forces neutralizes artistic content and stabilizes a status quo vision of society. Indeed even when radical new voices and styles emerge to challenge this stasis, they no longer violate cultural norms so much as become new and exciting commodities to be absorbed within them. In a very real sense, professional artists at the closing years of the century have been brought into direct and uncomfortable conflict with the very structures that sustain them. The new task espoused by many artists is to enter the as-yet-uncharted space opened up by the economy and reestablish an avant-garde that looks with precision

and critical honesty at the dominant reality—a task professional painters in America have a long tradition in honoring.

A FINAL WORD

It is at the crossroads of individual and cultural histories that artists reshape the way reality is envisioned. If we are to chart the way forward with care and responsibility, if we are to move beyond the vagaries of instant art, instant culture, then to know where we have been is essential. For as Karl Marx once wrote, "Historical events and personalities enact themselves first as tragedy and then, in their repetition, as farce!" Knowing where we have been and who we are is to recognize that we have it in our own hands to make the future in a more careful mold. A more detailed look at the many occupations in which artists now serve provides a panorama against which more informed education can take place, higher goals set, and new opportunities forged. Artists also need to build bridges to their public, to help raise consciousness and not consign the fate of their efforts to those who manipulate images simply for commercial gain. In our uncertain, multifaceted world, artists have a particular responsibility and a particular challenge to help us envision anew both ourselves and our surroundings through their endeavors.

NOTES

1. In the main, early limner artists who plied their trade along the Eastern Seaboard came from Holland or England, where they may well have seen the paintings and drawings of the masters either in the original or copies. Thus early folk paintings were enriched by what was remembered of foreign styles, poses, and techniques.

2. The desire to perpetuate personal likeness has its roots in the dawn of art history, and in this, early settlers were no different from their ancient forebears. Portraiture was one of the staples of English and Dutch painting at the time, and of special appeal to the image-conscious, growing middle classes who, with accumulating wealth, aspired to the symbols of the upper levels of society.

3. John Trumbull made his career out of depicting American history. He did many portraits of famous people and completed four large wall paintings of Revolutionary battle scenes for the rotunda of the Capitol in Washington, D.C.

4. John Trumbull, John Vanderlyn, and Samuel Morse are among the best known documenters of what was to become a perennial subject for American painters.

5. Goodrich, Lloyd. *Three Centuries of American Art*. New York: Whitney Museum of American Art, 1966.

6. Information about mail-order art training was circulated on match book order blanks. Interested candidates simply filled out the application blank, and their first training information was shipped to them. Students completed work, sent it back for comment, and by return post received their next training package. See Funk, Clayton.

The Development of Professional Studio Art Training in American Higher Education. Unpublished Doctoral Dissertation, Teachers College, Columbia University, 1990, p. 81.

7. Robert Henri attracted a large and devoted group of followers before his death in 1929. He was an inspired artist and teacher whose sensibilities, expressed in his book *The Art Spirit* (1927. Reprint. New York: Harper & Row, 1984) are far removed from the kind of ugliness of which his group was accused.

8. In New York paid attendance to the Armory Show reached 70,000, in Chicago 188,650, and in Boston 12,627.

9. Now in the Philadelphia Museum of Art.

10. For a discussion of the Armory Show of 1913 see, Brown, M. W. *American Painting from the Armory Show to the Depression.* Princeton, N.J.: Princeton University Press, 1970.

11. Norman, Dorothy. *Alfred Stieglitz: An American Seer.* New York: Random House, 1960, p. 114.

12. During the 1920s the Mexican president Alvaro Obregon sponsored young artists to decorate public buildings in Mexico City with depictions of the revolution. These muralists, including Rivera, Sigueiros, and Orozco, were paid a small wage and left free to express their views. They produced works of a fine, monumental quality that has frequently been compared to the great wall paintings of the Italian Renaissance.

13. McKinzie, Richard D. *The New Deal for Artists.* Princeton, N.J.: Princeton University Press, 1972, p. 116.

14. While the House Committee on Un-American Activities reserved most of their criticism for federally supported theater and writers' projects, such was the furor created in the press that the public was inclined to believe all branches of the arts guilty in equal measure.

15. The origins of free-form abstraction can be traced back to Kandinsky and the Blaue Reiter, whose expressions of subjective emotion were later explored in Dada, in the automatic writing of André Breton, and in the paintings of Arshile Gorky—long held to be preludes to Abstract Expressionism in the United States.

16. "By now it has been established, it would seem, that the irreducible essence of pictorial art consists in but two constitutive conventions or norms: flatness, and the delimitation of flatness; and that the observance of merely these two norms is enough to create an object which can be experienced as a picture. . . ." Clement Greenberg, "After Abstract Expressionism." *Art International* 6, no. 8 (October 1962), pp. 24–32.

17. Rand, H. "The 1930s and Abstract Expressionism." In Wilmerding, John, ed. *The Genius of American Painting.* New York: William Morrow, 1978.

18. Rivers, Larry, and Carol Brightman. "The Cedar Bar." In *New York Magazine* (November 5, 1979).

19. It is interesting to note that *False Start*, a painting made by Jasper Johns in 1959 and sold for $3,150, was resold for $17.1 million in the fall of 1988—a record for a living artist.

20. Steinberg, L. "Contemporary Art and the Plight of its Public." In *Harpers*, March, 1962.

21. "An 'artist' is an individual whose personal efforts create or may reasonably be expected to create a picture, painting, sculpture, statue, etching, drawing, cartoon, graphic design, or original print edition." Federal Tax Law, 1988, code sec. 263 A(h)(3)(c).

22. During the 1979–80 auction season, fourteen paintings and drawings sold for $1 million or more; in the 1987–88 season, 121 broke that mark. The most astonishing price of $53.9 million was paid for Van Gogh's *Irises*, and Sotheby's and Christie's together

recorded over $3 billion in sales during this one year alone. Additional information on the art market is available annually in the September issue of the magazine *Institutional Investor* under the heading "The Million Dollar Club."

23. Van Gogh's *Irises* was bought by Australian millionaire Alan Bond, whose financial empire has recently slid $5.5 million into debt. In order to sell the painting, Sotheby's loaned Bond $27 million, which, it has been argued, helped inflate the value of the work. Bond is now seeking a buyer for the painting; by selling so soon, this almost guarantees lowering its value on the world market.

24. The Salamon Brothers, Inc., annual report of June 1988 on compound annual rates of return on investments reveals that from June 1, 1988, investment in old master paintings outperformed investment in coins, foreign exchange, treasury bills, diamonds, housing, gold, U.S. farmland, oil, and silver.

The Painter Speaks

CHUCK CLOSE

B. Everett, Washington, 1940. Attended Everett Junior College, Washington, 1958–60; University of Washington, Seattle, 1960–62 (B.A. 1962); and Yale University, 1962–64 (B.F.A. 1963; M.F.A. 1964).

RCAC: Would you tell me what were some of your initial experiences with art?

CLOSE: Well, I always wanted to be an artist. I think my earliest recollections are of wanting to be an artist. I think probably around four. The first thing I wanted to be was a junk collector, a garbageman, because people threw away such good stuff. And then right after that I decided to be an artist, and they're sort of compatible.

RCAC: When did you decide to be an artist, and how did you know?

CLOSE: Well, it was the only thing I was ever any good at, and I was learning disabled, although they didn't know. In the forties and fifties no one knew from dyslexia or anything like that, but now I realize that that was what was going on. And I used art to pull my ass out of the fire, as a way of indicating to my teachers that I was not a shirker or lazy or stupid, a way to prove that I was interested in the course material, even if I wasn't able to spit back the facts in a test. So, really, from third grade on I remember doing extra-credit art projects—maps and stuff like that—that could be used to bolster my crummy academic performance.

RCAC: Where did you grow up?

CLOSE: State of Washington—Tacoma, Everett, Seattle.

RCAC: And what was your family unit, your brothers, your sisters?

CLOSE: I'm an only child. My father died when I was eleven. He was a kind of a jack-of-all-trades, itinerant inventor, handyman, sheet-metal man, plumber, electrician, carpenter. And he invented a lot of interesting stuff. And my mother was a classically trained pianist, although the Depression came along, and she never performed. She taught music lessons in the house. And I had a lot of support for being an artist. It was a preferable profession to others. I grew up in poor white-trash America, where no one aspired to be a doctor or a lawyer. In my high school graduating class of five hundred, we had one doctor, and he was a chiropractor. It was a mill town, Everett, Washington, in which everyone worked in the paper mill that his or her father or mother worked in. In fact all my classmates are still there, about ready to retire now from the paper mill. So it wasn't a question of aspiring to be an artist rather than a doctor, but when I suggested that I might want to be an artist, it was certainly not pooh-poohed, and it was a better thing to be than other things, probably.

I started to study art privately at around the age of seven or eight, I believe. And my father found a sort of a fly-by-night art school run by a strange woman—who I later figured out was probably a prostitute, but, you know, I'm not sure how she met my father. At any rate I think the nude models were probably other working women. And I was drawing from nude models in 1948 and painting, and I did that for a couple of years. There was never any question that that's what I wanted to do. For a short while, in high school, a momentary wave of pragmatism wafted over me, and I thought, "Gee, how will an artist make a living? You know, this is probably a silly thing to do." I'm sure nothing practical ever occurred to me personally, so someone must have introduced this as an idea: "Gee, how will you live if you're an artist?"

So I thought, "Well, maybe I'll be a commercial artist," until I took one commercial art course. And growing up then, in this little mill town in Washington, my only exposure to paintings were *Saturday Evening Post* covers and *Collier's* covers and *Look* magazine and all of that stuff. So it was the whole idea of illustrator. At that point magazines were still largely illustrated by paintings rather than photographs; it was all kind of mushed together in my mind. I wasn't sure where a fine artist left off and an illustrator began anyhow.

RCAC: Did you have peers around this time? In high school?

CLOSE: As a matter of fact, I went through high school with a number of other people who also became artists, a couple of whom I'm still in regular contact with. One was just out to visit me this summer. And

another one—we actually go back to junior high school, seventh grade—is still an artist. And it's funny that this funny little town, which produced no doctors or lawyers, produced several artists.

RCAC: Were there teachers who influenced you?

CLOSE: I had a wonderful junior college. My eighth grade teacher, who was the pre–high school advisor (I had her for everything, homeroom, math, science, literature, English, everything except band and art), was a by-the-books kind of person. Although I'd gotten good grades up until the seventh grade—by doing a lot of extra-credit stuff and by convincing people that I could write reasonably well if somebody else could spell it for me; and I was articulate and I spoke up in class and I was always raising my hand trying to show people that I cared about the stuff and had opinions—she was really by the books. She couldn't fail me, because my work wasn't that bad, but she gave me straight Ds. And this was very demoralizing. She convinced me that I would never be able to take algebra and geometry and physics and chemistry. So she convinced me that I would never be able to get into college, I would have to have a trade, I should go to body-and-fender school, or something like that. And she convinced me to take general science and general math and stuff like that. So I was not able to get into any college in America, having taken no college preparatory courses. And when I graduated from high school, the local junior college in my town, in a kind of open enrollment, they'd take any taxpayer's son or daughter who was a high school graduate, and you could make up whatever deficiencies you had while you were in college. And I discovered, as opposed to high school, where you had no choice as to whom you studied with, that I could sort of interview to find who taught which courses and what was required, and I could take courses where I could write papers rather than take exams. And I did extremely well in the junior college, transferred to the University of Washington, where I actually graduated summa cum laude and with the highest grade-point average of anybody in school, and sent my official college transcript to my eighth grade teacher.

And to this day, if I get into the popular press, if *Time* magazine does an article or something, I really am most interested in the hope that if Ruth Packard, the bitch, is still alive in some nursing home somewhere, that she might read it and realize what a hideous mistake she made. So she's been a negative driving force in my life, I think. And if I could meet her in a dark alley, I'd beat her to death.

RCAC: Clearly a seminal person in your life. Do you have any mentors in the art world?

CLOSE: Oh, many. I don't think anybody gets anywhere without mentors. It's one of the things that I find very distressing about the art world right now, with the rampant careerism. When I came to New York, I came here with a lot of other people from Yale, and we really did support each other and help each other. And when a dealer would come to one of our studios, we'd send him to the other ones. And there was a real sense that you'd help each other, and I hate to see the kind of draw-the-wagons-into-a-circle mentality where people begin to see other artists as adversaries or people to compete against rather than colleagues.

But absolutely, mentors all along, from art teachers in junior high school and high school and wonderful, supportive people in college. And then when I went to graduate school at Yale, I had wonderful friends and I was always at the right place at the right time. The golden moment to be anywhere was when I was there. So there's also a lot of luck, and, you know . . . I think you can make the most wonderful things, but if it doesn't happen at a time when the art world is interested in looking at stuff like that, it might as well not happen. So if you do what you do and it happens to cross, at the precise moment when the art world is looking for that sort of thing, you can be very lucky. And if you miss it, you can be very unlucky. Actually I liked Kirk Varnadoe's analogy, in his recent book about somebody deciding to pick up the football and run with it with the invention of rugby. And the fact not only that he decided at that particular moment to pick it up, that it occurred to him, but that the world was receptive; otherwise somebody would just tell him to put the ball back down and go on playing soccer. The field has to be ready as well. So I think all of these things, support and events, that drive you to make a nurturing environment rather than a hostile environment for ideas or anything is essential.

RCAC: Do you think when you went on to college and graduate school you kept gathering more peers?

CLOSE: All along. Friends from the University of Washington I still have contact with and follow their careers. And certainly at Yale. I mean, my class reads like *Who's Who in American Art* of the sixties and seventies. And we all moved to New York and sort of made "Yale South" when we moved here. And all had lofts within two blocks of each other. I helped Richard Serra build his first lead pieces, one of which is even named after me. I helped Nancy Graves make all her early camels and schlepp them up and down the stairs. All the early people I painted, Phil Glass and those people—he was Richard's primary assistant, he helped make all the early lead pieces. And there were novelists, filmmakers. Rudi Willitzer was there. Spalding Gray was helping to build them.

Michael Snow, Steve Reich. A wonderful mix. Wonderful mix of ideas. Richard was smart enough not to have another sculptor help him make his sculpture, but we were all involved with ideas, and all involved with things that were in the air at the time. And we were doing it—Phil and Steve and Lamont Young and those people were all involved with extending certain kinds of ideas.

RCAC: When did critical review start to play a part in this for you?

CLOSE: In the sixties.

RCAC: So you were about how old when you started to get reviewed?

CLOSE: Twenty-eight.

RCAC: How did it affect you?

CLOSE: Well, the work became visible in the late sixties, at a very rich time. A lot of people think of the work as work of the seventies, but actually Richard and Nancy and all the rest of us, Brice Marden, Bob Mangold, Baxter Downs, Janet Fish, all of us were at Yale at the [same] time. Jennifer Bartlett was the next year, she emerged a little bit later. But if you look at the Whitney Biennial, or at that time Whitney Annuals of the late sixties, it really is amazing who surfaced in sixty-seven, sixty-eight, sixty-nine. And it was of course an incredibly active and rich and scary time in America anyhow. The whole world seemed to change in sixty-eight. And it was a time when we were also emerging, and getting a lot of critical attention, and in shows like the Whitney Annual and stuff. All my first sales were to museums. The Walker bought the first one. The Whitney bought theirs in sixty-nine.

RCAC: So the critical reviews had a direct effect on your market right away.

CLOSE: Well, actually, the sales to museums occurred often before I had a gallery and before I had been reviewed in some cases. Real word of mouth and networking. People bringing people by. But actually, yeah, sure. I had sales to the Walker and the Minneapolis Art Institute and to other places before I had a show in New York. I was in a very instrumental and important group show in sixty-eight, at Bikert, although I may have been in the Whitney Biennial before. So there was a sense of becoming visible. All of us were becoming visible all at once.

RCAC: Did you join any organizations at this time, or form any kind of formal affiliations?

CLOSE: No, we were involved with the Arts Drive, we were protesting the war. It's funny, I noticed that the Met is covering some of its paintings in black for the Day Without Art, which is what we tried to get them to do at the bombing of Cambodia. We tried to get the museums to close for a day. And almost all the galleries either closed or hung their

paintings with black, some of them for a month. And I remember
Douglas Dillon coming to the steps of the Met, where we were protest-
ing, and giving us cookies, cookies and tea. Bob Morris and Leon Golub
and I sort of put this art strike together. So there was certainly some
politics. We got involved in a lot of antiwar stuff—which I'd been
involved with for a long time before.

RCAC: But no artist-oriented groups? These were politically oriented
groups.

CLOSE: Well, you know, I always tried to do political service. The art
world's been good to me; I try and give back to the art world. And I've
always been on boards from Skowhegan and MacDowell and served on
CAPS juries and done a lot of work for the National Endowment for the
Arts. I'm on the board of the New York Foundation for the Arts, Studio
in a School, you know. I've tried to give something back.

RCAC: Let's talk about grants for a minute, since we're talking about this
kind of agency. Do you think that they are important?

CLOSE: Oh, absolutely.

RCAC: Any particular stage, or not?

CLOSE: Yeah. I'm involved now with the Sharpe Art Foundation. We're
trying to do something which I've called the Critical Moment Grant,
where you give something to somebody when they actually need it, not
just as validation later. I got one of the first National Endowment grants,
before you even needed to apply for them. But when they still gave them
out. They got a jury together and they sort of decided who to give it to.
But it didn't come when I was starving. I was already beginning to make
some money. I was teaching; I was not living off of my work. And I,
like most artists, never applied again after I was able to make a living,
even a modest living, even what would be considered virtually a
poverty-level income in regular society. It was always considered to be
in poor taste and borderline obscene to apply for grants after you were
making a living off of your work.

There are some obvious exceptions to that. I know that David Salle's
gotten a lot of criticism for applying for and getting Guggenheims.
Et cetera. Each artist has to make that decision for himself or herself,
but my generation, I think we're very self-censoring in that respect.

RCAC: Tell me what "the critical moment" means.

CLOSE: Well, everything to jump start a flagging career, you know, to
be someone older, someone who's been around for a long time and the
peer approval will be just what he or she needs to hang in there, to go
the extra mile, to be able to allow someone to take a year off from
teaching or from slamming up Sheetrock or whatever one does, since

very few people teach anymore. I mean, there are very few teaching positions. One of the things we're doing in the Sharpe Foundation is giving free studio space, as opposed to giving grants of money. We hope that somebody who's maybe painting in a little space or sharing a space, or painting in a space at night and somebody else paints in that space during the day, or maybe can afford to live in a small apartment but can't afford studio space at all, that we can offer him or her decent studio space, and that, at the right moment in someone's career, might allow them to make more adventurous work, larger work, concentrate more on something, not to have to work just to pay for a studio.

RCAC: And the evaluators of this critical moment know something about these critical moments?

CLOSE: Well, we hope so. We hope so. I mean, I've been on juries, and I've found them to be amongst the most moving experiences of my life. I've also been on criminal juries, which I also found very moving. And in very similar ways. I was on a criminal jury once, and I'd been sitting in the jury room for a week with these people, and I found many of them to be racist and incredibly narrow and uneducated. I thought, "Oh, my God, I feel sorry for anybody who gets this jury." And then to be picked with some of these same people, to have to watch the jury transcend their narrowness and their prejudice and be better than they were, and to respond with the highest of integrity can be incredibly moving. And to be on an art jury, and to have people with their own narrowness and their own stylistic points of view—I don't know that I'd call that prejudice, but at least predisposed toward certain kinds of things—and to see that jury make every effort to pick the right artists and to horse-trade, and to say, "I'll give you my passion vote for your passion vote," and usually for per diem pay (awful, a hundred dollars a day or something like that), and to see people give back to the art world in this particular way can be incredibly moving. And I've always found it to be one of the things that I find very upsetting about what's going on with the National Endowment now. I mean, this is one of the few things the government does well. And to see this peer-panel review system, which works so beautifully, even from the point of view of conservative lawmakers, I would think that they would like it. There are no quotas, they don't try and give out work based solely on need or anything like that, and it's supposed to be about quality and all those things. But if the jury reflects society at large, or the applicant pool, if it reflects the regional distribution, if it's sex neutral, you have half men and half women, and if you reflect the minority interests of the applicant pool, then without any effort being made to make sure that a certain number

of women get grants or a certain number of minority artists get grants, if you just make the decisions on quality alone, it just falls right down the line. And it can be incredibly reaffirming. This is what makes the art world a special place, and it simply reflects that.

And then when that grant comes to you, not only is the money important, but the fact that it was your peers, and that you know who was on the jury . . . I mean, I just found out who was on the jury for the Skowhegan Award, and it meant a lot to me that those particular people gave me the grant. The effect that that can have on an artist's career is immeasurable. I mean, it's fantastic what it can do.

RCAC: Would you say your occupation is the same as your career?

CLOSE: Luckily mine is. Most artists' aren't.

RCAC: Do you have any benchmarks in your career? You know, by the time I'm X, I'll have done Y?

CLOSE: Oh, absolutely. I think everybody, whether they admit it or not, does it. I wanted to have a one-person show in New York by the time I was thirty. Did that. Wanted to have a retrospective by the time I was forty. Did that. Then I sort of stopped. Should have had something by the time I'm fifty, because I'm fifty. Become a quadriplegic by the time you're fifty, something like that?

RCAC: Maybe it's not necessary anymore.

CLOSE: I don't know, maybe. These are the silly things that you do. I hear young people today who are making such tremendous sacrifices to live here [New York], far greater sacrifices than we were ever required to make, saying that they're going to give it five years, because they're thinking what they're doing is an investment. It's costing them so much that they are willing to invest five years of this kind of sacrifice. I think that's unfortunate. I think it's making for a different art world. It's unfortunate that it's so expensive to be here and to be an artist. And I think it's already having an effect on the kind of art that's being made.

We had the sense, when my generation came to New York (I feel very long of tooth talking, in the olden days, when I was a youngster), we had the sense that we had the whole rest of our lives. There were dichotomies. There were things that we wanted to have happen, but there also was at the same time a sense that you did have time and that you were not required to have a mature voice instantly. That you could find who you were, and that this process of finding a voice or an idiosyncratic personal point of view, which was, after all, the prime motivating factor in the choice of an art career in the late sixties, was you wanted to make art that did not look like anybody else's art. And if anybody stood in front of your art and thought about anybody else's

art, then you had failed. So we were driven to find this personal point of view. And this is something that we felt we had a considerable length of time to accomplish. One of the things that I think has happened is if you've got to make a career happen fast, if you've got five years to put it all together, then there's no way that you can find that mature, personal, stylistic point of view, et cetera, that quickly, and I think this is one of the reasons why there's been such an appeal in appropriation. Because when you appropriate, you appropriate someone else's mature style immediately. And once you know what that looks like, you can make something that looks mature instantly. Now I'm not against this work. In fact I find a lot of what's going on today incredibly interesting, and I find the art world just as populated with interesting artists as I think, in terms of percentage, it's ever been. Don't get me wrong, I don't think that appropriation has just produced uninteresting or work of no particular value. I think, in fact, it has. But I think the appeal of it was that you could go immediately to something which did not look like student work, did not look like an immature artist struggling, trying to find a voice. So I think its effect is there. And the kind of careerism that manifests itself in the adoption of a strategy over following your work wherever it might go. If you follow your work wherever it might go, it might go someplace not very fashionable. It might go someplace which is not the prevailing sensibility of the moment. On the other hand, if you feel that the way to be successful as an artist is to adopt the right strategy, then you're very connected, either in reacting to or reacting against what's going on at the moment. I think that's driving the art world. And it's the carrot leading the art world, in a sense.

RCAC: In view of this whole discussion, are there certain themes or certain problems that you have been trying to solve or deal with throughout your work?

CLOSE: Well, I've always tried to have my own urgency, so that I was protected from the winds of change. And following my own—I almost called it logical development. I don't think there's a whole lot logical about it. But my own trying to let the change grow out of the urgencies that I find within the rectangle in my own studio rather than sticking my finger to the air and trying to figure out where the art world's going. Well, that's afforded me the luxury of simultaneously being acutely aware of what's going on in the art world and also being rather isolated from it. It doesn't affect me—I love looking at art, I try to see everything, I learn a tremendous amount from looking at all kinds of stuff, even stuff I don't like. You learn as much from a work that you don't like as you do from one you love. And I've always tried to remain aware of what's

going on, and it means a great deal to me to be a part of this community. It's a kind of family et cetera. But it doesn't have to determine what I make. And the luxury comes from the fact that I have now, for twenty years, sold my work. And when you said is your occupation your profession, I always assumed that I would have to have an occupation to support my profession, as most artists do. I've been extremely lucky, and I've had great representation in the form of two—only two—dealers, Bikert Gallery for the first ten years of my career and then Pace Gallery for the next twelve. And with both Klaus Curtis, at Bikert, and Arnie Glimcher at Pace, have had tremendous representation and great mid-career management which kept my work visible. I've been able to live off of my work. It's like dying and going to heaven. I get to do what I want to do every day, and I get paid to do it. You know, without trying to figure out, well, you know, do I need to do this and get someone to buy it? If I did that, would that make my work more successful? So I try not to be critical of other artists who maybe have had to do more to chase success. I don't know what I would have done had I not been successful. I might have been willing to do virtually anything. I haven't had to. But I don't want that to seem like, oh, I'm above it all.

RCAC: What would you say, then, has been your relationship to money throughout your career? Obviously you've sold your work. But what's been your relationship to money?

CLOSE: Well, it's really been almost—and I know that some people will find this hard to believe—but I have been able to convince myself that I'm on one great stipend, or almost on a great form of welfare or something. That the work leaves the studio and the money comes in, and I have been able to convince myself that there's no real connection between the two. Now, this takes a lot of effort sometimes, to maintain this fantasy, but it's allowed me to not think that I'm making a painting for someone else. I try never to have a collector see a piece before it's finished. And for years I never had collectors in my studio at all. I make the piece, the piece goes away, and then it's sold, and the money comes in, and I try not to think about an association. It's gotten more and more difficult.

RCAC: I'm sure. Were there any gatekeepers in the art world for you, people who either let you in or barred the way as you were coming through?

CLOSE: Well, there have been a lot of people who have kicked doors open. And I think other artists kick doors open. They make things seem possible that heretofore weren't. You know, when I was looking around, when I was trying to make representational painting in the sixties, when

it seemed highly unlikely and not a particularly interesting road to go down, there were people like Alex Katz and Phil Perlstein and other people who were the generation prior to mine, certainly the Pop artists, who I think were never understood to be the representational painters that they in fact were. They made it seem possible to follow, to go down a particular road, where it might have seemed blocked before.

RCAC: Gatekeepers is a sociologist's term. It just means, you know, people who keep the gates. Obviously you can go in the gate, or you can be stopped from going in the gate.

CLOSE: Gatekeepers. Well, I've never seen the art world as a conspiratorial place. You know, I think I choose not to see it that way. There probably is evidence, if I wanted to look for it. So, I guess I've always looked for and found encouragement. In my entire career, I can only think of one person who I know ever actively tried to screw me in the art world. He's a very famous artist. And I had the opportunity to return the favor to him at one point. And, of course, with a great sense of moral superiority, chose not to, because it was more important for me to feel morally superior than to get justice, I guess. But in all the years, that's the only time that I can think of where I know somebody actually attempted to put direct major roadblocks in my career. Some people weren't very helpful, but that's their prerogative.

RCAC: Do you think your career aspirations—what you wanted for yourself, in the art world—were different than your actual opportunities?

CLOSE: Not markedly. That doesn't mean that I think it can happen for everybody the way that it happened for me. You know, I don't think there are tremendous pockets of undiscovered genius out there. But I think that there are a lot of very competent artists, easily as competent or more competent than many artists who are extremely well-known and extremely successful, where things have not worked out for them. They can't all be totally self-destructive. They can't all be operating in their own worst interests, although many of them probably are. But sometimes it just doesn't work out.

RCAC: What do you think are the major turning points in your career?

CLOSE: Well, I left the end of a Fulbright in Europe, and I went to teach in Massachusetts for two years, before I came to New York. And I met my wife there. I think she's played an extremely important role in my life. She gave my life a certain stability, and she was a check on certain self-destructive traits that I had. I think I knew I needed someone like her, and I probably went out to try and find someone. And it's not always fair to ask someone else to do for you the things you seem to be unable to do for yourself, but I think that she provided that for me. So that the

choice to move to New York and to lay my neck on the line in the marketplace of ideas, rather than to stay in a regional situation, she was definitely part of that. We came to New York together.

I think the decision to have children was very important, because I think that prioritized my life and put my career into another perspective, did not make it so God-awful important. That was important.

I think the dealers that I decided to show with played an incredibly important role. And I think just having people out there who believed in me and were supportive—all those things came together, to create a nurturing environment.

RCAC: What about materials? What was your relationship to the materials you decided to use?

CLOSE: I went through all the permutations. I realized a long time ago that I could have the look of change in my work by changing the subject matter. But if I changed the subject matter, what I did in the studio each day would have stayed almost . . . the same. And when I became bored with what I was doing, or no longer as engaged in what I was doing, it was usually what was going on in the studio that I was tired of, not the imagery. So when I began to look around for variables that I could alter in the work, to keep myself engaged and to keep moving, many of them were material in nature. Throw those materials out, those tools, that stuff, use something else, and then see what you do. So I've used it as a way to program change and movement in the work, by altering the conditions that generate the work.

RCAC: So it's really a challenge, a self-challenge.

CLOSE: Um-hmm. Part of the self—self-imposed limitations—which is interesting now. Since I've become quadriplegic, I've had limitations imposed from without. But I think all the years of working with severe self-imposed limitations have probably stood me in good stead and prepared me for the challenges of working.

RCAC: Have the costs of doing your work changed a lot, since you began your career?

CLOSE: Absolutely. Oh, of course! God, lofts that were fifty dollars a month when I came to New York are two thousand, twenty-five hundred a month. When I first came to New York, you could teach one day a week for six dollars an hour. I made less than four thousand dollars a year. And we lived in a twenty-five-hundred square-foot loft, and we ate meat. I remember that a week's groceries, which were several bags, could be gotten for ten or twelve dollars. Those days are gone. Artists do live better than other people on less money. No question about it. Artists who are poverty level manage to take vacations in Europe,

somehow, and go someplace warm in the winter, somehow. I guess it's because we don't put a lot of money into BMWs and stuff like that. But the costs are tremendous. And I worry about the art world. I worry how far afield you have to go.

When we first settled in what was later to become SoHo, there were maybe six people living between Canal and Houston. But it wasn't a dangerous, horrible place to live. It was actually one of the safest areas in the city, and you got a lot of space and privacy and stuff. And, as always, artists are the pied pipers of real estate, and wherever artists go, gentrification is right on their heels.

But, as you watch people go to less and less desirable neighborhoods, further and further away from the center, with rents in Brooklyn or Long Island City or Hoboken being almost the same as Manhattan . . . You know, I've heard people talk about Pennsylvania as the new Hoboken. Well, Hoboken, to me, even though it's only one subway stop away on the tubes, always it was a psychological distance, as there was to Brooklyn. But, I mean, if Pennsylvania is the new Hoboken, you're no longer in the city. You're doing something else.

RCAC: What about the public? What's been your interaction or relation to the public over the years?

CLOSE: Well, I think you form a kind of trust with the audience, that what you do is you put it out, and they pick it up. So I try to orchestrate experiences for viewers.

RCAC: How do you mean?

CLOSE: Well, I have my own experience in the study. There's this kind of ritual dance which you do and then the painting is this kind of residue, this kind of evidence that, in fact, the ritual dance took place. It's sort of a performing art, but nobody watches the performance. And then this thing, which stands for the ritual dance, kind of goes out into the world and stands for it. And I always liked the definition that Duchamp gave to a work of art, that the artist had only fifty percent of the responsibility, and that was to get the work out, and that the work was not complete until it had been returned by the viewer and come full circle.

And I believe that art is either about communication or it's therapy. And I go to therapy for therapy; I don't make art for therapy. And so I believe that there's this tremendous contract made with the viewer. You put it out, and you do everything you can to make your work clear, to present it in a way which helps to make it understood and to make it clear, what you think the issues are, what the priorities are for you, and that you are in fact an orchestrator of experience. You do certain things, you follow certain roads, and then you drop these crumbs, like Hansel

and Gretel, for the viewer, that they pick up, and they take this trip retracing your steps to have the experience vicariously. That's what I believe. I don't believe that all artists have to do that, but that's the agreement I've made with the viewer, that I will try to do that.

RCAC: What's the viewer's responsibility?

CLOSE: Well, you know, it's always nice when you get feedback, once people read your paintings. I think that the older, more trusted eyes, the people who have been with you the longest, who have seen all the changes and watched all the permutations, those are the people that you look to most to read your paintings and to tell you how you see them. But it would be like attempting to learn a language without ever speaking to anybody. You can learn the words, and you can even learn a little bit of the pronunciation, but unless you've used that language, unless you say something and you get a reaction back, and you think you said one thing, and somebody else thought you said something else, you cannot learn nuance and subtlety of communication by being engaged in a dialogue. And I believe that the same thing happens in visual communication, and if you don't take advantage of it, if you secrete yourself in an ivory tower or you take a position in which you don't give a shit what anybody thinks, then, in my opinion, you have cut yourself off from that bottom level of nuance and subtlety, which is where the real joy for me takes place.

RCAC: What kind of control do you think you exert over your own destiny as an artist?

CLOSE: Well, there are certain things that are outside of your control. But I think you have tremendous control over the work and over the rhetoric. And you can try and be clear about what it is you're doing, and you can at least control that.

RCAC: What are your own criteria for success as an artist?

CLOSE: Well, the most important thing is the respect of one's peers and colleagues. I'm showing this spring for the first time in SoHo, first time I've ever shown downtown. I lived eighteen years on Prince Street before we moved; about five years ago we moved uptown. But this show, which is the first show that I've done since I became a quadriplegic, is incredibly important for me, because I want the art world and my colleagues to know that I'm alive and working, and I hope that they will find that the work is still interesting—if they ever thought it was interesting in the first place—and, you know, that I haven't lost it in some way.

Getting it out in front of my peers, downtown, seemed much more important to me than showing it uptown on Fifty Seventh Street. Even

though I know artists travel uptown, there's a sense of community which is very important to me. I found it extremely sustaining while I was in the hospital. The art world really came out for me; all my friends were at the foot of my bed all the time. And it was very reaffirming because looming over the end of my bed were the heads of all of these people, and I became aware all over again just how compelling these visages are to me.

RCAC: Perhaps there are different kinds of success. I mean, clearly, money is another kind of success.

CLOSE: Oh, yeah. I mean, I'm not going to say that money isn't import-ant. I have a wonderful life-style that I've grown accustomed to, that I would find it very difficult to do without. Could I get by with a lot less? Obviously I could. I don't want to. I hope to hell I don't have to. But I think—and I hope this isn't just bullshit, I hope that I haven't just convinced myself of this—I think that the other stuff is far more important than the financial success. Usually the two go together.

I was just reading a piece on Einstein, and Einstein always quoted—Heine. "Who has much will soon have more. Let this law be unmistaken. Who has little, then from him, even that little shall be taken. But if you have nothing, why, go and jump into your grave. Only those with something have any right to live, you knave." It has to do with the guilt of being successful. You know, there is guilt for being successful. And many of my friends and colleagues, for whom I have tremendous respect, have stick-to-itiveness and dogged determination that I don't know that I would have. It's never been tested. To hang in ten, twelve, fifteen years, making tremendous sacrifices, giving up having children, giving up having, you know, a lot of the nice things in life in pursuit of a career. I don't know what I would have done, but there is guilt for being successful and looking around at other people who have worked just as hard and don't have the attention. And the financial success.

RCAC: Do you think your definition of success for other artists is different than for yourself?

CLOSE: Oh, sure, I think it's different for everybody.

RCAC: Are you satisfied with your career as an artist?

CLOSE: Oh, yeah. I mean, on one hand, enough is never enough, and on the other hand, it's exceeded my wildest dreams on some level. I always thought that I would be successful on some level. I thought that I could make things that might matter to other people, and that I might have some kind of visibility and success that way, but I never dreamed that I'd be making money and live the way we live.

RCAC: What do you think is your greatest disappointment in your professional career?

CLOSE: I don't know, I guess I could search around for something that was a great disappointment, but nothing leaps to my mind, nothing seems that profound a disappointment. I mean, there are things that I would like to have had happen at different times or happen again, but it's not a driving force in my life.

RCAC: You talked about how the art world has changed. What advice would you give to somebody who wanted to be a painter in this day and age as opposed to your day and age?

CLOSE: There's that old saying, that you should try and talk everybody out of being an artist, because the ones you can talk out of being artists should be talked out of being artists, and the ones you can't talk out of being artists will go ahead no matter what you say to them anyhow. I don't know that I necessarily subscribe to that. But I think that you have to be really prepared today if you're going to be an artist to withstand the most tremendous pressures and to make the greatest sacrifices that, in my experience as an artist, I've ever seen people have to make. And I think you have to want it maybe more than my generation had to want it. You could go out and see how it worked out—and always retreat to a teaching job somewhere. It didn't seem to be such a terrible risk, and it didn't seem to be connected to the economy. Now with the looming federal deficit, everything—the past, the legacy of the Reagan years, the piper now having to be paid—there's this sense of imminent doom practically. And in some ways, it's not a very positive time to be trying to enter the art world.

On the other hand, it's a wonderful thing to do. I never understood somebody wanting to do something for fifty weeks out of the year and then reward himself with two weeks of vacation to make up for it. I never could understand that. The art world can be an extremely gratifying place to be. You do things that matter to you and attempt to convince other people that it might matter to them. I'll tell you one thing I think is really wonderful about the art world. For all the talk of connections and stuff like that, it's still the only place that I know of where you have a chance to be rejected by the person who owns the store. If you were a musician, you couldn't expect the head of MCI Records to hear your tape; you'd have to go through all these strata. You'd have to get someone on a very low level, and there are all these chances for things to go wrong before anybody would ever be in a position to actually make a decision about what you do. Whereas you can walk in off the street with your slides and throw them on the desk

and have the work looked at by whoever runs the gallery. You can have a chance to really make the case where you work and try to get them down to your studio to see what you do. I know of no other profession where there's that kind of access.

Honors: Medal in Painting, Skowhegan School of Painting and Drawing, 1991; Honorary Doctorate, Institute of Fine Arts, Boston, 1991; Sixth Annual Infinity Award for Art for Important Use of Photography in Mixed Media by a Visual Artist from the International Center of Photography, New York, 1990; Lab School Outstanding Learning–Disabled Achiever's Award from the Lab School of Washington, DC, 1987; Fulbright Grant, Vienna, 1965–66.

Representative collections include: Private: Mr. and Mrs. Eli Broad, Ray Learsy and Gabriela Ferrara, Sidney and Francis Lewis, Paul and Camille Oliver-Hoffman; Corporate: Chase Manhattan Bank (New York), Paine Webber (New York); Public: Art Institute of Chicago, Metropolitan Museum of Art (New York), Museum of Modern Art (New York), National Gallery (Washington, DC), Tate Gallery (London), Walker Art Center (Minneapolis), Whitney Museum of American Art (New York).

Professional affiliations: Artists Advisory Committee, Marie Walsh Sharpe Art Foundation, New York Foundation for the Arts, Studio in a School Association, Tiffany Foundation.

JIM DINE

B. Cincinnati, Ohio, 1935. Studied at the University of Cincinnati and the Boston Museum School. B.F.A., Ohio University, 1957. Lives and works in New York City and London. Exhibits internationally.

RCAC: In your early childhood, how were you first initiated into the world of art?

DINE: I wasn't initiated; I was born that way.

RCAC: How do you mean?

DINE: I mean, I was born an artist. I didn't ever do anything but that. So it's not a question of some memorable experience where I had a breakthrough time that I knew I wanted to be an artist. It's the only thing I can do. It's what I'm here for.

RCAC: How would you describe your family in your early childhood?

DINE: I had a mother and a father and a brother, who's five years younger than I am. My mother died when I was twelve. My father worked in the family business—hardware store, plumbing supplies. My mother was a housewife; my brother was a little boy.

RCAC: How did they feel about your talent?

DINE: My mother was very proud of me and encouraged the art, as much as someone in Cincinnati, Ohio, first-generation American could. My father was a cipher, and he didn't really care one way or another. He got some degree of satisfaction from the social prestige of his son being an artist, even at that age—which is completely bananas. I mean, he just

told me that, just before he died last year. I said, "How did it seem to you when I went to the art museum in the summertime to draw?" He said, "It didn't make any difference to me." He's a real bastard. And I said, "Well, what did you think about it?" He said, "I didn't think anything about it, just that it meant that your son was going to the art museum in the summertime, so that gave me a certain degree of social prestige." I don't know what he was talking about—"social prestige," for crissake. But he was a very cold, depressed, turned-off character, who lived for my mother's whims—and a kind of Don Juan figure. After she died he went on to have a series of relationships with women. Satisfactory or not, it didn't matter; that was the obsession. So that's what he was like. I hardly ever saw him after my mother died. I ran away from home, and I went to live with my maternal grandmother, because the evil stepmother was beating me up. Then I finally got my brother out a few years later. They were really abusing him, 'cause he was little and also because he taunted them. Then I lived with my grandparents until I went to college, and then I never lived again with my family.

RCAC: This was also in Cincinnati, your grandparents?

DINE: Yes.

RCAC: And college was where?

DINE: College was a year and a half at the University of Cincinnati. I went to a very fancy high school—that is, it was fancy intellectually. It was public. It was based on the Boston Latin School and had been started, I guess, during the First World War, or maybe just after, as a six-year *Latin* high school. So all the smart Jewish kids and the privileged WASPs went, and a few token blacks. And the blacks always went to Harvard, because they were really motivated. And the Jews most of the time, a few went to Harvard and Ivy League schools, and mainly they stayed in the state schools—they didn't have any money—or the University of Cincinnati, where you really didn't need any money. And most of them became doctors. And I went there because I had such a difficult time in high school. I only got through it because I'm real smart and I knew how to cheat. Otherwise I could not have done it. I have learning disabilities which I know now because two of my sons do. I thought I was stupid. I couldn't do the work because psychologically I was distracted by my earlier experiences, to say the least. The only thing that saved me was when I was sixteen and I got a driver's license. I got in that car—in my grandfather's car—and I went to the Art Academy in adult education at night, and it really saved me because then I knew I was home. I knew I had found it again. Out of this morass and this swamp of semi-juvenile delinquency and rebellion I was living in, it

didn't make any difference anymore, that business. I just knew that I was an artist now, and it was great. I took classes with people who had been my grade school teachers. I mean, by accident, a shop teacher who had beat me in the fifth grade was standing next to me, and the bastard never said anything, and I never said anything either. I mean, we never even said hello. He was a student with me, you see, when I was sixteen. I went right in when I was sixteen and painted a painting. And I just thought to myself, "I got the magic." I mean, I know I've got the magic, you know? And so I went to the University of Cincinnati, because my high school teachers hated me so much. This is not paranoia; this is truth. These old ladies hated me so much. I was such a disruption that nobody told me about college boards. If you were a Cincinnati resident, they had to take you then. So that's what I did. That's the only place I could possibly go, so I just went. And it was horrible, because they didn't have painting, only design. I went into the College of Applied Arts. And they said to me, after the first semester, "If you'll leave, we'll pass you. If you will please leave the school." I was such a disruption. First place I couldn't make my hands do what I wanted them to do for a variety of reasons, not the least of which was it's very tough for me to mechanically draft. That's what it was about. It was a very rigid kind of thing. Then also I already didn't want to do what they wanted me to do.

So I went to liberal arts where I couldn't do the work. I said, "This is ridiculous; I'm going crazy here. I mean, it's the same old thing like high school again." So I had a friend from high school who said to me, "You know, you ought to come to Ohio University in Athens, Ohio because it's only eighty-five dollars a semester if you're an Ohio resident, and they have this great art department." I didn't even care, but I went up there. They didn't have a great art department; it was ridiculous. They had one old man who was a landscape painter and a couple of ladies from Columbia Teachers College who were in their late sixties, who hated everybody. And they did like ninth-rate Georgia O'Keeffes, because that's the way they were taught at Columbia Teachers College. They did not know what to do with me at Ohio University, so they just left me alone. I stayed there and I married there and I spent a year in graduate school. By that time they'd become very smart, and they had a head of the department from the University of Iowa. He'd come in my senior year. And so he was making a real master's program thing, and I just got out; I just couldn't take anymore. He was a nice guy too, but I was not able to write a thesis; I couldn't do anything. I just wanted to paint. So my wife and I left. And I never went to formal school

again. But I actually hadn't gone to school. I mean, I have no recollection of any teacher meaning anything to me.

RCAC: What are your recollections then of a validation of your art as you were growing up, aside from your own validation?

DINE: Well, the teacher at the Art Academy was interested. He knew something was going on, and he encouraged me as much as he could. I didn't understand what he was talking about all the time; he had some goofy theories, but he was encouraging. I knew I was on the right track, see? I could feel the power. I'm trying to think of any other validation. . . . I had a friend in high school who was an artist also, who ended up going to Cooper Union. I didn't even know Cooper Union existed; nobody told me about that. But he was interested. And we talked a lot about painting and things. And I had other friends who were interested, and they were interested in having a friend who wanted to be an artist. There, in Ohio amongst Jewish boys, it was not something everybody did. So it's not like if you had gone to school at Music and Art, in New York City. I mean, we're talking about the Midwest and Northwest Territory, and the tradition was not that. The tradition was Columbia Teachers College, again. My mother went for two years to the University of Cincinnati in Applied Art, it was called then. In some women's program. It was like a teacher training thing for women—that's what girls did. There was a tradition of women working in the crafts in Cincinnati. My mother's training came out of the arts-and-crafts movement too, because Rookwood Pottery was there, and in the nineteenth century the potters were women. So it was something women did. And my family—my grandma and grandpa—they were peasants. My grandma was the only one of my grandparents of the four who was born in America. She was born in Richmond, Virginia, and she was just a southern peasant lady. If she had been a Christian woman, she would have been a sharecropper. But she wasn't; her father was a tinker. Her father and mother had come from Hungary, where they had eight children who died of diphtheria, and so they came to America and had eight more. I asked my grandma once what her mother died from. She said, "Honey, her womb fell out." So I said, "It's no wonder, she had sixteen children." She died when she was about fifty. My grandma's father was just a traveling tinker, and he killed chickens and koshered them. And he circumcised little boys, if he got to that town at the time when anybody needed a boy circumcised.

My grandma was real nice to me. She loved me. My grandfather naturally thought [painting] was ridiculous. He thought this is not a profession for men; it's not something to make a living, naturally. But

I never listened to anybody anyway, so it didn't make any difference to me at that point. It was too late. I worked in the family store all my life, from the time I was nine. My family didn't know about child labor laws, and so there was a lot of exploitation of us. I hated it, absolutely hated it. I was unable to read a book; I could not comprehend what it was. Although obviously I could read something to get into high school, I could not concentrate. And even today much of my reading is done in bookstores, standing up reading from the back, starting at the back. And two of my kids are like that too—I mean, we're left-handed males. And it's a classic thing. I guess it's dyslexia or whatever it's called, minimum brain dysfunction, something.

At Ohio University I had a lot of validation from other students, and a lot of other students thought I was nuts and a threat. But some of the professors were quite good about it, and my wife validated me. She was an art student.

RCAC: Why a threat?

DINE: Because I was better than everybody else. I just was. I could do things that other people couldn't do. I'm not saying technically; I mean, I had ideas. I was an artist. You know what I mean, I was not a craftsman, as it were.

RCAC: Did you specialize in painting from the beginning?

DINE: I always did a lot of pottery when I was a little kid, but I don't think there is any difference between drawing and painting and sculpture, so I do all those things, and I always have done them. But I would always call myself a painter. I would probably call myself a painter, because it's the medium I've expressed myself in the most. But I am a sculptor, and I certainly draw all the time.

RCAC: You mentioned this one friend in high school. How important would you say peers were to you in high school and at later periods?

DINE: Well, he was great to me in high school. We took art in the last year of high school from a woman who just couldn't cope—we were wiseguys, he and I. We knew more than she did; we simply did. We'd look at paintings, and we cared about paintings. We went to the museum, we had books. I went to the library—I stole library books and pinned up reproductions of great art. I knew who Picasso was. Matisse. So peers were very important to me. And he was particularly important to me then, because he was an artist my age. He eventually became a graphic designer, but at the time he wanted to be a painter, I guess. That's what he did at Cooper Union. Plus my other friends who weren't artists, as I say, were proud of me in some way. They thought I was a bit nuts, but I think they were envious of what they saw as personal

freedom. I had no choice; I chose it for myself or it was chosen for me, and I just went with it.

RCAC: Did you have any role models during this time in your high school years and into college?

DINE: No, no, no. Teachers were horrible to me, really horrible to me. I just took it naturally that I was a natural continuation of the history of art, that all artists were role models to me, all painters from another time—dead painters, Picasso. And I worked at the art museum when I was a freshman in college, matting prints and framing things. And that was great, because I could touch paintings. I mean, literally, it gave me a chance, when people weren't around, just to put my hand on paintings, which was important to me. To feel them.

RCAC: Do you think your training adequately prepared you?

DINE: My training is going on all the time; I'm training myself all the time. In 1974–75 I simply stopped painting and drew from the figure for five years. I literally did it every day, because I felt I was unable to speak as clearly as I wanted to speak a certain way. I had come to some kind of impasse in the painting, and I just thought I've got to do this. So I did that. There's always training going on.

RCAC: How did that period come to an end? How did you decide when that was over?

DINE: Well, it's never been over, but the rigorousness of it was over when I realized I wasn't just learning, I was really using it creatively. Rather than making exercises for myself and looking hard and leaving things unfinished, I was finishing things and was ready to show things as a result of it, and that's when I thought it was over. I never again hired models, and I just used friends after that.

RCAC: Did you have any benchmarks during your career? For example, "If I'm not at point X in five years, I'm going to do Y?"

DINE: No, I never felt like that. I never felt any way except that I knew I was going to go to New York and be a painter.

RCAC: When did you know that?

DINE: I knew that when I was nineteen. I took off a semester when I was going to be a junior at Ohio University to go to the Boston Museum School because—this is really provincial of me—I didn't think of coming to New York to go to a New York school. I thought Boston was really *the* seat of culture. So I got into the Boston Museum School, and they put me back a year. They wanted me to start as a sophomore; I said, "Fine." And I went to the Boston Museum School for a semester, and it was absolutely repulsive. It was very academic and they wanted me to do certain things, and I sure as hell wasn't going to do them. I had

already had a real taste of freedom at Ohio. I did what I wanted to do. I had my own place, a cubicle to paint in; it was great. So I only stayed there six months and had a bad love affair, and then I just left. Plus that it was too far from home. By "home," I mean Ohio.

Then all the time I would go to New York. We'd drive all night to New York from Ohio on the Pennsylvania Turnpike. See, we were right there on the West Virginia border, and you just got right into Pennsylvania and then it took about fifteen hours. We'd drive all night and then have all day Saturday to go to galleries, and then we'd drive back on Sunday. And we'd do that like once a month or something.

Then I was stealing all this time—from the library, bound copies of *Art News*. At the time *Art News* was the only art journal in America of any substance. And Tom Hess had made it a kind of propaganda journal for Abstract Expressionism. In terms of role models, I knew this is what I wanted to do; I wanted to play in this arena. And I never had any question I was going to stay anywhere and teach school or anything like that. So when I decided to come to New York and not finish the master's program, Nancy and I just packed up a trailer and came to New York. We didn't have any job or anything and I was twenty-two. And it was a recession—1958, I think it was—and there were no jobs in New York City. Nancy got a job as a secretary. I looked around for a job all summer; I would have done anything. And then I had this idea. I'm quite larcenous, as I had stolen all these books. I decided I'd go to a teaching agency—an elementary school teaching agency—and say that I was trained as an elementary school teacher. Now, you know, it was before computers, and people believed me. So I got this job on Long Island. Remember, I'm from Ohio, so we didn't have any idea that you weren't going to work or that your wife should work and you could paint. I was from some kind of ethic where the man worked.

So I went out to Long Island; I had this interview in Patchogue. The superintendent of schools was really nice, and he gave me a job immediately as the art teacher at this elementary school. I didn't know what to do. But, I mean, it wasn't so long ago that I had been in elementary school, so I realized I could probably do whatever they did with me. And at the same time he said, "Are you married?" And I said, "Yes." He said, "Would your wife like a job?" And I said, "I guess so—I'll go ask her." So she got a job teaching the second grade. She was not trained at all. And then she got pregnant after two months, and naturally in those days you couldn't keep on teaching, so she had to quit immediately, but I stayed there a year. And it was horrible, really horrible, because I wanted to be in New York. I was in Patchogue, so

we were going in every night to New York. Finally I said, "This is crazy, let's go to New York." So I got another teaching job in New York—grade school. The one in Patchogue was from the first grade to the sixth grade, and the one in New York for two years was junior high and high school. And it was just across from the Museum of Modern Art, and I was able to hide in there, so it was great.

RCAC: How long did you teach there?

DINE: Two years at the Rhodes School, it was called.

RCAC: Were there any organizations you joined when you first got to New York as an artist?

DINE: No.

RCAC: Did you start to become a subscriber to things like *Art News*?

DINE: Never. I'd buy it on the newsstand sometimes.

RCAC: Have there been any institutions that provided you with any benefits along the way, health or otherwise?

DINE: No, I taught school. I mean, I've taught at Cornell University, at Yale, and at Oberlin. So, I guess, at Cornell—I taught there a year—I would have gotten some health plan if I had been ill. But the other places, I didn't even know if I would have. I was just a guest for a semester each time.

RCAC: What do you think about things like Artists Equity, unionization for artists?

DINE: I think that everyone in this society should be under a national health plan. I absolutely do. I think that you're never going to get artists to organize, and it's a shame, because we're getting screwed. But of course it would have to take everyone at Pace Gallery to say to the boss, "We're no longer going to put up with this. You're taking too much." But nobody'll do it, because for the most part, artists don't want to mess around with that part of the business. In fact the gallery does give services—not just selling, but all the other services of photography, keeping the records, et cetera. It's just not done very well, and it still couldn't be costing them what they're taking. So I think there's a great need, but it'll never take place, because artists don't want to work with each other. We're a jealous bunch of bastards too, you know, and competitive, and nobody wants to put that aside.

RCAC: Describe for me the time when you think you first received professional recognition as an artist?

DINE: I received professional recognition when I first came to New York, because we started this gallery in 1958. When I left Ohio and went out to Patchogue, that next year we started showing at the Judson Student House at the Judson Church on Washington Square, because this friend

from high school that I told you about was living there as a student at
Cooper Union. He introduced me to the minister, and the minister said,
"We'd like to start a gallery." He was actually not the minister; he was
a minister who was hired by Howard Moody, a man called Bud Scott.
He was hired to go to bars and hang out and talk about God, talk about
Christianity. That's the way I understood it. It was quite interesting.
And he was a kind of bohemian minister, and he hung out in bars, talking
about God, I guess, or getting drunk. And at the same time that Marcus
and I started this idea of a gallery in this basement at Judson Church,
Marcus knew a guy who worked in the library at Cooper Union who
was Claes Oldenburg, so then Claes and I and Marcus would show. And
then Tom Wesselman—we knew him from Cincinnati—was at Cooper
Union. I didn't know him in Cincinnati, but Marcus did. So he would
show a little bit there in the beginning. But mainly it was Oldenburg
and I who took over, because we had the power of this whole thing, and
we knew other people, and that's the first place I got any recognition.
But it was almost immediate. And then Kaprow and these other people
came from the Reubin Gallery to see us and said, "Do you want to show
over here?" And we did that, and we got recognition the next year. Also
Claes and I started making performances, and *Time* magazine would
write them up. And from then on I was always recognized. I wasn't
making any money, but I was recognized—the beginning of fame. It
was the beginning, when young people had fame. I was just the first
generation, and I was probably the youngest—except for Samaris,
maybe, or Red Grooms, he's a year younger or something. But after all,
those Abstract Expressionists had been hanging out in bars, and they
were like sixty, and they were just getting known, and here I was,
twenty-four years old, getting in *Time* magazine with Claes, and we
literally never looked back.

RCAC: Would you talk a little bit about competition in the art market-
place then and now?

DINE: It's basically no different now or then. Among competitive people
who are artists who make their own product, and care about it, and for
the most part make it themselves or have it fabricated, but at least are
all the ideas behind it—it's not a group effort. It's very difficult to share
your recognition with other people and also to be in a gallery situation
where somebody is selling work and you're selling work. And there's
work for sale, and it's like a little bit of camaraderie. In those days it
was. But also we were competing with one another, which is the reality
of it, in this consignment shop, which is what it is. To me, it's always
been real and very unpleasant. I've chosen to walk away from it rather

than be involved in the macho competition of the way it was then, particularly. I never hung out in bars. I had children very early, and Nancy and I had a life at home. So, I mean, I painted all day or taught school or painted all night if I was teaching school, and then we had a life with these little boys. And we had some social life too, but I was not fit for it in those days. I knew a lot of artists, but by the time 1962 rolled around and all of us were lining up into galleries of prestige, a lot of people weren't seeing a lot of people anymore. It wasn't a group effort.

As far as competition now goes, after all, we've just come through a decade of such glut, excess, and spending, and I've been the beneficiary of this. I made a lot of money in the eighties, as did everybody, but I was not of that generation, fortunately, of people who never had anything else but this success. And I've kept my distance on the subject, because to me, the most important thing has been to make pictures and not to make money, although I don't pooh-pooh it at all. It's made my life tremendously pleasant. And I have a lot of dependents. I have my granddaughters, and I got kids who are all artists. They're not making a lot of money, so there's a lot of people to help—not necessarily directly, but one way or another. So I'm pleased about the benefits from art. It's afforded our family—our big family—a kind of life as though we've been successful ranchers or something like that, you know. It's been a family business.

RCAC: In view of all this, then, who became your peers during this time?

DINE: Other people who weren't artists; it was much simpler. I realized that early on. I couldn't take the competition out of jealousy. It hurt my feelings too much, you know? So I made friends with people who weren't artists. We went very early to Easthampton, before it was smart—Smarthampton. We went to Easthampton in 1962 for the first summer, and we started to rent houses there. I just met people on the beach. But it was real unpleasant too, because I didn't realize I was walking into a lair of tigers. Those Abstract Expressionists who were older than I was, but who had never made it, boy, I mean, I had just been taken up by Sidney Janis and all this kind of thing and nobody wanted to talk to me. And I was naive to even have my feelings hurt; it's stupid. I mean, who wouldn't feel the way they did? But I met other people and developed friends through the years. And I had peers. Through the years I've seen Oldenburg on and off, because we grew up together in a certain way; although he was much older than I was and much more mature. I learned a lot from him. So we're still cordial when we see each other.

RCAC: What part did critical review play in all this?

DINE: Only that critics hurt my feelings; nothing else. They had no bearing on anything. There's nobody writing—and I don't believe there ever has been in my time, of any distinction—that would make any difference. And for the most part they're jealous—small, petty people who are jealous of artists. Not just their success, but the fact that they are not artists. And it comes out in their vitriol. It had nothing to do with me whatsoever. I give no credit for anything.

RCAC: If someone asked you to say what was your occupation and what was your career, and were they the same thing or different, how would you answer?

DINE: Well, exactly the same. I mean, that's what I do.

RCAC: Were there any gatekeepers at various stages of your career? Gatekeepers is a term that sociologists use—people who keep you out, close the gate, or people who open the gate, let you in.

DINE: No, the only thing that kept me out was my childhood experience, and it debilitated me, and it kept me out for many, many years. What it kept me out of was society and the full enjoyment of a full life on the journey through life. I've worked very hard to overcome that, but it's taken many, many years of psychoanalysis.

RCAC: What about the people who helped you as opposed to kept you out? Who helped you get in?

DINE: Well, dealers took me up because they believed in the work. My wife has been a constant companion and extremely loyal to me, and very helpful, extremely helpful. I simply could not have gotten this far without my wife. And friends, I have some very, very loyal friends. Unhappily I've lost two great friends in my life who were very important to me, and so I had more good friends than I have now.

RCAC: You think there was a major turning point in your career up to this point or a few of them?

DINE: Major turning points in my career have been when I've decided to do different things. I think when I decided to make sculpture full-time, that was a major turning point in my career, and I did that in 1982. And it made a big difference to me. A major turning point was when I decided to draw the figure for five years and stop painting. A major turning point was when I went to Europe for the first time to live in 1967. I'd never been to Europe until I was thirty, and I went to make some prints. A publisher said they'd pay the way, and we went in 1965 to London, and I was overwhelmed by it, because I could move so freely. I wasn't inundated with the petty problems of the day-to-day New York art world. I just moved like a citizen in Europe, and I felt at home there. I

taught at Cornell the next year, and the following year we moved to London. I had a little money saved, and we lived there for four years—and that was a major, major thing for me. I've never stopped living there, actually. I mean, I came back to live in America in Vermont, but I'm going there on Sunday; I keep a studio there. Some years I spend half the year there.

RCAC: So these turning points are really, as I hear you describe them, very self-generated. They're not imposed on you by anyone else.

DINE: I've made my own situation. Yes, I believe that's important.

RCAC: What's been your relationship to money throughout your career?

DINE: I'm a big spender. I was always a big spender when I had no money—made no difference to me. Not that I ever lived luxuriously, and I don't now. My relationship to money is that when I have it, I spend it, and when I don't, I don't. I don't change paintings to sell paintings; I don't do anything like that. I've kissed, as they say, very little ass in my time. And I've made it work, because I believe in the quality of the work and also the way I've chosen to run my career. That is, in private. I've stayed away from schools, groups, et cetera. I've not been matey with some people, and it has been lonesome, but it has paid off in terms of my career and money, in that I've been able to focus on the work. I believe work that sells, for the most part, and continues selling is quality work. I believe I produce that. Some is better than others, some is more inspired than others, but not knowingly have I ever let anything out for money. When I had commissions in recent years, I've never taken a commission where I've had to submit anything. They either want me, or they don't want me. That's just the way I feel about it.

RCAC: Have there been influences in that direction, to make you try to produce what someone else seems to want?

DINE: Yes, people have said, "I want this," and I said, "I'm sorry, I can't do it." You know, I don't do it that way. Either you take me, or you don't take me. And I would never impose anything on anyone if they took me and *I* thought it was terrible, or they didn't like it at the end. Obviously I don't want to be at the party and not invited, you know?

RCAC: How have the costs of supporting your art changed over time?

DINE: Here's how they've changed: Painting costs nothing. I mean, I've always been able to afford paint and canvas from the moment I started to sell paintings—it doesn't cost anything. Sculpture's another story. Sculpture's deeply expensive to produce in bronze—which is what I've been doing for eight or nine years now. In the beginning I paid for it, because I wanted to feel totally independent from the gallery, but then I realized we were doing the same thing. The gallery offered to pay for

it, and it's the same deal always: Who's ever paid for the production gets that off the top of the selling price. So the gallery has paid for it, and I'm very appreciative of the gallery's support financially that way, because I haven't had to lay the money out. On the other hand, they've also sold the sculptures, so they've gotten their money back pretty quickly. But I watch it—not in a day-to-day way and not in a dollars-and-cents way. I just have a feeling when I've overspent in producing prints or lithographs and things. I do it frugally then; I prefer that. I don't like wasted things. A lot of artists I've seen have things laid on for them at the print shop and the bottles of booze and the cars at the airport, but I've always found in the end *you* pay for it. You know, it's got to come out of somewhere, and if they're paying for it, they're going to take it out of you somehow. So I watch those sorts of things, and I object to it when it's inflicted on me. I have a real good sense, though, of my career—I mean, of how to run it, business-wise. And I've learned it through the years, and it's fun for me—how you price a painting, for instance. I remember when I was at Sidney Janis in the sixties. It must have been about '62 or '63. Philip Guston left Sidney Janis, and I said to Janis, "Why is Philip Guston leaving the gallery?" And he said, "Because his prices aren't going up and de Kooning's prices are, so he was angry with me." Now, this may not be the story; it may not be the truth. But I thought to myself, "What a stupid bit of ego, how self-defeating. What relevance does it have, one man's prices to another man's prices?" I do understand it, of course, depending on how secure you are. Through the years I've never looked at other people's prices. I mean, I have because I've been interested—I love to see what's going on—but through the years I've priced things with my dealers in what we thought was fair. I think that's the way it was done. With Ileana Sonnabend, I think it was done with what was fair for my work. And I learned a lot about that; I had a feeling for it. And when I went to Pace Gallery in '76, Arnold Glimcher also had a feeling for that. And the eighties got out of hand with a lot of people, but I have not lost sight of it—of what it was ten years ago, for instance, the price of things. I've always felt that I would rather sell some pictures at a lower price than to have my paintings high priced and not sell. I want them in collections; I simply want them out there. If I don't want them out there, I'll keep them. Otherwise I don't see any point in doing it. You know, you're doing it so you can make this connection with other people.

RCAC: You said you set prices with your dealer. Have you always done that?

DINE: Yes. In the early days with Janis, I let him do it because he knew

better than I did. I didn't know anything. But it also sounded right to me, and it was always modest. The price was not huge. But recently I pretty much set the prices. I really have a feel for it now, of what is appropriate. I'm in it for the long haul. I don't care if people twenty years younger than I am made money last year. I wish them well; it doesn't mean anything to me.

RCAC: What about grants, awards, competitions, any of that? Have you been involved in that?

DINE: I've only been involved in it on the side of giving it. I've never felt it was appropriate for me to apply. Now, this is my problem. I realized when I went on the Guggenheim Committee I was stupid, but I felt if I was selling some paintings, I would be taking it from somebody else who wasn't selling paintings. But they kept encouraging us to give it to recognized artists. Which I thought was appalling, by the way. I eventually left that committee for a variety of reasons. There would be people who didn't need the money who got the fellowships to enhance the Guggenheim's roster. But I never applied for anything. I once got one though; someone gave it to me. There was a foundation in Chicago called the Graham Foundation, which has gone bust, I think. Anyway, they gave me ten thousand bucks in 1970, and I bought an etching press with it. But I didn't ask for it; I didn't ask for the ten thousand bucks.

RCAC: What about competitions? Have you ever been in art competitions of any kind?

DINE: I don't know of any that one could be in, except there are a lot of print competitions which I never would enter, and once I was in a competition that I didn't know was a competition. Janis Gallery sent a painting to the Chicago Art Institute, and it was a competition and I won the second prize. Ellsworth Kelly told me later he gave it to me because he was the judge. I won a thousand bucks, and I was going to buy a piece of federal furniture. I thought it would be a great idea. And Nancy said, "What a great idea." And then I got our grocery bill, on which we owed nine hundred bucks, so that was that.

RCAC: What's been the influence of location of your work space and location of where you work to your career?

DINE: I'm curious in that I work everywhere—hotel rooms and little hovels, it simply doesn't matter to me. If it was luxurious, that would be nice too, but I would never take the time to do it. All winter I worked in Paris in my hotel room. I like that. I liked the transientness [sic] of it. I like to carry it on my back, my landscape. I don't need luxury to create. I just need a *little* bit of room and nobody bothering me about

getting paint all over it, destroying something. I mean, I really destroyed a hotel once, in Santa Monica.

RCAC: What kind of control do you think you exert over your destiny as an artist?

DINE: Well, there is no control over the whim of the public, or the whim of the critics, or prejudice of the critics. There's no controlling that. I think one can only produce the best work possible; that's all you can do. And I mean, I can't stop working. I do this because I have to do this. This is my obsession, this is my life, this is what I'm here for. God put me here for this. So therefore, I mean, the only control I can exert over that is to . . . be as inspired as one can or gain access to the inspiration as clearly as possible, so that when I have something to say, I am able to say it clearly and with the right degree of feeling and emotion that's called for. Otherwise I don't think one can know that you should be in Berlin at a certain time or you should be living in New York City at another time. That's luck.

RCAC: Do you do certain things when you don't have something to say, or when you're struggling to find what it is you have to say?

DINE: My method is correction—that is, I work all the time because I love doing it and because, as I say, that's what I do. And I make a silk purse out of a sow's ear. That's my theory. I never throw anything away. I never destroy or put my foot through the painting. I just wait. It will reveal itself. As the years have gone by, I'm more experienced at that, at finding how the canvas reveals itself. And I noodle around until I find the way to go. I always am looking for the way. I mean, it can sit there for years now. I used to paint very fast, and now it takes me years. Sometimes I send canvases to England and then I send them back, or I leave them in England a year and then I go back and I noodle around some more and find a way, that's all. It's always there. And you're there in the picture, you know? It's you who made it, so it's just a question of getting through the mire to find the clue and the road to go.

RCAC: Does that have any relationship to how you feel when the work goes to someone else's hands?

DINE: When it goes to somebody else's hands, I prefer not to think about it, because it's a double-edged sword. I made this thing, I liked it, I'm involved with it, it's a piece of me. It's like living tissue. And then it goes into somebody else's hands. I just prefer not to think about that. It's my one luxurious bit of unreality. When I see it somewhere, I'm usually jealous.

RCAC: Of what?

DINE: That they have it and I don't.

RCAC: How have you interacted with the public throughout your career?

DINE: I had twenty years of surliness when I was most unfriendly. It made me unhappy, but it was the only thing I could do. It was my method. But through the years I've gotten more pleasant. Nancy and I both feel very strongly (and I've had a lot of shows in the last ten years—museum shows, things like that)—we try to go to every one. If a show travels, we try to follow that show everyplace, because I think people have been nice enough to allow me to show there; they deserve to meet the artist, and I always am available for that. For the most part I really enjoy that. I enjoy meeting people who like the work, who come to honor the work. I mean, by accident I was just at the Chicago Art Fair. It was a terrible place for artists to be. It's tacky. But I was there because I happened to be in Chicago doing a commission, and I wanted to see the booths. I was there and I met some dealers from West Virginia at the Pace prints booth. And I was so pleased to meet this guy. I mean, I went to school in Athens County, and this guy lives in Huntington, West Virginia, and he's selling my most difficult prints out there. This guy deserves to know me, to shake my hand, to see what it was all about, to meet the guy that made these. He's not just taking hearts out there, decorative things, very beautiful painting; he's taken the most difficult skulls and things that I've made, because he's involved with the work. And I really feel I owe him something; I owe him a piece of me. I mean, he deserves to know me and to say, "I met Jim Dine and we spoke about this work."

RCAC: What are your criteria for success as an artist, for yourself?

DINE: I have that. I mean, I have the success.

RCAC: What are the criteria that make that?

DINE: Lots of people love my work, and it's been expressed in a variety of ways, not the least have been financially. It doesn't come up at auction as much as a lot of other people's. People care about it. Then they buy the work. My work is not always accessible—that is, artistically accessible—and I am very, very appreciative that so many people have it. I'm amazed most of the time. And I consider that a great success. I mean, I'm smart enough—I could have made money other ways. You know, I didn't have to be an artist for that. That's just gravy and that's fine, but the real success has been that people love my work, and that really makes me feel great.

RCAC: Do you feel that other people's success has the same kind of measures?

DINE: I really have no idea; I never asked anyone.

RCAC: For you to think someone else's work is successful, what would that mean?

DINE: That would be if I responded to the picture. If the picture moved me in some way, if I thought, "Jesus, this is a great painting." Then I think the guy's successful.

RCAC: Are there certain periods of work that you feel more satisfied with than others?

DINE: Well, as I have all these shows in the last ten years, I've had a chance to see retrospectively a lot of work, and my assistant and I over the last few years, we go through the warehouse. I keep a warehouse of older work. I've tried to keep a few things of everything I've done. There isn't a time when I don't see a painting I don't want to work on again. There isn't a time that I don't want to correct it, that I don't want to enhance it in some way, that I think I could do better now. I love the story of Bonnard being caught by a guard in the Tate with paint in his pockets, touching up the paintings. I mean, I don't blame him.

RCAC: How satisfied are you with your career as an artist?

DINE: I don't see how it could get much more satisfactory. I'm not satisfied with what I make; I'm never satisfied with what I make. But I'm very satisfied that it has turned out the way it has.

RCAC: Is there someone you talk to in your mind when you paint, or to evaluate your work?

DINE: Me. The self is very important and strong with me. And, yeah, I'm a very tough censor. But also it's me pitting myself against the past all the time. When I get up in the morning, I got to look in the mirror; I'm very aware of history. I'm very aware that there have been artists who have been very famous in their lifetimes, and nobody ever cared about them again, because they weren't necessarily of great quality. And I'm also aware that people have had great success that has remained through the centuries. History is very fickle, and I think fashion, in the sense of how we see something, changes—not necessarily in a shallow way, but the fashion for looking, of what looks good, what doesn't look good from century to century. So, there can be people making millions of dollars right now who may never be heard from again or whose work we put away for a thousand years. We just don't know.

RCAC: Posterity has a significance then for you.

DINE: Oh, yeah. Oh, yeah. Oh, yeah. I'm in it for the long haul.

RCAC: What would you describe as the greatest satisfactions in your career?

DINE: Finishing the painting, finishing the work. Each time, yeah. That's the great satisfaction, finishing the work, or in the midst of the work, finding the road to go. And then it just goes easy, you know?

RCAC: How about the greatest disappointments?

DINE: I have months of disappointment, of just not going well, of being slow, of being aware that physically I hurt, from stooping down or something like that, all the time, and nothing coming of it. And then when the work works, you aren't aware of that anymore. You're not aware of creaking bones and things.

RCAC: Do you think your relationship to your materials has changed from your early career till now?

DINE: I'm more at home with more materials. I can use more materials without thinking about them. In fact I don't really think about that anymore; it doesn't matter to me what I use.

RCAC: What would you say would be the one major point you would make to a young painter who was contemplating a career as an artist today?

DINE: I don't think there is any point to be made to a younger artist; I really don't. I think the point is already there for them, or it's never going to be there. I mean, it's nice to be supported by someone older. I mean, one is put here with this gift. It is your charge to go on and to exercise your gift. I won't stand for anything other than that. If you're given this gift and you fuck around with it and say, "Aw, it's not working for me. I'm so discouraged, and the world has become so commercial," or, "There's too many artists," it's true. There are too many artists, and it's too commercial. So what? It's irrelevant.

RCAC: Do you wish that there had been something that someone had said to you as a young artist?

DINE: I just wish somebody'd been nice, that's all, and encouraging. I wish my mother hadn't died, for instance. It was a tremendous loss for me that I'm still missing her. So I wish that. But otherwise, you know, it has not been so bad.

Honors: Elected to American Academy and Institute of Arts and Letters, New York, 1980.

Representative public collections include: Art Gallery of Ontario (Toronto), Art Institute of Chicago, Baltimore Museum of Art, Bibliothèque Nationale (Paris), Brooklyn Museum, Centre Pompidou (Paris), Cincinnati Art Museum, Cleveland Museum of Art, Hirshhorn Museum and Sculpture Garden, Smithsonian Institution (Washington, DC), Kansas City Museum of Art, Library of Congress (Washington, DC), Los Angeles County Museum, Los Angeles Museum of Contemporary Art, Louisiana Museum (Humlebek, Denmark), Ludwig Museum (Cologne, Germany), Metropolitan Museum of Art (New York), Minneapolis Art Institute, Moderna Musset (Stockholm), Museum of Fine Arts, Boston, Museum of Modern Art (New York), National Gallery (Washington, DC), New Orleans Museum of Art, Philadelphia Museum of Art, Rose Art

Museum, Brandeis University (Waltham, MA), San Francisco Museum of Art, Solomon R. Guggenheim Museum (New York), Stedelijk Museum (Amsterdam), Tate Gallery (London), Toledo Museum of Art (OH), Walker Art Center (Minneapolis), Williams College Museum of Art (Williamstown, MA), Yale University Art Gallery (New Haven, CT).

SAM GILLIAM

B. Tupelo, Mississippi, 1933. Attended University of Louisville, 1952–55 (B.A. Fine Art, 1955) and 1958–61 (M.A. Painting, 1961). Lives and works in Washington, D.C. Exhibits internationally.

RCAC: Sam, what were your first experiences in art?

GILLIAM: When I was very young—I learned to draw quite early—I made lots of things out of clay, and then I started to paint quite early, about ten years old, just bought some paint and started.

RCAC: What was your family like in those days?

GILLIAM: My father drove a truck and he was a carpenter, and that helped a lot because he left a lot of materials around—hammers, saws, wood. My mother had been a schoolteacher, and she was the one that encouraged the art, because there were seven other kids and someone pointed out to her that I was the quietest. It was because I was always doing something, so if I was kept with art materials, I would always be quiet.

RCAC: Where did you come in the line of children?

GILLIAM: I was number seven.

RCAC: Were any of your other older brothers and sisters interested in art?

GILLIAM: Yes, I had a brother who drew, but he was fairly mechanical and drew cars. I had a sister who made drawings.

RCAC: Was there much art around the house?

GILLIAM: Yes. My mother sewed and made lots of bed clothing and would literally make all the clothing for the children or would take up other people's clothing.

RCAC: Where did you grow up?

GILLIAM: Tupelo, Mississippi.

RCAC: Was your father in favor of your art? Was he helpful?

GILLIAM: Dad was in favor, yes and no, but he would rather have seen me go out-of-doors and play ball like he did when he was a kid. But that wasn't too important for me, because I was very good at this. In fact I was unusually good. Although I later went outdoors and played ball too, he sort of left me alone. It was my mother's sort of permission that actually kept things going.

RCAC: Did this encouragement go on throughout school?

GILLIAM: Oh, yes. Some of my teachers noticed that I was particularly good at art, and they allowed me to use it at Christmastime, drawing on the boards. We had an art corner; I was always there. And then finally, in junior high school, I was able to take special art courses. In junior high school, where all the kids who drew, all the kids who painted got together and could tie together the ideas of painted pictures and various things on a sheet of manila paper and with tempera. That was taught by Mrs. Jongs, and she is one of the ones who takes credit for my being where I am today.

RCAC: Were there any members of the family that were particularly supportive?

GILLIAM: I had three older sisters who formed a singing group, so that the idea of doing something individual or doing something else meant that we were generally in support of each other. If I did something that was like art, then they were supportive and they still are.

RCAC: As you think back to grade school and early high school, were there any particular experiences that stand out in your mind as ones that gave you validation, particular support?

GILLIAM: There was a group of us, by the fifth grade, who ran around together because we all drew and we had tablets that were full of drawings of all kinds, even comic books we had made up. Also the garages that were attached to our houses were places where we made movies or had art studios. We were really into being artists! One boy's mother bought him the whole Draw-Me Kit from the Minneapolis School of Art that we could all then copy!

RCAC: Did that group continue to stay in contact?

GILLIAM: Only one person from the group do I still know, and we stayed in contact. He now is a mathematician. And one person became an

illustrator for Coca-Cola, and I don't know where the other two boys are.

RCAC: That's unusual because all-boys groups are usually in sports.

GILLIAM: Well, you see, two boys, I remember, that drawing was about all they could do. They were slow readers, but they could draw! Of course that seemed the same way during high school; kids that could perhaps not do well in other studies would stay at the back of the room and draw. Of course I always knew them, and I learned a lot from them too.

RCAC: Were there any experiences that provided particular resistances?

GILLIAM: No. The high school, because it did not have an art program, was very good in trying to validate any sort of vocational interests that you might have. Through the library I was able to order any book that they didn't have, so that it was exciting to get a book on Michelangelo. And I wondered if the librarian knew what she was getting me. I was a good student, so I was given this kind of freedom to do a lot of things. It seemed that drawing was something that I did in addition, but I was not going to be an artist.

RCAC: Were there other subjects that particularly interested you?

GILLIAM: Math and history, English. The fact is that actually in high school I had to be an English major, because there wasn't an art program. But I think I later found out that that was all right. It means that I wasn't overused. There wasn't the over-accomplishment perhaps that happens in some high schools before you get to college, and therefore you generally lose interest.

RCAC: What art forms particularly interested you as you started?

GILLIAM: Cartooning and later painting, like landscape painting a lot. I also was very good at building things like wagons or using saws. All the money that I could save I would use to buy blades for a little saw and to buy plywood, and would build circuses with circus wagons and anything that I actually drew that I could cut out. And it was great, because Dad was always building a house, and deep in the basement there was always clay, so that you could just make anything. And I think the other thing is that all of this kind of activity made for immense dreams. I mean, I would wake up in the middle of the night, and what I would think about was what I was going to make the next day when I got up. So it was a kind of activity that was self-propelling. One of the things that sticks out very much is that my sister brought home a lobster that she needed drawn. And after staying up all night, I had it on the paper just perfect, and this made me her buddy! The idea that if I need this done, my brother can do it, and so I did!

RCAC: When did you become an artist, and how did you know?

GILLIAM: I guess I really became an artist professionally after I graduated from college; I started painting in undergraduate and graduate school. When I graduated from college and had taken education courses, persons were pushing you into teaching. The chairman of the department said that I should be a teacher, because as an artist I'd starve. Even my first practice teacher thought it was ridiculous that I was going to be an artist. You know, that I wasn't going to be of any use. She thought that artists sat around and worked for themselves and worked out their own ideas and weren't any good to anyone else. I think it's then that I became an artist—particularly at that point where I decided that when most people who had graduated from college didn't paint, I continued to. I lived at home and I could use the basement, so I could use the paint.

RCAC: How did you know you'd become an artist? What do you think was a turning point or a sign inside yourself?

GILLIAM: I think that when I felt that I had won the struggle. It's very, very strange to have wanted to have been something all one's life, and then suddenly when I got into college, there was something that I couldn't do because others thought I shouldn't be doing it or because others seem to have been better at it. Only by the senior year did I start to paint paintings that would win prizes. All through this time in coming home and talking to my mother about this, I still remember that she had the foresight to see that I'd get over this. And I always wondered, "How did she know?" But I think that when I went into the military for about eighteen months, that period was spent doubting if I would ever be an artist and doubting if I would ever go back to art school. I think the external forces were so great, and I doubted that I could make it. And when I got into graduate school, I met a graduate professor who had come over from Munich and he was so encouraging. He said that although I had problems, I was a worker, and one day I'd make it. He warned me that he had good students like me before, but whenever he would go to see them five years from the time that he taught them, they would show him how well their students were doing. He said, "Watch out! That's the trap. If you want to be an artist, you have to work yourself, and it's all right to teach but watch out!" And that was the evidence I needed that not only should I be able to show my students' work, but I should also be able to show my own work. I did teach though. I taught for four years in Louisville.

RCAC: Let's go back just a minute. Where did you go after high school?

GILLIAM: I went on to college, University of Louisville. I went into the military. And then to graduate school at the same place, and I graduated

from graduate school in 1961. I was primarily an art major, and I got a chance to use all of that when I was hired as a sixth grade teacher and I taught all the subjects. It was very exciting because I replaced my own sixth grade teacher, who had just died when I got out of the military, and I was in my own room where I went to the sixth grade. I made certain that they had a big art table.

RCAC: In the period after college and after graduate school, how important were your peers?

GILLIAM: They were very important. I joined a fraternity, and I noticed that anyone who wasn't an artist was always much more attractive. This person was a football player, yet this person was going into philosophy. He was much more interesting than someone who was an artist. It took a little bit more than being able to draw to maintain friends, so that I made certain that I developed those other sorts of skills: being funny or being risky or various things like this. But finally I did find the friend of a lifetime in another artist. He was about fifty years old when I was about twenty-five or so, and I'd never seen an artist that I could look up to. Of course his experiences were the same, because he had wanted to be a writer and his father was a minister and that is what he didn't want him to do. So we exchanged notes about growing up, and I just saw him. He's about eighty now. He was a role model, and then I became his role model too. His wife really didn't want him to paint, and I was at his house all the time talking about something that I'd painted. We lived around the corner so we were both good at sustaining each other, and allowing each other to do the things that we weren't supposed to do. Because he was a writer he had a special language for painting. There was a way of using silk-screen inks and transparent bases and utilizing deep space. I mean he just really knew what painting was in a certain sort of way. When I came to Washington in 1962 and when I saw paintings in museums or even when I went to New York, I felt that I knew all that was going on because I literally had it demonstrated for me by an older friend. By helping me to do something, he was also helping himself do something. I think that in verbalizing the fears of his childhood, in verbalizing the way that he had to sustain what people did not want him to do, I think helped me to get over a lot to become a man because you're always scared.

RCAC: When did you feel that your involvement with artists was sort of meaningful?

GILLIAM: I think that once I'd come to Washington, I started to think about Morris Louis and Jackson Pollock—the two of them together, because Louis drew from Pollock or from Frankenthaler, so to speak.

And then once it became all right to do that, I felt that obviously the significance of that for me is that the more you paint, the more you fill yourself, the more you're going to know about something that he did, and the sense of fear disappears because you have someone to maintain a dialogue with, whether it's Matisse or Picasso.

RCAC: And do you think there is much active dialogue that you pick up and stop and start again with your fellow artists here and with fellow artists in New York?

GILLIAM: Yes, even with students. One is taught, particularly through the exhibits that have been going around for at least the last five years. The recent Titian show or the Picasso-Braque exhibit—there's a lot to talk about and a lot to discuss because there's a lot to see. There's a lot that just hasn't been seen before. One learns to keep an art world alive, even the things that come and go, if they are different things. That's one of the things that's been the importance of being an abstract artist twenty-five years or so, and how that kind of faith is maintained because you're silly enough to see everything the same way.

RCAC: Do you think your peers were influential?

GILLIAM: Yes. There was a young lady whom I was very close to, and she was very enthusiastic about the civil rights movement, and through her I joined the NAACP and the College Chapter and became president. And we started picketing, and that was a strong contrast to everything else that I had done in art. Organizing groups, organizing marches, and doing things like this, and I learned a lot. After about two years of working, I realized that I had to make a choice between wanting to be an artist and wanting to do that. So I chose to be an artist, but I think I kept the understanding that I had reached. One thing about working with people and organizing them meant that you spent half the night talking about something, talking about philosophies and various things. And I think that kind of thing has kept me very close to people, very close to a sense of the community, a framework, and not only has it kept me close but also has given me the knowledge for being able to do something about a lot of things.

RCAC: Are you involved with discussions like that with your fellow artists and your fellow arts community?

GILLIAM: Not as much now, because artists are also rivals. They're quick to become jealous, and there are times when you can be close to them and then there are times that you actually have to stay away. So it's yes and no. There are apprentices that work at the studio—there's the one studio assistant that I've had for about ten years that I can be very, very close to. It always bothered me that I never had a black

assistant, but now I have two black people, one person who's literally a street person who just has worked his way in. We taught him to stretch canvases. Then I have an apprentice from Howard University. I think that's meaningful. I also work with the arts organization that I helped to form. I could give up a lot of things, but I still wouldn't give up the painting because I think that's essential.

RCAC: Going back to the period when you emerged as an artist, how long did you teach sixth grade?

GILLIAM: Two years.

RCAC: And then after that?

GILLIAM: I taught junior high school for two years; then I taught high school for five years. That's nine years of teaching. I was able to get a break when I got a National Endowment Fellowship in 1967. In the meantime I had gotten married and had moved from Louisville to Washington, and Washington was certainly a much more active environment, and teaching was made all right when one found more artists making art. I had a family of three, and it made more sense to work rather than to idealize not working and do only this, because at least then not only could I support at least the family, but I could also support my art. I could buy materials and that was about the happiest time of my life, I guess. We had kids and sometimes we'd all get in the car and drive down to the canvas place and buy a roll of canvas and put it on top, and we'd come back and we'd get busy working at art. By '65 I had started to show in galleries in Washington—none of the people whom I had been dealing with for advice had gone that far. And of course theirs was just fear to a great extent.

RCAC: What inner qualities do you think you need most at this time?

GILLIAM: Tenacity and openness and being a risk taker, and also having a goal.

RCAC: What materials were you working with?

GILLIAM: I was working with oil paints, and then later I started to work with acrylics.

RCAC: How would you describe your relationship to your materials?

GILLIAM: I've always placed a high stake on knowing how to use your materials very, very well and that they will help you to create or find a way that you're going. I immediately changed to acrylics too when I found out about them, or found artists around me using them. That was a reason for early success here in Washington, because it was a city that was devoted to color painting, and that meant that they were devoted to the kind of color that could be obtained through using acrylics.

RCAC: Do you think your training adequately prepared you for a career as an artist?

GILLIAM: No, I think if it hadn't been for the professor whom I had met, I would not have the inclination or the intellect. But the fact that graduate school left out contemporary painting, left out American painting in that sense, I think the education left me eighty years behind what I needed to know. This is still going on now. Teachers have a way of teaching students only what they are interested in or only what they know.

RCAC: Did you give yourself certain benchmarks for achievement when you started?

GILLIAM: Not really. When I first started here, particularly in Washington, I was just as frightened as I had been in Louisville, and I didn't really know where to begin. It was probably not until 1967 that I really was willing to take the risk for the kind of changes or the responsibilities for actually making things move. But I had artists who supposedly looked after me.

RCAC: What were the first organizations you joined as an artist?

GILLIAM: The real first artists' organization that I belonged to was the College Art Association, and that's when I was later teaching in college. I am not a member of the board any longer, although I had been. But I'm a member of another board as a result of the College Art Association and that's the National Cultural Alliance. I joined the College Art Association when minorities in general—hispanics, blacks, women— were all sort of fighting for recognition. It was a very interesting time because one worked for a great deal of change, and one got to know and have different allies. There was a time here in Washington when we were operating against the Corcoran. The Corcoran was the only ball game in town. That was very scary, but it was not scary for the right reasons! And this is the thing, that everyone has always used fear to keep one down and out of a situation. I mean, it's not enough sometimes just to side with artists because artists can be wrong too. Nonetheless I think that we have fought so many issues in Washington that Washington almost ended up forgotten. Also if you would ask many of the artists what their opinion is about artists from other cities, New York, showing here—they don't want them! That's a strange position to be in.

RCAC: Have you joined any other organizations that gave you particular benefits, like health insurance or studio insurance?

GILLIAM: I've always had a secretary and an accountant who took care of everything, and I found the best insurance for me.

RCAC: How do you feel about unionization for artists?

GILLIAM: I think in limited form it would be good. You know, I believe

in a number of wide, broad issues that artists should unionize for or collaborate for.

RCAC: Such as?

GILLIAM: Ahhh! Well as far as teaching is concerned, I think almost everything. But as far as personal exhibitions and various things like this, I don't believe that collaboration should determine what galleries you show in, et cetera. Kind of contracts, ability to write and to define contracts, and things like this, yes.

RCAC: Describe the period in which you first achieved professional recognition as an artist?

GILLIAM: I had just had one show in Washington and I met an artist after that show who told me that he felt that I was afraid to paint, and that in my show he only found one painting that sort of made any sense. We later became friends, and I really started to work real hard. I started exchanging conversation about painting with him and then discovered that because he's well-known, that he had more ability to get me into a gallery than I had by going there. So I depended on that in that instance. Unfortunately I was always in the position where I was the last to recognize myself as having done something, but it was particularly the help that he gave and it must have been such a good recommendation that when the dealer came to look at my paintings, she played with my kids and then she told me what day the show was. But it was the help that he gave me.

RCAC: Who are your peers now?

GILLIAM: Well, my gallery and the people with whom I work primarily. I have a couple of other friends that I talk with. There are a lot of people whom I consider myself to be in a loose-knit group here with. I think we all admire each other in order to keep each other going.

RCAC: Is that a group that's primarily artists?

GILLIAM: Yes.

RCAC: Is it primarily black? White? Mixed?

GILLIAM: It's a mixture of black and white. Most of them are younger than I.

RCAC: How have your peers influenced your career?

GILLIAM: I had known curators or writers or various persons who have been able to give you the leg up that you need from time to time. And I think once you learn a technique, once you learn an approach, you continue to use it. Washington requires a different approach in living, you know, so that you have to involve people. Since there's not that much that's going on around you, that will involve you, you have to involve them sometimes.

RCAC: Do you differentiate between your occupation and your career?

GILLIAM: Yes, I do. Well, that used to be when I was teaching; the occupation would be teaching, and then the career of course would be being a painter. But now I'm not teaching.

RCAC: In thinking about your general job history since the days after graduate school, do you see a pattern or a progression?

GILLIAM: Yes, there is. I no longer teach public school, but I teach college. And in teaching college I'm able to elevate to what may be better positions in certain schools.

RCAC: Does that come with better-quality students?

GILLIAM: Yes.

RCAC: More interesting students?

GILLIAM: And higher tuition.

RCAC: Describe the gatekeepers at various stages in your career, those who let you in or those who kept you out.

GILLIAM: I think the most significant gatekeeper was a director at the Corcoran who helped to make a lot of things possible at a particular time. I think that a studio, a show at the Corcoran, and then exits from Washington—the Chicago Art Institute, the Museum of Modern Art, the Walker—after those kind of accomplishments, it's all those galleries at that level that I couldn't get into. But then the real gatekeeper from such a point became me, because I began to say that nobody could keep me away from anything that I actually wanted. And if they did, I didn't let them anyway, so I think that I started to realize those dealers that I could show with—and that for them, I'd work just as well as I would have worked for showing with others, and I think I was much better off.

RCAC: Were there any gatekeepers that particularly kept you out?

GILLIAM: Well, those that didn't take me, but that had been a trap for everybody in Washington. Everyone here followed the path of Kenneth Noland. He went to Emmerich and he went to Castelli, and two younger artists here literally died wanting that same sort of trail. And of course when I was in a similar position, I didn't get asked either. But I decided that I wasn't going to die!

RCAC: Have there been any major discrepancies between your career aspirations and your actual career opportunities?

GILLIAM: Oh, yes. I guess that's what I'm talking about now. I had always wanted to be one of those kinds of stars here, but I think learning to take advantage of the art business has been extremely important. I think that by taking advantage of those opportunities that were there, I'm at this moment probably the best-exhibited artist in Washington.

I've also seen how that taking advantage of the opportunities makes opportunities, and that's one of the things that's very important.

RCAC: What have been the major turning points in your career?

GILLIAM: Well, the major turning points have been in the past: the 1969 exhibition at the Corcoran, the Venice Biennale of 1972, the exhibition at the San Francisco Museum in 1974, and I think recently, the unusual opportunity has been to plan two installations for USIA for two places overseas. Right now I think that the one in Korea is going to take place. And what was interesting about this particular project is that it's based upon the drape paintings and a chance to pull them together again. That's been perhaps one of the best learning opportunities that I've had in a very long time.

RCAC: What has been your relationship to money throughout your career?

GILLIAM: I've never had enough of it. One of the interesting things is that I had to learn the feel of money being an artist. You know, what kind of money you can depend upon and when you were really broke. You have to know how important your work is versus how important the lack of money is, and that sometimes you can hang on a lot longer.

RCAC: Have the costs of supporting your art changed over time?

GILLIAM: Yes. It's become much more expensive. For at least the past ten years, I've been working in metal—aluminum—and not just doing paintings. I could run up some very large expenses that exhibits just never take on.

RCAC: How have grants, awards, and competitions or emergency funds affected your career?

GILLIAM: I think grants always have been very handy in that they allow you to plan in particular. When I was younger I could be very, very serious about a grant and do something very significant and that would work. And now they still have the same significance.

RCAC: What has been the importance of physical location and work space at different stages?

GILLIAM: I've had three studios and each one has been larger and larger, and I think that there is a noticeable improvement in the work. And I notice improvement in the quantity of work as I've moved from each place. I think each studio that I've had has always been known by a window or an open door, and whatever has been out there has always been just as much the subject that I was interested in as what was on the inside. I've always had a studio in the U Street area or the 14th Street area in Washington, and that's been very exciting.

RCAC: What kind of control do you exert over your destiny as an artist?

GILLIAM: I think more and more I've learned, let's say, to live as an artist, which means I live as a worker and that that's the thing that I do. I now have a five-day week or a seven-day week depending on what is really going on that gives me a lot of confidence. I also devoted some time to printmaking outside of Washington, and that kind of pulls the work together because I find that it's not work alone. It's sometimes freshness, an environment of a particular place, that sort of wakes you up and allows you to do things. I feel for over seventeen years I've made prints in Wisconsin and I've never been in that kind of environment before, and I know that allows me to bring something back here to work with.

RCAC: How have you interacted with the public?

GILLIAM: I do a lot of slide lectures when I'm not hiding from the public. I have those periods in which I am the most accessible and easy person to get to, and then I have those periods when I'm not. I have one bad habit: I never feel that I'm getting enough done. I never feel that I'm caught up.

RCAC: What are your own criteria for success as an artist?

GILLIAM: I think that my criterion for success is to work all of my life, and I think that a great deal of success that one wants right here only comes a lot later, when you're much older, so I want to work all the way through.

RCAC: Do you use the same criteria for other artists?

GILLIAM: Yes. My favorite artist all of a sudden is Claes Oldenburg. He seemed to have disappeared and now suddenly he's seen in shows, making sculpture and various things like this, executing much the same that he was before. I think that one looks at the senior artists more like Jasper Johns, etc. I pay a lot of attention to other artists. I think that it would be great if American artists had real criteria for being artists. I really had something that I wanted to do once, that did not depend on anything but a fad, and that was to help design a park. But I haven't thought about that in a very long time.

RCAC: Do you have a number of central ideas you keep working on?

GILLIAM: I do now. For the past ten years I had been working between what I call painting and sculpture. I've worked this out for ten years— theoretically now I'm turning everything over and doing it my way, which means between soft and hard and various things which pertain more to painting than actually pertain to working in metal. I'm curious just where this will go.

RCAC: Are there particular periods of work that you feel more satisfied with than others?

GILLIAM: Yes. More recent work, I think. I think that there are times that I surprise myself, but the more recent work is what pleases the most.

RCAC: What are your feelings about critical review of your work?

GILLIAM: I'm trying to become very mature.

RCAC: How satisfied are you with your career as an artist?

GILLIAM: I'm very satisfied with some parts of my career, if I can't say that I'm satisfied with all of it. This has been a very full year, I've had a very good time, so I'm very satisfied.

RCAC: What have been the major frustrations to your professional development?

GILLIAM: I have a daughter who went away to Milwaukee, and she was talking about a lot of problems that she was having. About three months later I asked her, "What about those problems?" She says they went away because I was the cause of them. And I think that this is a way that I see, that I'm not experiencing a number of problems even though the recession has become very meaningful in terms of the way that one has to work or the way that one has to think; it teaches you a lot! I think that I've arrived at a way of working that really is sort of satisfying and that seems to get the job done most of the time.

RCAC: Do you have any particular greatest satisfactions?

GILLIAM: The greatest satisfaction was always doing the indoor or outdoor drape pieces. It is something that was very satisfying and very, very thrilling.

RCAC: Has there been any particular greatest disappointment?

GILLIAM: Not that I haven't taken care of or made to work.

RCAC: What has been the effect of the marketplace on your work?

GILLIAM: Well, I'm still wrestling with that. Responding to the marketplace is much like responding to another audience. If a person is held out by money, then you have to draw them in a lot stronger through some other means. And then if you draw them, they'll still wish they had it, and eventually you'll begin to sell that work. I know that if I do a show now, and I'm sort of risky sometimes, a dealer will say, "Well, you make sure we have something to sell!" So I have to take care of the "something to sell" as well as the something to really exhibit. But that's not bad. It's not a bad idea to make certain that things work as well as just to go out and take those risks and then when you exhaust them, you pass them on to someone else. They may not be back for a while.

RCAC: How has your relationship to your materials changed from the beginning to now?

GILLIAM: A great deal. Acrylics have changed almost one hundred percent from what they were in the very beginning. I've kept up with a

lot of these changes. Things constantly change according to the chemistry of a material, and that's very interesting.

RCAC: Do you think that's also affected some inner relationship you have with the materials as well?

GILLIAM: Yes, I think that my philosophical way of dealing with material or with paint is to create change. So I'm always happy to find that something scientifically or chemically has changed, and it does satisfy a certain desire to make something new, to be a part of that making of something new. It's an inner need to make change or to want change—and not only to make it, but to want it made by you.

RCAC: Have your absolute basic requirements for being able to do your work changed since the beginning?

GILLIAM: I would think so. I think the fact is that I used to work alone a lot, and now I'm lucky enough to be able to work with other people and still get to call it mine. But I think that this relaxes you a lot to think about what you want to do in other ways.

RCAC: Is there one major point you'd make to young artists today?

GILLIAM: Yes. I think to maintain a certain openness to history, and also I think not to be afraid to keep oneself in one's work.

Honors: Honorary Doctor of Arts and Letters, Northwestern University, 1990; Individual Artists Grant, National Endowment for the Arts, 1989; Honorary Doctorate, Atlanta College of Art, 1987; President's Award, Maryland College of Art and Design, 1987; Distinguished Award for Pioneering in the Arts, The American Black Artists, Inc., 1984; Mayor's Art Award, District of Columbia, 1982.

Representative collections include: Private: Donald Eiler, Aaron Fleishman, Aaron Katz; Corporate: Arnold and Porter (Washington, DC), Coca-Cola (Atlanta), Southwest Bell (St. Louis); Public: Art Institute of Chicago, Corcoran Gallery of Art (Washington, DC), Denver Art Museum, Indianapolis Museum of Art, Musée d'Art Moderne de la Ville de Paris, Museum of African Art (Washington, DC), Museum of Modern Art (New York), Walker Art Center (Minneapolis).

SALLY HALEY

B. Bridgeport, Connecticut, 1908. Attended Yale University, 1928–31 (B.F.A). Lives and works in Portland, Oregon. Exhibits nationally.

RCAC: What were your initial experiences with art?

HALEY: I had an older brother who was an artist and who went to the Art Students League, and we saw him work, we saw his paintings, and it was there. Another brother went to Pratt. My father was a very wonderful photographer, very early in photography, when it was probably closer to an art form that it became later, and which is now more of an art form again. So it was my environment as a young child, a child at home, and I took to it like a duck takes to water. I was the art editor of our yearbook, and I had many drawings in it, a long time ago. My projects were always constant in high school, doing posters and being active in that area, doing the backgrounds for the plays.

RCAC: Where did you grow up?

HALEY: In Bridgeport, Connecticut.

RCAC: How would you describe your family and early childhood? How old were your siblings?

HALEY: I'm one of nine! I was in the middle, sort of, sort of close to the end, but in the middle end. It was very lively and wonderful. I had very caring parents, but they didn't project themselves into our lives, or direct our lives, or in any way insist that "you're this and that, and you should go this way or that way." It was your choice; you made your choice,

and you got your support. They supported your efforts, without expecting any great returns. So it was very comfortable.

RCAC: Was you father a professional photographer?

HALEY: Oh, yes. He was apprenticed to a photographer when he was nine years old. He was born in 1870, and in the early stages, to be apprenticed as a photographer, I guess it started out doing all the sweeping out and setting the fires and chores. And then you graduated into all the activity of paper and wet plates and so on. He was very happy with it and became a very fine photographer. As a matter of fact he was quite known in the East in his time. He was an associate of Steichen and Stieglitz. It was a rich life.

RCAC: Did your mother do any particular art forms?

HALEY: No, my mother was the anchor in the house and a very wonderful person. With all of us, she always had room for company. It was always, "Move over, put a leaf in the table, get another chair." She was a very loving mother; she was a great gal.

RCAC: You said two of your brothers went on to art school. Did they become professional painters?

HALEY: My older brother did, and he was very good. And my second oldest brother became a photographer. He did some work, but not much.

RCAC: Did your brothers and sisters support you in your artwork as well as your parents?

HALEY: Well, I don't know what you mean, "support." I did what was expected. I guess they were pleased with what I did; I wasn't a burden. It was just very comfortable. My older brother was very lively for me, because we didn't always agree, and it was stimulating to disagree. You'd begin to track yourself.

RCAC: What educational experiences in school provided you with early validation?

HALEY: I never did take art in high school. I avoided that for some reason, I don't know why, so I was never involved in either approval or disapproval in school, in grammar school or high school.

RCAC: There weren't any instances of any particular resistance to your doing art anywhere?

HALEY: Absolutely none. None at all.

RCAC: What art forms particularly interested you in grade school and high school?

HALEY: I don't really know. I guess my brother was a figurative painter, and I suppose since he was more or less my mentor in my early years, his books on anatomy were my guides, and I was just kind of self-involved with it.

RCAC: When did you become an artist, and how did you know?

HALEY: That was a word I rarely used. Then I found that using "a painter" was always mysterious, because nobody knew how to interpret a painter, because using the word "artist" seemed to be terribly ostentatious. So I was very, very reluctant. I still find it sort of pompous. It's a little odd to use, because I certainly don't go around thinking it.

RCAC: Was there ever any turning point, either with the word "artist" or the word "painter," which seems an easier one to use, where you suddenly felt you were one?

HALEY: No. And nothing, no matter how impressive you may be or something that happens to you may be—it still doesn't have a thing to do with that blank canvas and the blank work and the next painting and where you are and what you're doing. It doesn't really contribute anything, because that's what you're involved in. So I guess you don't really think too much about it.

RCAC: Where did you go after high school?

HALEY: Yale, the School of Fine Arts, Art and Architecture they called it at that time. My family thought I might want to go to the Art Students League, and I went down with my brother and my father. You had to take an elevator to get up there. I still remember the elevator; I didn't take to it very well. The next day I came home and my father and the folks were not there. That's very unusual. They had gone to Yale, and they had enrolled me. So there I was, and very glad. I didn't mind it a bit. So I went to Yale. Now it's a graduate school, but at that time it was full of kids who were taking classes right from high school, and there were also graduate students working for their masters in the same groups.

RCAC: Did you know that painting instead of sculpture was what you wanted?

HALEY: You had to make a decision; you didn't take both. Now I think that some of the students do take some of each, so that you get a little diversity and you also get a little experience, so that you're more sure of what you're doing. Everybody just went in—first class, drawing, second class, painting, right through. Drawing, painting, drawing, painting. And those who were sculptors—drawing, sculpture. It was very academic.

RCAC: And was that fine with you at the time?

HALEY: Oh, sure. I had no reluctance to spend all my time drawing and painting, none at all. The more I drew and the more I painted, the more I learned, and I was perfectly content. It was like a cloistered life anyway, so it was fine. There was a lot I didn't know until I graduated,

and then I said, "Well, now where am I? God, Cézanne, let me see, I'd better start thinking."

RCAC: Describe the importance of peers to you at this time after high school.

HALEY: I was a very good student. I'm reluctant to say that, but I was a very good student. I was probably one of the top students. It's very hard to have peers when you have that kind of a situation. I enjoyed my friends, but it was not with art or anything. I just kind of glided around.

RCAC: Did you have role models or mentors at this time?

HALEY: No, I think I was a loner in a strange way. Without ever looking, I was having a very nice time. I don't think I ever appeared to be a loner, but I think I was.

RCAC: What qualities do you feel you needed most during this period?

HALEY: I was very, very disciplined, and I never failed in the work that I put out. I put out more than I needed to. I worked very hard, but I didn't work for approval. I worked because of what I was doing.

RCAC: What materials were you using at that time?

HALEY: Charcoal for drawing, oil—it was all oil until my last two years, and then I was caught up in egg tempera, much to the dismay of some of my teachers. The professor who was teaching egg tempera was Dan Thompson, who was an expert—not as a painter, but as a theoretician—on the egg tempera process. He was very inspiring for some reason, for me; all the rest of the kids that were taking it dropped out, except Harry Ackerman and another gal. It was a very difficult medium, but something about it fascinated me.

RCAC: How would you describe your relationship to the materials?

HALEY: Well, egg tempera was the one that really enchanted me, and it still does. It's an exquisite medium. It requires a kind of decision and control; it's a disciplined medium. And once you get the discipline, and once you understand the limitations and the exquisiteness of the medium, then you're free; you're absolutely comfortable with it. For me it was so new in its demands, both the surface and the process. It was hard to do, very hard, but I did it. I did it, and then I stayed with it.

RCAC: Do you think your training during this period at Yale adequately prepared you for a career as an artist? As a painter?

HALEY: No, not at all. If you'd wanted to go into teaching, it was fine, because the credentials were immaculate, but if you wanted to be a painter, you really had to then face the big art. You had to ask, "What is it?" It's a concept that you've got to find, for yourself. And although I didn't think like that, in retrospect that's exactly what I did. I had to struggle to find why I was painting and what I wanted to paint, the whole

thing. The school control left you high and dry after you were through. I was offered a job teaching. I did teach art for two years in a high school in Connecticut, and believe it or not, mechanical drawing. I was offered the job! I didn't apply for it. But I only took it for two years, and then I resigned because this was not what I had studied. I didn't want to get trapped, and it would be a trap, because it was a very nice job, no problems, nothing. Nice. But it was also too seductive, and I could feel the ground just being pulled out from under me if I didn't resign. So I did. And then I traveled. My dear brother had been a disciple of the German Expressionist movement. I was pretty ignorant about that, so I thought, "Well, he's always talked about Germany and Munich and the painters, all that. I'm going to go see it for myself." I was really in an ivory tower all the time anyway. So in 1933 I took me and my ivory tower to Munich, and I looked around, and I made several paintings while I was there. I studied with a Professor Maxon, and then I went to Paris. Then I came home and I met Mike, who also went to Yale, although I didn't know him there, because he was in the class of '34 and I was the class of '31. So we could meet and enjoy each other's hostilities toward the school, people we liked and we didn't like and lack of preparation for the world of art. That really was true. Because what was going on in art—the Impressionists, the Expressionists, all these people were never part of the curriculum. So we received, I think, a thorough academic education, training, which was not too bad. I have a very high regard for that, even though I think it should be carried on in relation to the world you're living in. So we enjoyed rummaging around with that sort of complaining and fell in love, of course, and we got married, and then we faced the world. We had two of us.

RCAC: Did you give yourself certain benchmarks for achievement when you started?

HALEY: No, I had no perspective at all, and I still haven't any. I just paint, that's all. It's the most difficult thing that an artist faces, I think, to use the world around you, use your environment, work out of your environment. Don't work out of the magazine, don't work out of Sotheby's, don't work out of all of this stuff that goes on around it, work out of your environment. And I think you can. Instead of flipping around and changing because this is what's going on and that's what's going on, "I want to do something nobody's ever seen before, you know, want to make the big time." The waste, what a waste! I mean, you might do it, but it's not going to last very long. I mean, you have no perspective at all on yourself in relation to what you're doing. I think it's terrible. I think it's awful. You have to find your own way to be modern. You are

modern. You are living here, now, today, and you have to find a way to work that will reflect that, instead of jumping around looking for some kind of an answer. You have to find those things yourself, I guess.

RCAC: What was the first organization you joined as an artist?

HALEY: I think Artists Equity was the first one.

RCAC: Are you still a member of Artists Equity?

HALEY: No, that's kind of a dead thing now. I guess I've never been very active.

RCAC: Have any institutions or artists' organizations—not institutions like Yale particularly—helped or hindered your progress?

HALEY: No, I think I really realize now that I have been kind of a loner. Mike is a very active person in all the areas of art—painting and all kinds of organizations and efforts and all that—but I have not been. I guess my commitment has been to keep it smooth and easygoing and try to make both ends meet in a very tough life, actually, as far as financially. I think now we are enjoying a little bit of—I won't say success, because I hate that word, it's so misunderstood—but I think we struggle to keep ourselves doing what we wanted to do.

RCAC: How do you feel about unionization for artists?

HALEY: I think the artist is a person who lives in an isolated life to a great extent. There are some things that happen that I'm glad happened, and when they find the lead in the paint, all those things, when they find there's something, the organization like that will warn the artist about materials. That I will certainly support; that's a real service. But, I guess I wouldn't want anybody to have anything to do with me that I don't want. I wouldn't want to have anybody handle my work that doesn't want it; I don't want to impose anything on anybody. That's the way I feel, anyway. I can't think of any time when I felt, "Oh, I wish we were all marching together." As far as the environment is concerned, I believe in organization, tremendous organization, and I think the artists should support the organizations. That certainly is required; it should be done. I support all the peace things; I'm on every list! But I'm a loner, I guess. I think the WPA during the Depression was a very wonderful organization. I think that was very good because the artist was permitted financially to be the artist, and that's good. In a sense, yes, I guess I do support. I've talked myself into it.

RCAC: Describe the period in which you first achieved professional recognition.

HALEY: When I was at Yale, I would say, what I received could be used as professional recognition. I have been newspapered and stuff. I think

I've always had recognition on a small scale; as I move along, it kind of increases.

RCAC: How would you describe the group you rely on now as your peers? And who are your peers now?

HALEY: I'm eighty-two; I'm my own peer! Friends, all friends. The artists here are really very supportive. I think we have a very caring and wonderfully creative group of artists here in Portland.

RCAC: How would you describe your occupation, and is this different from your career?

HALEY: No, it's all the same. I live out of my environment, and this is it.

RCAC: How would you describe your general job history from the time you married Mike? You were still in Connecticut. And then what happened?

HALEY: Then what we did was skate along on very little, and then, for very little, we bought fifteen acres, more or less, outside of Waterbury, Connecticut. Had a house without water and without heat, without anything, and we moved in. It had a wonderful well, a beautiful well. It had a lovely space for a garden. And the war came along. So we had a garden, and we had some chickens. We were both city people, knew nothing about animals or gardening, but we got the little pamphlets from the government, and we studied them, and we got fifty chicks, and we raised forty-nine chickens, which is supposed to be a phenomenon, really. We made a beautiful place out of the house—still didn't have any water, but it was beautiful. It had an outhouse. And so we were really early hippies, I guess. And Mike worked in the war industry, which all the artists did, everybody did. That was a six-year stint. It was one of the most educational periods of my life. It was beautiful, and I think we developed a profound sense of independence. Had we not done our art, we could have become self-sustaining people, but of course after the war, we just said, "Oh, heavens, let's go back to our profession."

I painted all the time. Mike did some. But I even showed when I was there. Had exhibitions and did some work that helped out a little. But it was a very dramatic time. And it was exquisite countryside. We were on a great hill, with outcroppings of rock and oak trees, a forest behind us. Wonderful white birch in the forest and tulip trees. Great stone walls all through it and some zigzag stone walls from the Revolutionary days, I swear. And the view—the hill just swept down and over the fields. It was a southwestern exposure, so you had magnificent sunsets. It was a setting in which you could really just live forever.

What happened was at the end of the war, there were schools opening

all over the country, and art departments in all the universities, and the GI Bill. There was a great flourishing of this. I remember a great list in one of the art magazines that was looking for art teachers. So I got the typewriter out, and we sent letters all around. Mike applied to various places, and he was accepted at Blue Mountain and Macon, Georgia, and Schenectady, and someplace else, and Portland, Oregon. So we decided this was where we would come, for a year, and we never went back. I didn't teach; Mike did. One's enough. I think the pressures on a family for two people to run out the door is terrific—in the morning, you know, to go to work. And you have to shop and you have to do laundry; you have no time for anything. So I said, "No, one's enough. We can live on that." It certainly was a very small salary, but we did it! I think you make do, and it works. I still do that.

RCAC: Do you see, in your own work, a pattern or a progression over time?

HALEY: I see my paintings reflecting my philosophical development, my involvement with family and with work. What do I see? God, I don't know. I'm doing it; I don't know that I'm thinking it, I'm doing it. Mine is a visual world that I am recording. And I use the space that I'm in; I use it the way it is. When I was on Buck's Hill with that beautiful view and all that foliage, and the excitement of the weather, and the children, I painted that. There was a vigor that was in that time, a little bit probably corny, but it doesn't matter. I was painting. Then we moved here, and things became different. There was a kind of a closed-in feeling, and my paintings reflected that. Now I have really adjusted space for myself. How do I use what I paint now? I like what people write about my work rather than what I'd say about it. Which is nice. I've never been able to talk about my work, and that's all. I can talk about my life, but I can't talk about my work.

I am a great lover of art, of visual art, of music, and I have music with me, and I have my blank canvases, and I have my favorite world around me, and I try to dig out of that something that will carry a little meaning, an emotional impact. I talk to paintings. I figure out how they feel, what I feel, and what comes out of it, and what you might feel. And I try to convey those feelings. I don't know what else to say about it.

RCAC: How would you describe any gatekeepers at various stages of your career, those who let you in or those who kept you out?

HALEY: I think I had smooth sailing, frankly. I have never had any high ambitions; that's probably why I can be so comfortable. Had I had any, I think maybe I might have moved—who knows?—but we all think that. So that's any easy thought.

RCAC: What have been the major turning points in your career?

HALEY: Every time I move. Moving has always made changes, either in my work or my application.

RCAC: In Portland, after you came out, you lived first out in Vanport?

HALEY: Vanport, for about eight months. Then when the flood came, of course, we were already out. Then we moved out near Gresham. Mike bought a house. Housing was very tight here, and he bought a house from a GI that was going to school without seeing it even. I didn't see it either, until we moved out there. It was just one of those little row houses or whatever they are, stamped-out houses. And finally we moved here. I was sixty when we moved here.

RCAC: What has been your relationship to money throughout your career?

HALEY: Oh, you just make it, and whatever you make, you live on.

RCAC: Have the costs of supporting your art changed over time?

HALEY: Probably. Since everything else costs more, it does.

RCAC: Have grants or awards or competitions or emergency funds affected your career?

HALEY: No.

RCAC: Have you ever applied for grants or funds?

HALEY: No.

RCAC: Has there been a particular time when such money would have been most helpful?

HALEY: Always. Isn't it?

RCAC: What has been the importance of physical location and work space at different stages of your career?

HALEY: I've always made do. I always worked at home. I don't do very large paintings; maybe that's why. But I work in what space I have. If it's only the living room, I work in the living room. But now I have two bedrooms, which give me ample space.

RCAC: What kind of control do you exert over your destiny as an artist?

HALEY: Total. That's it. I really do. I organize my life so that I never have as much time as I would like, but as much as I can get. Maybe that's part of what happens. I don't want to go places. I don't want to travel, I don't want to do anything, because I don't have that kind of time. As I get older and older, time becomes absolutely precious. I don't want to waste it having fun, going places. So I use every bit of time, and it works. It's even possible to have my son and his daughter here. It crowds us a little, but that's all right. We have more space now than we've had up until the day we moved into this house.

RCAC: It's like your mother used to put another leaf in the table.

HALEY: That's right!

RCAC: What are your own criteria for success as an artist?

HALEY: If I have any success, it's because I have found a way to work where I fully am enchanted by it. Every painting I do, I am enchanted. I don't have to make an apology for my realism. I love realism. But I know I can't paint realism the way the Impressionists did or the way Peales did, Fantin Latour or any of them. I cannot paint like that, because that is done. I have to find a way to work, to do my still lifes. A still life is my choice. I could use a body, I could use anything, but I prefer something that is available and that I can see the beauty in and show it to you. I have to find a way that's modern in doing it, in our time, with our philosophy, with our isolation, with our kind of drama that we understand. I have to find a way to do it and a way that I can stand to paint all the time. I've never painted for a show. If I haven't got a body of work, don't talk to me about a show. I paint all the time. I'm in and out of my paint space, I'm looking at my paintings, I'm checking on them all the time. That's really a big part of my life—the biggest part probably, now anyway.

RCAC: And going back to the definitions and criteria for success for a moment, the criteria that you have for yourself, are those the same you use for other artists?

HALEY: Oh, no. I mean, I would never lay it down as any law for anybody. I think artists are unique; nothing fits anybody else. I couldn't live another artist's life. I can't even live my husband's life.

RCAC: Do you think your painting and Mike's painting have influenced each other over the years?

HALEY: Yes, but I wouldn't know where or how. I think we probably influenced each other, so I suppose in that respect, it rubs off in our art. I haven't seen his work, except a show, for ages, because I don't go down to his studio, but he sees my work all the time. I keep a sharp eye and see to it that he doesn't get too close! I mean, it's a very personal thing, art is. Once you've passed the instruction stage and your teachers, who are in there, telling you how to do it right, after that you're on your own.

RCAC: And you need to keep it that way.

HALEY: Oh, you have to. Absolutely.

RCAC: Do you have a number of central ideas you keep working on, throughout your paintings?

HALEY: I think so. I think my work is very recognizable. I always say that the subject matter is very repetitious, but my paintings aren't. Now if I can keep that, I'm okay, and I can find painting very thrilling.

RCAC: Are there particular periods of work that you feel more satisfied with than others?

HALEY: I think I like what I'm doing now. Yeah, I think so. Otherwise I would paint the way I did before.

RCAC: What are your feelings about critical review or critical dialogue of your work?

HALEY: Well, nobody likes it, and I don't either. I don't think reviews should necessarily be unkind to the artist. Presumably we're all putting our best efforts out. So that kind of critical review I don't like, but I've never had to suffer that, really.

RCAC: How satisfied are you with your career as a painter?

HALEY: I'm satisfied. I've done the kind of work I wanted to do, and I think it's been well received.

RCAC: What have been the major frustrations in your development?

HALEY: I don't think I'm a front-runner, but I can't think of anything that's bothered me.

RCAC: How would you describe the greatest satisfactions?

HALEY: Good health. I think that's a very big advantage. And I think all of us have been really good. Mike is eighty-one; he's a kid. He's only a year younger, but when you get old like this, a year's a world! But we're both very healthy, and our children are healthy. Grandchildren are healthy. We have not lived under the cult of happiness or anything, but I think we've all worked hard.

RCAC: Has there ever been a particular show or a particular exhibition that gave you more satisfaction than others?

HALEY: My last one, not only physically and emotionally but financially, went very well. It was sold out before the show. It was too big a show, though. I really ripped out myself a lot. I should have kept some. I kind of got swept into it. I thought, "Usually a show goes out, then half of it comes back." But it didn't. I was left with nothing much. So now, in the past period of time, I've been building a body of work.

RCAC: Do you keep up with where your paintings have gone to, with the people who have bought them?

HALEY: No, but the gallery does. The gallery is very, very conscientious about it, although I do try now to keep a record for my kids. I mean, it's a lifetime. About a year ago I had David Brown, who is a photographer and does work for the Laura Russo Gallery, take slides of all of the shows that I had there and other paintings that are available. Those and all the slides that I have that other people took and I took myself are not good slides, but they're a record. It's still not anywhere near the work

that I have done. I'm impressed with the work I've done; I can't believe it. It is an incredible amount of work. I don't often say things like that.

RCAC: Has there been any particular event or time that was the greatest disappointment?

HALEY: No, I don't think so. I'm geared to all those things, so that I have enough flexibility to absorb pleasures and disappointments and the anger and the rest of it.

RCAC: What has been the effect of the marketplace on your work?

HALEY: You know, I have no idea. I don't think, from my work itself, I know what happened. I mean, I have a nice following that welcomed my show, but the marketplace, that is too big for my concept.

RCAC: How has your relationship to materials changed from early on, from when you started, to now? Have your absolute basic requirements for being able to do your work changed?

HALEY: They've improved. They're better now, even though our old place had a beautiful studio—absolutely wonderful space—that was available for everybody. I made most of my little things like that, just being around. But now I have to go up to my studio. That is a little different. I like to work at night, and I would do that, but it's kind of hard to just walk away. That's the only area though. Other than that I've got my own space, and I like it.

RCAC: What one major point would you make to young painters about pursuing a career as a painter?

HALEY: Paint. That's all. Find it. Find yourself in it. You've got yourself with you all the time, so you can use yourself as your vehicle. I have nothing else. That's my solution.

Honors: Hubbard Award, Hubbard Museum, Ruidoso Downs, NM, 1989; Oregon Governor's Award for the Arts, 1989; Woman of Achievement Award for Artistic Excellence, 1988.

Representative collections include: Corporate: AT&T (New York), Barby Investment Co. (Portland, OR), Federal Reserve Bank of San Francisco, Harsch Investment Corp. (Portland, OR), Hoffman Industries (Portland, OR), Pacific Northwest Bell (Seattle), Safeco Insurance Co. (Seattle), Tonkin, Torpe and Galen (Portland, OR); Public: Kaiser Foundation (Portland, OR), Oregon Art Institute (Portland, OR), Portland Art Museum (OR), Portland Civic Auditorium (OR), Seattle Art Museum, State Capitol Building Collection (Salem, OR), Washington State Arts Commission (WA), Willamette University (Portland, OR).

AL HELD

B. New York, New York, 1930. Studied at the Art Students League, New York, and the Académie de La Grande Chaumière, Paris. Professor at Yale University, 1962–80. Lives and works in New York City and Woodstock, New York. Exhibits internationally.

RCAC: What were your initial experiences with art?

HELD: My initial experiences with art! Very minimal. I would say none, from my home. Oh, wait a minute. Now that you've got me thinking about this, there was a newspaper in New York City called *PM*—or it was the *New York Post*, I've forgotten which one. But for a dollar, one could send away and get a portfolio of Van Gogh prints, which my mother did and hung them in the apartment. And they were all over the apartment. And she had no idea who Van Gogh was; it was just simply pretty, nice stuff, and it was a dollar, and it was fine. And that was my earliest memory of art. And I still carry the Van Goghs around with me in the sense that I remember where they were on the wall. I was never taken to a museum as a child. The only other art experience I can remember is in public school in an art class, a teacher making some kind of complimentary comment, but I'm not quite sure what it was. But it stayed with me—the compliment, that is, not the image of what I did or what the interchange was, just simply that it was complimentary.

RCAC: How would you describe your family in early childhood?

HELD: They were working-class Jews. Both immigrated from Europe,

Poland, and met and married in New York City. My father was a lifelong Marxist, communist, which permeated the intellectual atmosphere of the house. I had a sister, who unfortunately died very young. She was younger than I was. She was a psychotherapist—very bright and terrific.

RCAC: Where did you grow up?

HELD: I was born in Brooklyn, raised partially in Brooklyn, partially in the Bronx, meaning that I was born and raised in New York City, but you have to be a New Yorker to understand what that means in the sense that Brooklyn and the Bronx are not Manhattan.

RCAC: How did the members of your family feel about the talent that led you to develop your artwork?

HELD: In the beginning incomprehensible, and great resistance against it. I started very late. I started painting after I had returned from the navy. So by the time I started painting, I wasn't living at home.

RCAC: And art wasn't something that was particularly discussed at home?

HELD: No, absolutely not. There, politics was discussed. My father read a great deal, but it was fairly orthodox, programmed communist stuff. He was an avid newspaper reader, my mother less so; my aunts and uncles, almost nothing. There's a miscomprehension by a lot of people, a romantic comprehension that Jews are intellectually and culturally active. It's not necessarily so. And particularly with the working-class Jew.

RCAC: Were there any particular resistances to art in school or elsewhere?

HELD: No, it simply didn't exist. It wasn't present.

RCAC: What kinds of subjects interested you in grade school and then in high school?

HELD: None. I was a very difficult child, restless and difficult. I was a habitual hookey player and spent most of the day, every day, playing hookey at two double features in the movies. So I guess there's some art form there. I'm an expert on forties films.

RCAC: When did you become an artist?

HELD: Well, I sometimes think I haven't! I started going to art school— let me put it that way—I started going to art school when I was about nineteen. I was very moralistic about it, in the sense that I felt that that self-appointed title was used too readily and too easily by too many people. So even when I was on the GI Bill and went to Paris with all my peers, I still referred to myself as an art student and not an artist. When I crossed the bridge, I don't know, really it's hard to tell, but I guess sometime in the fifties.

RCAC: What do you think that turning point was, or how did you know you became an artist?

HELD: Well, I don't feel this way now, but in those days it was sacred. Therefore one could not call oneself an artist, because one would feel too presumptuous. I guess it was a gradual evolution, where as I got more professional, that kind of presumptuousness sort of eased itself out of my consciousness. But it's still sneakily there in a lot of ways.

RCAC: In terms of becoming "more professional," what does that mean?

HELD: I don't know. I guess it's a combination of thinking of yourself as this is what you really do and this is what you'll be doing the rest of your life, and also learning or knowing or living in a professional art world. And knowing the etiquette and the rules of the game, so to speak. I remember years ago, we used to have a phrase, "He had no studio manners." It didn't mean he didn't know how to pick up a fork with his right hand or his left hand, it meant that he didn't have any studio manners. And there is a particular kind of etiquette to entering and leaving a studio, which I think still exists to a large extent, and I think in a professional sense, there are things that morally and ethically one doesn't do and one expects other people to live up to and not do or do.

RCAC: What happened next? You got through high school by seeing movies . . .

HELD: I didn't get through high school! I got through two years of high school before everybody concerned decided it was a fruitless exercise and wished me well. I joined the navy at seventeen. It was a very lucky thing to have happen, because I was out of the navy at nineteen, and the Korean War had started, and I would have been an eighteen-year-old high school dropout and a real prime candidate for the whole thing from the very beginning. And I spent most of the Korean War in Paris on the GI Bill, so it worked out very well. It was one of those life things that you by far can't plan but worked out very well.

RCAC: Was the art school in Paris, or did you go to art school here?

HELD: Well, I first started going to art school at the Art Students League in New York.

RCAC: And what made you decide to go there?

HELD: A group of peers—a friend, actually, one friend. When I came back to New York from the navy, I joined a political culture group—by accident—it had nothing to do with anything but social motivation. In this group was another young man who'd just gotten out of the army who wanted to be an artist. We happened to live in the same part of the Bronx at the time, and he and I used to take the train down to Manhattan, to this cultural group, which was a folksinging cultural group but

political. He used to fill my head with stories about what he was going to do and how he was going to paint these great paintings and murals. And he actually turned me on, got me excited, and I decided, out of the clear, blue sky, to try a class or two at the Art Students League. Fortunately there was no entrance exam; I mean, the Art Students League was an open enrollment, you didn't have to demonstrate any skill or any talent or anything like that. Just pay your money and take your chances. So that's what I did, and that's how it started really. I stayed I think a year at the Art Students League. And at that time all my friends and myself were quite political, and it was the time of McCarthy. And I decided that fascism had come to America, and it was time to get out. So I used my GI Bill, and I decided I was going to leave the country and study art someplace else.

And actually Paris was my second choice. My first choice was to go to Mexico and study with the Mexican muralists. I was going to enroll in a school where Siqueiros was teaching. And just before I was due to leave, there was a gunfight or something down there with Siqueiros, and the government took the accreditation away from the school; without that I couldn't go anywhere, do anything. So I immediately switched to Paris, my second choice. Again a very fortunate set of circumstances.

RCAC: And how long were you there?

HELD: About three years. It was a very, very unique and wonderful experience. Three years in Paris. After all this was in the very early fifties. The GI Bill gave you seventy-five dollars a month, which was quite adequate in Paris in those days. That's where I think things really changed for me in terms of my art education and seeing things and just getting acclimated to another kind of world.

RCAC: Did you take a lot of classes?

HELD: Well, you were obliged to under the GI Bill. After all you were being paid as a student! So I took some classes, I took classes with a sculptor called Zadkine, who was a fairly well-known Cubist sculptor, and pretty much got by with that. And there were a couple of Americans there, older men, who became surrogate teachers. One in particular was Earl Kirkham. There was a drawing class, a free drawing class with no instruction at this school called La Grande Chaumière. Earl, who was a much older man, became the instructor for a group of Americans there—well, not quite an instructor, but it was more like, "You dumb son of a bitch! Don't you know how to hold a pencil?" kind of thing! But he was quite cultured, and quite knowledgeable, and a Gulley

Jemson, the original Gulley Jemson of Gulley Jemsons. Quite an unusual and unique and wonderful man. He taught me a lot.

RCAC: Describe the importance of peers to you in this time right after high school or in early art school.

HELD: Well, peers probably taught me as much if not more than anybody else did, because I can't remember any really outstanding instructors or teachers. And in painting, unless you're really interested in the true academic education, there are so many options and so many ways that you can do it that it seems to me that no person, or particularly a young person, can absorb all that information, even in a systematic way. So the peer structure seems to work very well. It's very limiting, because it's always the cutting edge particularly, or the hip thing that's going on, that your peer group is very influential in. But you absorb a certain kind of craft and philosophy from this group. And it's a good education in terms of the interrelationship of different kinds of artists to each other and how a dialogue evolves and takes place. I buy into the thesis of that book *The Shape of Time* that you are impregnated with a certain ethic or aesthetic as you enter the mainstream of whatever cultural life that you enter into, and it never leaves you. And the peer group really stamps that on you very, very strenuously.

RCAC: Would you say your peer group at that time was fluid? Did it keep shifting in composition, or was it pretty much the same group?

HELD: Well, the peer group, the artistic peer group in New York the year that I started painting, was all social realists. And by getting out of New York and getting away from that social peer group and meeting a whole new group of people in Paris who were not particularly interested in social realism was very liberating. Because if I had to explain myself to my old peer group, that at that point I was not ready to give up their friendship and their respect, it would have made it much more difficult for me to move the way I had—the way I did move in Paris, by picking up a whole new group of people who were thinking and acting and reacting in a very different way.

RCAC: Who were your role models or mentors during this early period?

HELD: Well, the first period it was the Mexican muralists and the social realism and all the rest of that stuff, and you can imagine what the rhetoric was like. Just before I left New York, I had been very strongly struck by Pollock paintings, that scene. And I couldn't justify the emotional reaction to the Pollock paintings from the political-intellectual position Pollock was supposed to be vis-à-vis me and my group. And it was very confusing to me—until I had the brilliant idea in Paris that the way to handle it was to make Pollock into the true social realist.

So, you know, in all of these things there was a great deal of rational-ization, to make the square pegs fit the round holes. But by the time I got to Paris, the Abstract Expressionists, who I was not supposed to be interested in in New York because of my peer group, began to take over. And by looking over my shoulder, in a sense I became more of an American in Paris in terms of politics, in terms of aesthetics, than I had been in New York. In New York I had been kind of rebelling against anything American, be it art or politics. In Europe I started juxtaposing it with things I had seen in Europe. I realized how American I was, and not only how American I was, but that it was not bad. Matter of fact, it was pretty good. So that's what happened to me in Europe.

Most of the people that I saw and knew were my peer group, were other people on the GI Bill doing all kinds of things, from writing poetry to painting and sculpture. Picasso, Matisse were still the great giants. Giacometti and Brancusi and people like that were seen. I mean, I saw Giacometti continually, in the cafés. But he was a figure to be respected. Léger, ironically (even though I've come to deeply admire Léger), Léger had a school in Paris at the time, which I refused to attend except for a few odd sessions that another friend of mine brought me to, because I thought his work was abominable, with the kind of arrogance a twenty-year-old couldn't abide; you know, it was awful. And a number of my friends were enrolled in his school, and he used to have one day a week critiques, where all the work was laid out and he would sit and talk about the work. And I went to a few of those things just as a visit. So those figures were still around. Sartre was around. But none of these people were in an interactive role. Mostly it was the peer group. And looking over my shoulder to Rothko and Pollock and de Kooning and people like that that I had left in New York. But those were the people who were really beginning to act on me. The people in Paris who I saw were also very interested in these people. They were all Americans.

RCAC: What qualities do you feel you needed most during this period?

HELD: What qualities did one need most in this period? I was about to say stupidity, or innocence. I think knowing just enough to know that you needed to know more. I think the people that I have seen that knew too much couldn't really paint; they knew how bad they were and it would cripple them. So it was the stick and the carrot. I also think that the times were wonderful. I mean, we thought we owned the world. Not that we Americans thought we owned the world, but we young people thought we owned the world and we had the truth. And we knew what the truth was—and it was simple and straightforward. And the big trouble was to do it. But we knew it.

RCAC: Just a matter of translation. What materials were you working with during this period?

HELD: Mostly very traditional materials: oil paint, charcoal, graphite. I was doing it in a slightly untraditional way in the sense of working with very thick, heavy, impasto paint and troweling it on with palette knives and stuff like that, but basically it was really fairly traditional.

RCAC: How would you describe your relationship to the materials?

HELD: Tactile.

RCAC: Do you think your training during this post–high school period, the Art Students' League and then Paris, adequately prepared you for a career as an artist?

HELD: No, not at all. Essentially, I'm self-taught, and almost everything that I've learned, I've had to teach myself. Or learn from my peers or learn from people around me. I consider myself radically under-educated.

RCAC: Would you do it differently?

HELD: Yes, but I don't know how. I would not accept the way art is taught today as a good way of teaching art. But for the life of me, I don't know another way of teaching it. But I don't like the way it's taught.

RCAC: During this period of time, did you give yourself certain benchmarks for achievement?

HELD: Well, when I first came to Paris, I was very anxious to become an abstract artist because of Pollock. But I said I must know how to draw the figure first. There was some ethical, moral thing: One must know how to draw the figure before one gives the figure up. It's nonsensical, but that's how I felt, and a lot of people felt the same way. Of course I finally did something which I then rationalized as knowing how to draw the figure, so therefore I can give it up! A great deal of rationalization goes into all of these things, and so there were benchmarks like that.

I've been driven I think all of my painting life with notions or ideas about what something should be. And that's driven the paintings, and it has changed them, has made them into something else. And that's how the paintings have been pushed from one medium and one style to another: The ideas take over and motivate the painting. So if you want to, call that a benchmark. But they're basically motivated through ideas. I'm talking about an intellectual life.

RCAC: What were the first organizations you joined as an artist?

HELD: Oh, I can't remember any organization I've joined as an artist.

RCAC: Have any groups or institutions provided services you've used? Have they offered you benefits like health insurance, credit?

HELD: Just my teaching job. But outside of that, no.

RCAC: Do you teach now?

HELD: No.

RCAC: Have you taught regularly?

HELD: I did at one time.

RCAC: And was that for a long period, or was that a short interlude?

HELD: It depends what you mean by long! Eighteen years.

RCAC: That's a significant amount of time. Where did you teach?

HELD: I taught at Yale.

RCAC: How do you feel about unionization for artists?

HELD: I think that there's a great need for health insurance and all the social stuff that the artist, if he's on his own, finds very, very difficult to get, especially if he's a marginal artist who has very little money. I think it's very important; I think it's very necessary. The only thing that bothers me about it, if one thinks about the pattern of unions in America, is that I wouldn't want to do without unions in America (and I'm now talking about, let's say, automobile unions, Automobile Workers of America); I think they're very necessary. But on the other hand, they've really gone a little far in terms of protecting their people against the public interest, which is not as important to me as the professional interest. In all of these things, like tenure, what starts out to be something to protect and help the iconoclast or the unusual person or the person who, because for one reason or another is not part of a social order, ends up being the protector of the mediocrity. And that's my hesitation.

I think to work as a voice of social advocacy, I think it's stupid. I mean, I don't know two artists who can agree, let alone fifty artists who can agree on any issue, and to have a union that is going to speak for "artists" is a contradiction in terms. And if you had a union that would then try to fix philosophical terms for how an artist should think or perform makes me very nervous. But for social needs, I think it's very important.

RCAC: Describe the period in which you first achieved professional recognition as an artist.

HELD: Never. I'm being facetious. I don't think any artist really feels like he's gotten recognized. I mean, it's still a shock to me when somebody turns around and refers to me as an eminent artist or as a famous artist or a well-known artist. I don't feel that way. I think I'm still trying to get there. So that's the only way I can answer the question, since I don't think I've gotten there yet.

RCAC: But you have received a certain amount of public acclaim if other

people are referring to you as an eminent artist. When did that start happening?

HELD: I'd say when I started showing in New York, in the late fifties. I want to go back to one subject. There's something that I didn't say that I'd like to say, which is I think people of my generation—I'm sure it's been said a thousand times, and not just painting and sculpture, the arts, but I think all across the boards—the GI Bill was extraordinary and I think transformed in many ways America. Certainly the art world, as I knew it, but also more than the art world—all professions across the board in America. It just amazes me what the GI Bill really did. And it hasn't really been documented as thoroughly as it probably should be.

RCAC: Who do you consider your peers?

HELD: Everybody who's still alive! Well, pretty much everybody that I know who's got some kind of professional standing. I no longer make these deep, moral judgments about who is and who isn't. That's all.

RCAC: Do you feel that your peers have influenced your career?

HELD: My peers influence my career. I think my peers—and when I refer to the art world, I'm by and large really referring to my peers and not the commercial art world—have influenced a good deal of my thinking, a good deal of it negatively, but that's as much of an influence as the positive influence.

RCAC: How would you describe your occupation? And is this different from your career?

HELD: I haven't given it much thought. It's very difficult in this day and age to think of it this way, but if I weren't terribly embarrassed by it, I would still like to think of it as a calling, as something extremely special. I wouldn't get up in public and say it that way. But certainly that's what I would like it to be.

RCAC: How would you describe your general job history?

HELD: Well, my job history is I took any job that would support me. And they were varied and many and different, until I made enough money to live off the painting, which happened in a slow arc. I guess you could say that when I gave up my teaching job was when I had enough confidence that the income was going to keep coming in. As all artists, I mean, I'm fairly conservative financially, because I've seen things go up and down with such regularity that you can count on it. You can count on the sun rising, you can count on the sun setting; count on it. So I would say that I was really supporting myself four or five years before I gave up the teaching job. I didn't have enough confidence in the regularity of it to give up the teaching job.

RCAC: Was there a long period after Paris before Yale?

HELD: About ten years. I did everything from working in the Museum of Modern Art as a paint handler to a truck driver to a moving man. Didn't make much difference.

RCAC: And then you went to Yale?

HELD: Yes.

RCAC: And then stayed at Yale until . . .

HELD: I quit.

RCAC: And then you have been painting . . .

HELD: Ever since.

RCAC: You said earlier that your parents were full of disapproval, or that there was resistance at that point. Has that changed?

HELD: Well, my father's now dead. My mother's alive. Yes, now there's pride and, on my mother's part, a bit of frustration. Now she claims that her bragging rights are quite limited, because her peer group doesn't believe what she says. And she's very frustrated. She says she can't talk about me; they think she's lying! So I think that's very funny.

RCAC: Have there been particular gatekeepers at various stages of your career, people who have either let you in or kept you out?

HELD: In my mind it doesn't work that way. I think that there are people with different ideas of what art should be, and there's been any number of intellectual fights and discussions. And it goes on, and I think that's exciting. If those are gatekeepers. I guess there are people in the art world who designate hip and unhip things. But they come and go, and it shifts so fast that by the time you figure out who they are, it's somebody else or some other group. I think people go to the work they like, and they support the work they like, and then they build sand castles of rationalizations around that, but I don't think there's much you can do about that. People are either going to respond to your work or not.

RCAC: Have there been any particular discrepancies between your career aspirations and your actual career opportunities?

HELD: Of course. I've gotten realistic. My spirit is finite and my ambition is infinite.

RCAC: Have there been major turning points in your career?

HELD: Yes, I think so. And I think those turning points have really revolved around different ideas that I've had, or that have come about, and me acting on them.

RCAC: Have there been progressions? Can you see a pattern of progressions from the beginning through the different turning points?

HELD: Progression, you mean progress? Getting better?

RCAC: Well, some people describe it as getting better; other people just

simply see it as a pathway that has moved in different directions. You can call it getting better, you can call it shifting and following ideas.

HELD: Well, I like to think that the last paintings I've done are the best paintings that I've ever done. I really believe that, and yet I'm too realistic to really believe that. I think that with all the radical different ideas in my paintings that there's been a pattern, a concern, from very early on of abstraction, ordering, structuring. I think the different kinds of styles have all revolved around those preoccupations. So I've taken different ways of doing that, different ways of dealing with that kind of dialogue. But essentially the fabric or the glue that ties them together are classicizing and structuring and, well, just all those words. That's been the consistent thing.

RCAC: Are there periods of work that you feel more satisfied with than others?

HELD: Depends on which day of the week. It shifts; it moves around. It really does depend, not as much on each day of the week, but I'd say each week or each month, and it could be different things and different moments and different pieces of different things.

RCAC: What has your relationship been to money throughout your career?

HELD: I'm a child of the Depression, so that what I want from money is security, or freedom. Now that I'm getting a good deal of money, I've learned that I have absolutely no interest in the money. I have no interest in leaving it, I have no interest in building it, I have no interest in accumulating it. But I am very interested in getting enough of it to guarantee my absolute freedom to do anything I want to do. The rest of it I can burn. But I'm very, very concerned with the notion of being free from all concerns about money. And I've just gotten there. Now with the recession coming, it's very fleeting! But it's a wonderful feeling. I've learned about myself—and it's not a virtue; I don't put it down as a virtue or a fault—that it takes time to spend money, and I haven't got the time to spend it. And it takes energy to play with it, and I haven't got the energy to play with it. I just really want it as a security blanket. And beyond that I have no concern for it.

RCAC: How has the cost of supporting your art changed over time?

HELD: Gotten more expensive. So the nut, which started out at seventy-five dollars a month, has gotten a lot more expensive. But it's essentially the same nut; it's just that the studios have gotten bigger, the painting's gotten bigger, and the paint has gotten more expensive. Now I've got insurance, now I've got a warehouse to store the paintings, now I've got just endless expenses of just keeping the stuff together.

RCAC: How have grants, awards, competitions affected your career?

HELD: Minimally. Peripherally.

RCAC: Has there been a particular time in your career when such money would have been most helpful?

HELD: I think I've gotten two money grants, a Guggenheim and a National Endowment. And the money was always welcome and always necessary. I didn't get it at a time when I had a lot of money and didn't need it. So it was always necessary, but it eased things up a little bit for me. But I think what was more important was the recognition, or little pat on the head or back or what have you. I'm not saying it wasn't useful, but the money did not change my life. For instance, I've never gotten a MacArthur, but I imagine a MacArthur changes people's lives. That's significant. And I think it's wonderful that that grant is being done. A Guggenheim or National Endowment is very nice, but I don't know of it changing anybody's life, and I think there's a big difference.

RCAC: What has been the importance of physical location and work space at different stages of your career?

HELD: Oh, I think it's very important. And I am a painter of large-scale painting. And I've been very lucky to have been born and raised in New York City and the whole loft culture. In the years that I started out painting, the idea of getting a loft and painting in a loft was as natural as water off a duck's back, so that one assumed one would have large spaces. Whether one painted large paintings or small paintings, just a loft was a loft was a loft. It wasn't anything, was no big deal. It's gotten very fashionable, it's gotten very chic, it's gotten very expensive. And I do not envy young artists today in terms of trying to get space. I think it's much more difficult for them than it was for me, in my period. When I got my first studio, there were literally thousands and thousands of lofts that I could, did pick from. There was no shortage of lofts. I think my first loft—which was quite a wonderful loft, as a matter of fact; it burnt down—was forty dollars a month, and it was very big, over five thousand square feet, two skylights.

RCAC: That is big. Do you paint both here and up in Woodstock?

HELD: Yes.

RCAC: And do the spaces make the paintings different?

HELD: Yes, they do. I've got a wonderful space up there—much bigger than this space—and the country. There are no direct things I take from the landscape, but I think there are things that happen in the environment that do affect me in one way or another.

RCAC: What kind of control do you exert over your own destiny as an artist?

HELD: Not enough. Essentially I'm reactive. I am not an aggressive planner or doer of things. I'm basically a reactor.

RCAC: How have you interacted with the public throughout your career?

HELD: Well, I don't think an artist like myself has a public to interact with; I'm not Picasso, and I'm not Matisse, and I'm not Julian Schnabel, in the sense that I don't have a public like that. I think I have people who like my work and I think people who admire the work, and there's nothing to react to.

RCAC: What are your own criteria for success as an artist?

HELD: History. Just as a great panoramic thing out there. History. Enormous mountain peaks there. There are incredible accomplishments.

RCAC: And is being placed somewhere in that panorama part of your definition of success?

HELD: I wish. The odds are so remote, but of course that's the dream of dreams.

RCAC: What are your feelings about critical review of your work?

HELD: I like it when it's good, I hate it when it's bad, and a month later I can't remember any of it.

RCAC: How satisfied are you with your career as an artist?

HELD: Well, it's sort of two-edged. I'm very satisfied that I can support myself. I could put it this way: At this point in my life, I can do anything that my imagination, my mind, wants me to do, so whatever problems I have are my own. In that sense I am the luckiest man in the world. But then this history makes me feel very small. But in terms of my career and allowing me to fulfill anything I can dream of, or imagine, or think of, then I'm very fulfilled.

RCAC: How do you define success for other artists?

HELD: I don't. I don't know what a successful career is. I mean, if one wants to think of a successful career, it is so relative. Has Michelangelo got a successful career? Does Picasso have a successful career? I mean, it doesn't make any sense.

RCAC: What have been the major frustrations in your professional development?

HELD: Having to teach as long as I had to teach. Not having enough money to do what I wanted to do. Not being able to do something in a painting that I've been wanting to do, because I haven't had the skill or the imagination to do it. Just normal lifetime frustrations.

RCAC: Is there any one greatest satisfaction you've had? A peak moment?

HELD: No, they're mostly fleeting. I mean, there's always this kind of,

you know, wild, terrific, but then the next morning the wild and terrific doesn't look so wild and terrific.

RCAC: Has there been any one great disappointment, or several great disappointments?

HELD: No, I think the really great disappointment is sort of like growing up and becoming mature and realizing that the world is not your oyster. But things are pretty good.

RCAC: What has been the effect of the marketplace on your work?

HELD: It's helped me, in the sense that I think if Jasper Johns gets a hundred million dollars for a painting, it's good for me, because it helps me sell a painting for X, Y, Z—which again gives me the freedom to do what I want to do. So I think it's insane, I think it's crazy, but I'm all for it.

RCAC: How has your relationship to your materials changed?

HELD: Well, it has changed. It changes all the time, depending upon the needs of the painting. So I don't really see myself as a person who works with one material or another material; I work with the materials that are inherent in the paint. I'm basically an orthodox painter in the sense that right now they're all acrylic paintings. But my paintings always have been labor-intensive paintings. Things do not come quickly or easily; I don't trust the first shot. But that's me. And so paintings are worked over, and they're labor-intensive. And that's the characteristic that runs through all the paintings.

RCAC: When you start do you have much of a clear idea of where it's going to go?

HELD: No, no. There's basically a stylistic consistency to the work from painting to painting, but there's not a clear idea where they're going, no.

RCAC: Have your absolute basic requirements to be able to do your work changed since your early career?

HELD: Oh, sure, inside out. I mean, going from thick impasto paintings directly painted à la *prima*, wet into wet, to acrylic paintings—geometric acrylic paintings—that get all sanded down and repainted, finished, so there's no sign of human activity—it's changed tremendously.

RCAC: What one major point would you make to a painter starting out today?

HELD: I'll paraphrase something that was said to me. When I was a young painter starting out and asked an older painter some question or other, he gave me what I thought was (given the circumstances) the best answer one can give, which is search out your peers, or a group of your peers, and live with them and work with them in terms of the life of an

artist and the life of ideas. And that was the advice I got when I first met Rothko and was after him for something else. And he gave me that advice—not that it's the greatest advice in the world, because your peers can be very much mistaken, but there don't seem to be too many other alternatives.

RCAC: This is a post note added the next morning: He was very insistent after we'd finished talking that he did not feel that painting was an inner compulsion. He didn't believe in self-fulfillment, an inner drive to make art. He felt it was much more a question of intellectual curiosity, of following a problem day after day after day. Nothing terrible would happen to him if he did not paint, but it was very much what he did, the terms in which he thought, the way in which he looked at the world. But he kept insisting on not doing "inner fulfillment" to make art; it was just what you did, and it was your intellectual curiosity that carried you along. And he was quite insistent on that point as we were closing up and leaving the studio.

Honors: Painting Medal, Jack I. and Lillian L. Poses Brandeis University Creative Arts Awards, 1983; Guggenheim Fellowship, Creative Painting, 1966; Logan Medal, Art Institute of Chicago, 1964.

Representative collections include: Corporate: American Medical Association Art Collection (Washington, DC), AT&T (New York), Cleveland Trust Company, Exxon Corp. (New York), IBM Corp. (Tarrytown, NY), International Data Group (Boston), International Data Group (Framingham, MA), Mobil Oil Headquarters (Fairfax, VA), Wells, Rich & Greene (New York); Public: Akron Art Institute (OH), Brooklyn Museum, Cleveland Museum of Art, Fogg Art Museum, Harvard University (Cambridge, MA), Gallery of Modern Art (Iwaki City, Japan), Hirshhorn Museum and Sculpture Garden, Smithsonian Institution (Washington, DC), Metropolitan Museum of Art (New York), Milwaukee Art Center, Museum of Modern Art (New York), Nationalgalerie (Berlin), Rose Art Museum, Brandeis University (Waltham, MA), San Francisco Museum of Modern Art, Solomon R. Guggenheim Museum (New York), Staatsgalerie (Stuttgart), Whitney Museum of American Art (New York).

Professional affiliations: Board of Trustees, American Academy in Rome, American Academy and Institute of Arts and Letters Art Department.

CARL MORRIS

B. Youba, California, 1911. Attended the Art Institute of Chicago, the Akademie der Bildenen Künste, Vienna, and the Institute for International Education, Paris. Lives and works in Portland, Oregon. Exhibits internationally.

RCAC: Carl, what were your initial experiences with art?

MORRIS: My first experience was when I was in the eighth grade with a teacher who taught all of the subjects, from baseball to art. When she came to art class, each of us was to bring in a flower and make a drawing of this flower. This was out of my line of interest at that time, so I got my girlfriend to bring in a flower. Well, at that particular time, this teacher, Mrs. Payne, said to me, "Carl, you'll never be an artist." And with that, there was something of a challenge. Going beyond that, I have to say that in high school, I found that the key person in what I have done since that time was Glen Lukens, who taught ceramics at Fullerton High School, in California. He was a man with a very broad view of the world of art. When I took some ceramic and metal classes from him and found that my interest was more than casual, and that I would like to make a profession in this world, he was the one that told me that art is broader than making a pot. At that particular time he decided that we should look into schools all over the country. This, to me, was pure fantasy, because my family was poor. I didn't know I came from a poor family, because I had no needs. I had my food, clothing, transportation to school, and yet this teacher just took on the attitude you go for the

best. He did the research on the schools at the time: Otis Art Institute in Los Angeles, the Chicago Art Institute, Pratt Institute in New York. He discovered that, at Pomona College, there was a teacher who was a graduate of Pratt Institute. He made an appointment and drove me over. We were given an interview by this man, which turned out to be kind of embarrassing, because I never saw so many paintings in my life of Columbus, landing on the shores of eucalyptus trees. They were all over the place—not only his, but his students'. He saw that we were perhaps a bit disenchanted with him, but he was trying hard, and he said, "By the way, there's a Mexican over in the rectory who is doing a painting on the wall over there, and perhaps you'd like to go over and see."

School was out at this time. It was during the summer, but we went over to the rectory, and way over there on the scaffolding was Orozco, the Mexican muralist, painting Prometheus, and it was about half painted. He came down off of the scaffolding and talked with us. Looking at that painting and looking at that man I think was seminal, as far as I was concerned. The whole world opened up. I made two decisions there. One, that I was not going to go to Pratt Institute, and that's too bad, to make a decision about a school on the basis of one student, because Pratt Institute had a wonderful reputation. But still, since my interest was based in ceramics, there was a Mrs. French who was tops in her field in ceramics, and she was teaching at the Art Institute in Chicago, so I chose to go there.

RCAC: Let's go back to your childhood for a moment. What was your family like in early childhood?

MORRIS: I have a brother, and I have a sister, and I was the only one who wanted to go on to pursue further education beyond junior college. My mother and father came to California and carved out a section of sagebrush and planted a citrus grove, and I think that related to my father in some ways, in the sense that everything that could grow in California, he grew on his property. He had to put seeds in the ground; they had to grow. Later, when my income was not what he felt it should be for a person with education, I was pleading with him, "Look, Dad, I think you should understand as well as anyone what I'm trying to do, because in my field I was doing what you were doing with the grove." It is not economically sensible to grow all citrus fruits and keep changing them around, experimentally, if you're not just fascinated by the whole process. And I said, "That's your form of art. Mine happens to be painting." My father's answer to that was, "Yes, son, but I don't believe in a man starving to death in his own profession."

My mother was very inventive with canning fruit, and she made

practically all the clothes for the family, and she was good at it. She enjoyed it. Neither my father nor my mother had a great education. There was always an argument between the two of them; each went to either the first grade or the second grade. It was always a question. Was it my mother or my father? But my father in the same way, in the small community where we lived, became head of the Citrus Association, the Water Board, the Chamber of Commerce. Everything that required public service, he was out there doing it. So while he did not have an education, he did a hell of a lot with what he had to work with, and I think that if there was one thing he had great respect for, it was education. So I never had an opposition in that world. All during my high school days, I had worked summers in the citrus fields, driving a truck, hauling fruit, and on weekends I'd be driving a team working in the citrus groves. But during high school I also ushered in a movie house. I saved my money.

As I mentioned before, I didn't know that I came from a poor family, because at home I was provided with all of my needs, and then I had a choice: I could either earn money and keep it, if I got a job, or if I didn't earn the money, my father had plenty of work for me to do. I never worked for my father very much. So I saved this money, and this is the money that I used to go to school, when I went to the Chicago Art Institute.

RCAC: How did your parents feel about your choosing art and going to art school, initially?

MORRIS: Well, again, it was a sense of respect for education, and my high school teacher Glen Lukens went to see my parents and talked to them, and I have to give him credit for talking them into allowing me to go. Because, while there was a family conference over whether I should be allowed to go, it was not a question of they're now going to support me. It was a question of did I have permission to go. So they readily gave that, and after two years at the Chicago Art Institute, I ran out of money. Although I had a job in a restaurant there, it wasn't enough for the whole financial responsibility at the time, because that was right at the middle of the Depression. I wrote to my father and asked whether I could borrow money from him, and he said, "Well, son, I think you better come home and we'll talk about it." I knew what that meant. He didn't want to tell me no. So I went to the office of the Chicago Art Institute, to find out whether there were any scholarships or anything available, and they told me, "Well, there's a scholarship through the Institute of International Education in Vienna," and I applied for it and got it. Meanwhile, I got a summer job as a professional wheelbarrow

pusher on a cement job in the harbor, where they were building a breakwater. I got enough money from that for a round-trip ticket to Europe.

RCAC: Did the scholarship over there pay for room and board and supplies, as well as tuition?

MORRIS: No, it didn't pay for all of that, but all the time I was over there, I was fortunate to find out that there were always people who wanted to have conversational English, and I certainly wasn't going to give them an academic training, but I had magazines that were sent from the United States. I would read them, and then whoever was working with me would read them, and then I would be invited to their house, and over dinner we would have conversation in English. And this worked in Vienna and it worked in Paris. I spent two years in Vienna and one year in Paris, and what was very interesting to me was that in Paris my student was the minister of finance. And the rapport that we had with one another and his family around the dinner table was broad. We were able to talk about art; we were able to talk about music. We were able to talk about things that were written in *Time* magazine, and he was particularly interested in conversation that he could use in business dealings. He had a pretty good control of English, but he was not aware of the colloquialisms that appear a great deal in our news magazines. And so this is mainly what we were working with.

RCAC: Going back to childhood again for a moment, in grade school were there any particular educational experiences that provided you with either validation or approval, or disapproval?

MORRIS: There were no classes that I would suggest had any value in the arts whatsoever. I think the kind of experience that I mentioned first, the bringing in of the flower and copying the flower, probably did more harm than good. It didn't open up the world of art. It actually separated the boys from the girls, which I think is not a current attitude, but at that time it was. And it was very difficult. I mean, once I announced that I was going to be an artist, there is no question about it, people would look at me out of the corner of their eye, "There's something a little queer about that guy, you know."

RCAC: You mentioned the clay, particularly because of Glen Lukens. Were there other particular art forms that interested you in school?

MORRIS: During art school, yes. I had classes in watercolor and design. I had a friend—the two of us would go in my Model T Ford, we'd drive out in the country or down to Laguna Beach and paint landscapes. He was taking private lessons, so I would go with him. I'd had that experience, exposed to the act of painting, during that time.

But what I failed to mention was that when I got to the Chicago Art Institute, Mrs. French was not available. She was very much involved in the Hull House. I did go to see her, admired her tremendously because she worked with underprivileged children, and I looked up on the ceiling of this tall studio in which she taught, and she saw me looking up there. She said, "Oh, that. Those are little pieces of clay up there because I work with underprivileged children. And they all come in here, and I let them get it all out to begin with, and then they find out that if they work on the wheel or they work with clay, they can take out all of that energy just as well there, and they don't have to fight with one another."

Going back to the Art Institute, they had a basic course there. This included drawing, painting, composition, design, and there were two years of that. Then you could choose an elective after that, but these others were not available to you at all. Once I got into the painting classes, I lost interest in pursuing any work in ceramics. Not that I didn't respect the field of ceramics, but I got very excited about painting, and really the virus went deep, and I've been sick with it ever since.

RCAC: When did you become an artist, and how did you know it?

MORRIS: Next year I'll be eighty years old, and I don't think I've found out yet, but I'm not going to stop searching.

RCAC: Do you think there are any particular clues that will let you know when you have become an artist?

MORRIS: No, and I don't think I'm going to look for it either, because painting is of such excitement to me, is of such reward, that whether it is economically sensible to pursue the world of art or not, it's something that, once I started doing, I couldn't stop. I can't stop now. I've done all sorts of work from truck driving to supervising life raft construction in the shipyards, carpentry work, built our own house, all of those things I've done and have enjoyed. But during all of those things, it was night painting, I was still doing it, because it was not necessarily my work, it was my pleasure.

RCAC: At that point would you have described your occupation as being a painter, even when you were earning your money by these other things?

MORRIS: Well, after I was trained as an artist, yes, certainly. There was no doubt.

RCAC: After high school, at the school of the Art Institute, did you have a liberal arts education along with the foundation courses?

MORRIS: After high school and one year in junior college and after I came back from Europe, I had a year of teaching, and I took extension courses at the University of Chicago. So this was high school, Art

Institute, Vienna, Paris, and then back, and then I was filling in, primarily the humanities. I felt myself starved in that area and had to pick it up. I would have preferred that this training had been coordinated with the artwork. I would have loved it if there had been some classes in, let us say, creative writing. Though I had history of art, classes in philosophy and other humanities were not offered, and that's something that I simply had to pick up on my own.

RCAC: In this period who were your peers, and how important were they to you?

MORRIS: In Chicago there was Francis Chapin; he wasn't very much older than I was at that time, and he had gone to school with David McCosh, who later came to the University of Oregon. I was friends with Francis Chapin there and with David McCosh after I came to Oregon. But when I came from the Chicago Art Institute to the state of Washington, I came as director of an art center in Spokane. At that time there was Clifford Styll, who was teaching at Pullman and then moved over to Seattle, and our closest friend there was Mark Tobey. We became lifelong friends. The exchange we had was great. My wife, Hilda, and I had a houseboat on Lake Union. Lake Union is halfway between the city and the university district, and Mark had his studio in the university district. He was very much interested in Ba'hai. He'd go to Ba'hai meetings in the city, and then he'd be going home by bus, and if he saw a light in our house, he would buy a package of cigarettes and come over to our houseboat, and would probably find us manufacturing cigarettes in what was called a bugle machine at the time, and he'd say, "Put the goddamn things down, and here's a package of cigarettes. Let's talk." He would look at our work—Hilda's sculpture and my painting—and he'd say, "Now I'm all exhilarated. You can't leave me like this. You have to come to my studio." So we came over to his studio, and then we would look at his work. This was a favorite phrase of his, "You have to come and look at my work. I don't know what I'm doing." The first time we heard that, he had a painting—for him a large painting, about four by six—and it was very much like El Greco. It wasn't complete, but it also wasn't very good. But over on a straight chair that he was using for an easel, he had quite a number of things that he said, "I don't know, these things are just coming out. I don't know where they're coming from." And he seemed embarrassed to talk about it, but wanted to talk about it, and that was the beginning of his white writing. He hadn't shown them or anything at that time.

RCAC: Do you think that friendship with him and looking at his work influenced your own work?

MORRIS: I was so grounded in the training that I'd had in Europe, in the European tradition, that I saw him as experimenting for his own area, and he was looking in that direction. He was looking toward Paul Klee at that time, the French Purist pictures of Ozenfant, and other artists who were a little ahead of him, but not too much. Lionel Feininger was also a part of that group. Feininger and Mark Tobey became very close friends. I think the only artist that I know of who was a contemporary of Mark Tobey's was Feininger. Otherwise his association was always with younger artists.

RCAC: And do you think that influenced your work a lot?

MORRIS: His attitude toward art—I felt very grateful for that, and his criticism. We had exchanges that were very rewarding. He worked in tempera color almost always, and I was hoping to get him to work with oil paints. I don't know why, because I was working with oil paints. So I would prepare canvases for him, and then I would sit there, mix up paints, put paint on a brush, and hand it to him. And then he would start using that, as long as he wanted to. And then I would hand him the next color. He couldn't choose the color. Nothing of any significance came out of this, but this was the kind of way we talked with one another. We would sit and talk by doing sketches for one another. And that was, to me, extremely rewarding.

RCAC: Did you have any role models or mentors at this time?

MORRIS: No. If you're asking who the artists that I felt, and still feel, are great, I would have to say that the one person that if alive today, and I had the opportunity to meet, is El Greco, the whole transformation of that man's work from the time he worked with Tintoretto, then later when he was working in Rome. One of the paintings that I followed through is his *Christ Driving the Money Changers from the Temple*. If you look at that painting, there is a tiny little window in the back of the painting, and in the painting there are just some suggestions of his clouds. In the foreground it was elaborate, with all of the elegance of the time from the elegant furs, the riches of the robes—that sort of thing was in his paintings at that time, all in the foreground with tremendous detail in the costumes. What was interesting was that as time went on—he went from Italy to Spain, to Madrid—that little window in the back kept getting bigger. The clouds got more prominent. People got in there, and as the people came in, they started to drop their clothes until, finally, you had this tremendous sky, with these wonderful figures in

the foreground. It just absolutely reversed itself in its whole context. This whole development of the artist and the artist finding himself as an individual, where he came from and what he made out of it, has always been, I think, the greatest model to me.

I know Picasso can always be brought up in any context like this. I don't think there's a living artist who doesn't, in some way, owe a debt to Picasso, but I have always felt closer in what I got back immediately from observing the work of El Greco.

RCAC: What materials were you working with at that time?

MORRIS: I was working with oil painting at that time. I work almost entirely with acrylics now.

RCAC: At that point, when you were working with oils, how would you describe your relationship to the materials?

MORRIS: Very intimate. You asked earlier what I did to supplement my income, and I mentioned teaching, but another thing that I did, while I was in Vienna, I manufactured colors and put them in tubes. I learned the process of preparing canvases. I would sell prepared canvas and tube paints. I felt very good about that experience of knowing the material from the inside out. While I did it out of necessity, it was also very good training for me.

RCAC: Do you think your training adequately prepared you for a career as a painter?

MORRIS: Well, I think it was the best that was available at the time, yes. As much as one can be prepared. The moment when a person finds this drive to break away from one's training and go into his own area I think is very significant, because I think every artist has to learn to sing his own song. I think that every person who wants to be an artist is ultimately faced with that period of how do I use my training to find myself. And you keep searching. There are various experiences in my life of exhibitions that have been outstanding; the first one I mentioned was seeing an Orozco painting, the Prometheus. And then later, when I was in Paris, there was a show of Picasso and Gonzalez, the sculptor who was Picasso's teacher. I'm not exactly sure how old Picasso was at that time. I saw the show in 1935, and Picasso already had a reputation. But I saw this artist, who had already accomplished a great deal on his own, with the humility to go and study with somebody to enhance his own experience in the arts, and work with him. Then to see the two of them in a two-man show was a marvelous experience. And then, I have to say, across the street from the Louvre, at the Orangerie, were the wonderful paintings of Monet, of the water lilies. These are experiences that hit with a wallop, at the time. To walk into the

Orangerie and be surrounded by all of these water lily paintings—it was like being a frog in the pond and seeing the whole thing.

RCAC: Did you at the beginning give yourself certain benchmarks for achievement?

MORRIS: I have to admit to a terrible ignorance here. I didn't have a goal way out there. It went by increments, and I never stopped to figure out, "How am I going to make a living out of this? What am I going to do later? What will I be doing?" After I finished school, I had to face that in a hurry. But the time I was going through this, I didn't compromise my intuitive drive by saying, "Well, how am I going to use this later?" because using it usually means in a commercial sense, and this wasn't in my mind at all. I didn't know how I was going to survive, but I managed to survive.

RCAC: What were the first institutions or organizations you joined as an artist?

MORRIS: Artists Equity.

RCAC: Are you still active today?

MORRIS: Well, I'm a member, but I'm not active beyond being a regular member, contributor.

RCAC: Are there any artists' groups or institutions that provided services you've used, such as insurance or credit?

MORRIS: Artists Equity still continues to send out legal information and that sort of thing. And we're responsible for the fair practices in labeling. That is a very important thing in the sense that there are hazardous materials that are no longer used because of this type of regulation. In Vienna, when I was manufacturing colors, I couldn't for the life of me make a cobalt blue for the price that it was being sold in the stores. I couldn't even manufacture it at that price. So I took a tube of the commercial product to a chemist and had it analyzed, and discovered that the ingredients were ninety percent ultramarine blue, five percent cobalt blue, and five percent titanium white. And that's the way they were able to manufacture it as cobalt blue and undersell. It was a very cheap product. Materials of that sort aren't on the market anymore, because they have to say what they're using. Aside from the cost, the toxic materials that were used artists were totally unaware of—more in sculpture, I think, than in painting—that that's been a tremendous thing for artists.

RCAC: How do you feel about unionization for artists?

MORRIS: I think there are times when organization is the only way to speak with a meaningful voice. I don't think it's possible for individual artists to scream about things that they have in common and do it alone.

RCAC: Have any of the groups that you've been part of, like Artists Equity—have they particularly helped or hindered your progress as an artist, other than the danger signals on health issues?

MORRIS: Well, they were responsible for stopping a practice that was rather common for a long time in the national shows, for instance. Yes, the Philadelphia Museum was typical of what was going on in national shows, at museums throughout the country. Invitations would be sent out, a prospectus would be sent out, and artists submitting work had to pay their shipping at least one way. Some of them were also charged a fee. At show's end the work would be returned by the museums at their expense, if accepted. But—now I'm going to use figures loosely—of the paintings that they presumably were selecting from the entire country, two hundred of them came by invitation, from galleries in New York, and fifty were brought before the jury, and this was not commonly known. Now the artists who were submitting to these shows were paying ten to fifteen times more out of their own pockets than the museum was paying to put on the show. We felt that was unfair, and so the practice was stopped. Now, it may have been a boomerang, because there are very few shows in the country anymore that are national, and this makes it very difficult for younger artists now to be exposed. Today artists are absolutely at the mercy of galleries.

RCAC: When did you first achieve professional recognition?

MORRIS: It was in those national shows and the regional shows, but in the national shows, I was lucky in getting prizes from the San Francisco Museum, Denver Museum, Seattle Museum, Portland Museum, the Metropolitan Museum. Then Pepsi-Cola had a national show, and I was selected out of that for a one-man show in New York. They also gave me a bronze medal that I never figured out exactly how to use!

RCAC: Moving back into a discussion of peers and peer influences, how would you describe the group you rely on as your peers today?

MORRIS: There aren't a great number of them, simply because of age. I have a very close companionship with Bill Ivy. We spend a great deal of time fishing together and looking at one another's work. We respect one another's work. But there was a period of time when Mark Rothko and Mark Tobey were very much companionship. Mark Tobey would come and see us quite frequently when he was in Basel, Switzerland; we went to see him there. When Mark Rothko was living in New York—you know, he originally came from Portland, but he didn't like the reference very much, he became as New York as anyone that I have ever known—we had a close, great relationship. And Jack Tworkov also.

RCAC: And do you think they influenced your career?

MORRIS: All the time. Every time we went back to New York, Mark Rothko was constantly asking, "Why don't you come home? Why don't you come back to New York?" And at one time I said, "Well, Mark, your closest friend is Bob Motherwell. Tell me, what conversation, what exchange do you have in your field?" And he said, "Well, frankly, I'm married, have a couple of kids. Bob Motherwell is married, has a family. We talk about refrigerators and schools." I don't know whether one can talk about a very strong intellectual exchange that goes verbally. It's almost by osmosis that we have an exchange with one another. I mean it. It's the way the guy grunts at your work that shows whether he wants to see this again. It's not talking. Talking to other artists has not given me as great an exchange as I have with musicians and with poets. This has been a strong relationship because there's no inhibition there. We're not talking in one another's field. We're talking about the field of creative expression, and we're not talking materials. And I think that there is often a handicap in companionship with artist to artist in shoptalk, rather than the broader areas. I don't mean that I avoid artists' companionship for this, but I do know that Mark Rothko's remark one time was, "Well, I'm not looking for opinions from other artists. I know where I'm going." Well, I suppose that's an honest way of answering it, that a lot of the rest of us wouldn't say. We don't want somebody else to suddenly tell us what you're doing there.

RCAC: How would you describe your occupation, and is this different from your career?

MORRIS: No, I'm an artist, I'm a painter. That's it.

RCAC: How would you describe your general job history from the beginning until now?

MORRIS: After being trained as an artist, I have taught. I'm not a good long-term teacher; I'm pretty good as a short-term teacher. I have taken guest artist positions at the University of California, in the school in Minneapolis, the University of Illinois, Boulder, Colorado. I've had periods of teaching in all of those places, but when I say I'm not a good long-term teacher, I find myself quite involved with the students, right from the very beginning. And it doesn't end at four or five o'clock in the afternoon. It goes on, practically on a twenty-four-hour basis. After four to six weeks of this, I'm absolutely exhausted and begin to resent the students, because I can't get any work done. But up to that point, the give and take between students and instructor is an even exchange. I get a great deal from it. But I can't sustain that over a long period of time, and knowing that, I don't try, or haven't tried.

RCAC: Do you see any particular pattern or progression throughout your career?

MORRIS: I think there's been a rather consistent pattern from the first paintings that were not entirely literal but figurative, and more literal in that sense of using the figure, that I was getting response to my work for what I felt were the wrong reasons. I would get a literal feedback, rather than a feedback from the visual expression that I was making there. So that became a turning point, because I turned more to abstract use of color and form so that the objects wouldn't get in the way, so that you'd be able to see the painting. Consistent throughout my work is the relationship that I've had to nature. Nature forms have been recurrent in my work from the beginning, and they're still there. I have felt that the more abstract my work became, the more directly it was connected with the subject that I had in my mind than it would be in using figures. That continues today.

RCAC: What have been the discrepancies between your career aspirations and your actual career opportunities?

MORRIS: The Second World War. It stopped everything, except night painting. But that was what everyone was in, so I wasn't unusual in that respect. Also at the time that I was director of the arts center in Spokane, that was so demanding. That happened to be coincidental to the time that Gandhi was very influential, and I discovered that every Monday he set aside for prayer. From there on out, I set every Monday aside for painting, and so I had one day a week painting, and I wouldn't answer the phone, see anybody, or do anything, I thought I owed a debt to God for that.

RCAC: What has been the major turning point in your career?

MORRIS: Well, one major turning point was when I returned from Europe to California. This was in the middle of the Depression, and I got a job at Universal Pictures in Hollywood. And it was one of those situations where few jobs were available, and I happened to know the right person, who got me in and so forth. Their design department looked at my portfolio, and I told them my school record in California and the Chicago Art Institute, the school in Vienna, and in Paris. They looked at all of this. Their one comment was, "Well, you can't blame it on your school, then, can you?" So they gave me a job in their set planning and building. It was a little bit like a model-making shop, a craft shop. It wasn't in their design department, and I worked there for about four or five weeks, and I was given an assignment to go out and tear down five acres of vineyards, because they wanted these long streamers. They were going to wrap them with black cellophane and

drop them from a penthouse, which was a setting for a B movie that they were making, called *Top of the Town,* and these streamers of grapevines that were wrapped in cellophane would sparkle when there were lights on them. There was enough of the farmer in me that I didn't like this abuse of agricultural products. Also at that time, Toscanini was doing background music for Shirley Temple, and I thought, you know, this Hollywood isn't a place for an artist.

I called a sister that I have in California, and I said, "Would you loan me a bus ticket to San Francisco? I've got a commission up there." I'd never been to San Francisco before, but I got on the bus and I went up there, and I managed to survive a year in San Francisco. That was a turning point. Then I applied and got a job that year at the Chicago Art Institute, where I both taught and went to classes. That was a big turning point, because it was a definite commitment. I couldn't push in that other world where the artist was used in such a minor capacity. I felt I couldn't do it.

RCAC: What has been your relationship to money throughout your career?

MORRIS: My relationship has been to take whatever job that I could that didn't interfere with painting. I already mentioned why I can't do a long-term teaching thing, so the jobs that I have done have been in carpentry and the general building trades, and I don't find this lacking in reward. That had a certain value to me. If I could have made peace with the teaching side of it, that would have been one thing, but I was able to make peace with the other, because I have not objected to physical labor.

RCAC: Have the costs of supporting your art changed over time?

MORRIS: Well, I have been lucky. I have lived quite a number of years, far more than the average person, I think, supporting myself by my work. At one time I was actually surviving on prizes.

RCAC: That leads us right into how have grants, awards, competitions affected your career?

MORRIS: This was just before the Second World War, where it was extremely important to get a purchase award in the museum shows. You have to realize, however, that what one could get for the money that one had at that time was a lot compared to what you could have now. Incidentally I had an award for a post office mural through the Treasury Department, and this was just a year before Pearl Harbor. There was an artist, Biddle, who had a brother who was a senator. So the artist went to the senator and said, "Look, the Treasury Department has a budget. And out of this budget, two percent of the money that is for building is

set aside for decoration, and artists have never been a part of this. We're not asking you for any new monies at all. We're simply asking you to stop putting marble, brass spittoons, brass chandeliers, and all of that and open up competition for artists in federal building." So that became the first movement in this percentage for the arts. In any case I won this mural competition, for two paintings at the opposite ends of the post office lobby in Eugene, fifteen feet long and six feet high. For those two paintings I got twenty-five hundred dollars. I had to paint those at night after working ten hours a day in the shipyards, because they wouldn't give me an extension. I had to install them over a weekend, when I pretended sick leave, because I got no time off at that time. At the end of the war, the twenty-five hundred dollars that I had saved from that commission would either move us anyplace we wanted to go in the United States, or we could live on twenty-five hundred dollars for a year, doing our own work. And we gambled on ourselves and, for the most part, have been independent from that time on.

We were living in Portland, went from Spokane to Seattle for two years, and I entered the competition in Seattle. Well, I will tell you this story of that. There were two artists that were in the finals in this regional competition for the Western states. It was a federal grant, and when the local jury selected not me, but my competition, they did so saying if it was for quality of work, there was no question but that they would have selected Carl Morris, but they were selecting this other artist because he reflected the *verdure* of the region and understood the region better. So when this went into the office in Washington, D.C., they said, "Here, here, we never put such restrictions on the artist."

Actually they had made it so free that I remember one of the things they said: You could be as abstract as you liked, even including President Roosevelt's Statement of the Four Freedoms. So they said if this is your recommendation, then we recommend to you that the two artists be allowed to resubmit under your conditions. So they did, and then I won the competition by coming down to Portland, going down to Springfield, going down to Eugene, and doing two panels, one on agriculture and one on timber products.

RCAC: On the verdure.

MORRIS: I'll tell you, after that experience, I decided that I was not very fond of competitions: working with committees and everything else, not a great experience.

RCAC: What kind of control do you exert over your destiny as an artist?

MORRIS: I have complete control. Perhaps I can answer that another way. I feel that it's a little bit like I have a secret, and my secret is my

life, and I don't want anyone to design it for me. I don't want controls over it, and so I don't want to work the routine job. I don't want to live like other people do. I want to live my own life. For this reason I'm not very sympathetic with any artist who chooses to be a crybaby and think that the world owes him a living, because I know I'm perfectly capable of making a living in other areas. I don't choose to do so. I choose to do this, and if there are hardships from time to time, it's my choice. Nobody's put me into it. Yes, I have control of my destiny, because I can always go out to do the other thing, but I keep coming back. I think that it is unfortunate if the artist looks to museums or the government or any other organization as a surrogate mother. We have to be our own parents. We have to choose our own lives. I think with this—the kind of freedom that I am suggesting here is—artists are free to do anything we wish to do, providing we're not doing it for someone else, but we're doing it for ourselves. And the minute we have any control from government or museums or any other organizations, we've lost our soul.

RCAC: Do you think that's true of the NEA and the granting process in all of this?

MORRIS: There's a very great fear there. I think that in the overall picture, the NEA has so much good that it does, that I certainly am not against the NEA. But I am opposed to any kind of restrictions, whatever they might be, that would go beyond the restrictions that an artist would put on himself. And to that extent I feel that it can be a handicap, and it's something that the artist doesn't wish to sell his soul for.

RCAC: How have you interacted with the public throughout your career?

MORRIS: I haven't found it a great difficulty to live the life of an artist. My hope is that in my lifetime, I can give back more than I get out, and I feel that I'm running a losing battle all the time, because I get so much back from the act of producing the work. It's not what I get back from it financially, or get back from it from accolades from other people, but the mere act of doing is such a rich experience to me that that's the reward.

RCAC: What are your own criteria for success as an artist?

MORRIS: I think the most important thing is to please myself, and I find that that's not too difficult. Then the reward from one's peers—the respect of one's peers is very great. But getting back to getting reward from oneself, in the best sense of the word, the act of painting, to me, is a relationship with a canvas that has a personality, and there are times when that canvas is nothing but a limp rag and refuses to talk to me or have any conversation with me, and there's nothing but a battle and a rejection. If I can get some exchange, some intercourse or dialogue

going with that canvas, and this operates and it works, I don't even care whether that canvas is any good the next day.

RCAC: Would you say you have the same criteria for other painters, for other artists?

MORRIS: Yes, I think I do. I think that the artist who is working for goals outside of himself compromises his whole approach. Stanley Kunitz was asked the question, "Who are your companions today?" Well, Stanley is just two or three years older than I am, and his answer to the question, I think, would serve me as well. He said, "Well, I have to tell you that right now, the people that are my age are either dead or quit." And he said, "My companionship are people who are mid-age, who are still working as I am." And I feel that way to a very great extent, that if I want excitement from painting, I want to see those who are beginning to make their statement and are out there finding themselves. I find that search for oneself so exciting. But I think the idea that the artist can ever retire or think that his work is ever done, I am with Stanley Kunitz at that point. Stanley Kunitz is still very active and, I think, one of the greatest poets of our time, and he's still working hard.

RCAC: Are there particular periods of work that you feel more satisfied with than others?

MORRIS: I think it's a disease of all artists to think that the last thing that they worked on or are working on is the best that they ever did, and perhaps that's the thing that keeps us going. But I've always found that subject matter, or what I want to do, is never lacking, because every time I do a canvas, it suggests four or five ideas immediately, and very often, when I get to a point in a canvas, in mid-stage, this canvas could go several ways. I pick out the best of the two and pick up another canvas, try to bring it up to this point, and then I make these two race to the finish line. Sometimes I get two canvases out of this; sometimes I only get one. But the one that I get is going to be better, because I've had those two competing with one another, and I didn't have to give up an idea to do it.

RCAC: What are your feelings about critical review or critical dialogue about your work?

MORRIS: Well, very often those can be very influential to a person, and you can't ignore it. I had a show at one time in San Francisco. It was the first show that I had in a department store. Gump's had a tax write-off gallery, and the person who had it asked me if I wanted to show. I said, "Well, I have a show in Los Angeles that can come to your place." She said, "Well, I have to warn you, I've only sold a couple of watercolors." "Fine," I said, "the show is going to be on its way home.

You can have it." So, she had the show there for a month, and nothing sold, but the day after the show closed, a review by Alfred Frankenstein came out in the *Chronicle*, and it was a very favorable review. She held it over a week, and I sold five paintings. So I can't ignore the fact that reviews are effective. I mean, they can kill an artist and they can support an artist. If you ask whether or not I respect them, I find that all I can answer is that I think we would do better without them. And since we can't do without them, at least we can ignore them.

RCAC: How satisfied are you with your career as an artist?

MORRIS: I have to answer that by repeating myself. The satisfaction is on a daily basis—what satisfaction I've had from the encounter, with the canvas—and I've had a lot of those.

RCAC: What has been the major frustration?

MORRIS: The major frustration has been that I like living in the Northwest, but the Northwest does not give you the casual exposure to museums and exhibitions, and that makes it necessary to do a lot more traveling. But I found I have spent long periods in New York to try to find out whether I could work there, and I am simply comfortable working here. I find that this is a good studio, but I must say that it's not without sacrifice of that other exchange that one has in New York or Paris or Vienna or wherever. I could move today if I want to, and I don't want to move. The location of the studio is the most important thing to me because I have long periods of concentrated work, and then I come out and then I travel. But oftentimes when I am away, when I am in New York or Rome or Paris, I find that I shorten that period of time because I'm not working at the same time, and I want to get back.

RCAC: What has been the effect of the marketplace on your work?

MORRIS: Well, the marketplace has changed so drastically that, when I came back as a student from Europe in 1935, there were no galleries in New York showing work that did not have a European connection. A few included people like Calder and Feininger, who came here to live but were originally from there. But today there are more galleries in Portland, Oregon, than there were in the whole United States when I came back. The marketplace has done two things. It's provided me with a living, but at the same time, galleries have proliferated to the extent that gallery dealers have taken the initiative, and museums as a whole have abdicated responsibility for representing artists of their time. There are very few communities in the entire country that initiate shows and take pride in the people that are produced in their areas. I find that regrettable. But I have to say at the same time that I am indebted to this

change and to the dealers that have worked with my work; I'm indebted to them for providing me with the means of existing.

Honors: Aubrey R. Watzek Award, Lewis and Clark College, 1985; Governor's Awards for the Arts, Oregon Arts Commission and the Governor's Office, 1985; Design Commission for Oregon Symphony Poster, 1976; Master Painter at Port Townsend Summer School of Arts, 1975; Purchase Award, National Drawing Show, 1975; Retrospective Exhibition, awarded by the Ford Foundation, shown nationally, 1960–62; Purchase Award, Ford Foundation, 1960.

Representative collections include: Private: Philip Hart, Fred Rothschild, Diane and Dick Rubenstein, Arlene and Harold Schnitzer, Mary Winch; Corporate: The Bank of the State of Washington (Tacoma), Mead Corp., Safeco Insurance Co. (Seattle); Public: Metropolitan Museum of Art (New York), Museum of Modern Art (New York), Portland Art Museum (OR), San Francisco Art Museum, Seattle Art Museum, Solomon R. Guggenheim Museum (New York), Whitney Museum of American Art (New York).

Professional affiliation: Artists Equity.

JOAN NELSON

B. Torrance, California, 1958. Attended Washington University, St. Louis, Missouri (B.F.A. 1981) and the Brooklyn Museum School, 1981–82. Lives and works in Brooklyn, New York. Exhibits internationally.

RCAC: I want to start by asking you what your initial experiences with art were?

NELSON: Early in childhood? My mother was interested in art and always provided us with lots of scrap paper and pencils. Actually the paper was from my father's workplace. And that was just a form of entertainment while I was growing up. Then I got to high school, and it was the thing I always did best. My other sisters were really good at art too, but they did other things well also. I got out of high school and didn't know what I was going to do. I didn't always think, "I'm going to be an artist." I just wondered how I was going to survive and thought maybe I could do something related to art. Then I went to junior college and they helped instill a seriousness toward art in the students. And then I decided I wanted to be a painter somewhere around that period, the first year of junior college.

RCAC: Would you describe your family to me in your early childhood?

NELSON: There were four girls, all a year apart. I'm the youngest. There was probably a high degree of competition.

RCAC: Do you think that was inherent in your deciding to do what you did?

NELSON: I just always had a desire to really excel at something. I did not really know exactly what. It turned out to be painting.

RCAC: Were you like that in school?

NELSON: Yes, but I wasn't a great student; I was a good student. But I was often considered the class artist, and I always liked to be set apart from the rest of the class.

RCAC: How do you think the members of your family felt about the talent that led you to become an artist?

NELSON: Well, we were all sort of equally talented, some in different ways. One sister was never that interested. She's not very creative, but she's very good at chemistry and things like that. My other sisters were creative—inventing, little cartoons, and things, which I was never good at. I was good at rendering something. I could draw something that I saw, and render it really well, and thought that was really pretty inferior, more machine-like. I didn't really gain confidence until I was in school. Art became a hobby for my sisters. They excelled at other things, as well as art. And I only did well at art.

RCAC: What educational experiences provided you with early validation, or resistances, to being an artist or developing your art?

NELSON: In junior high school I had an art teacher who praised me a lot. I never trusted his opinion. I guess I was getting some form of reinforcement for something I was doing at that age.

RCAC: What art forms interested you in your early education?

NELSON: I always liked drawing more than anything else. My mother provided us with paint, and I painted a little and also sculpted with clay. I would take sculpture classes in school, which I was good at. In high school I really liked to do clay busts. I was commissioned to do a bust of Mahler. My mother was a high school teacher at the time, and a friend of hers in the music department couldn't find a bust of Mahler and provided me with photographs of him. I did a bust, and he was just overjoyed with it. So, it gave me some little boost. Plus I just would do it on my own. I would make clay busts of heads, maybe fictional, or someone I had seen once, or someone whose head I thought was particularly nice.

RCAC: That leads to the next question. When did you become an artist, and how did you know?

NELSON: I don't know. I think I was taking myself seriously by my junior year of college. I didn't like the painting department. The teachers—they didn't like me. They were all too traditional, so I went to the printmaking department, where they allowed me to do anything

I wanted. And I was making these constructions, these boxes, with little doors that opened with scenarios inside. I think I liked Joseph Cornell.

Anyway, then I started looking at magazines and realizing there was a whole entire art world. I was in a group show then, at a little cooperative gallery. It was an invitational show, and it was extremely exciting when I was still in college. It got reviewed in the St. Louis newspaper. Maybe that's when I started to consider myself an artist. It was just an attitude I started to take toward doing the work; I started to take it seriously and wanted to express something. It was probably a little before that, when I was trying to gain admission into the university. I put together a portfolio. I had taken off a semester of school. I took off two semesters of college for various reasons—one to make some money, and also illness. And I did art. It was completely my own structure and motivation. That's when I had to take it seriously. It wasn't like I was doing it for anyone else. I felt like I had to choose some way of expressing my own vision.

RCAC: When did you begin to specialize in painting?

NELSON: I think my senior year in college. I was doing collages that had painting in them. I did some paintings on velvet. I think I did painting on sponges. I would make some sort of large structure with varied objects and things glued together, and then do some painting on that. I think that the paintings I did in my last year of school were exploring freedom. I realized I could do anything I want, so I was trying to do everything, anything. And then I got more specialized, doing a little more straight painting, but I still had peculiar shaped structures I was painting on.

RCAC: Where did you go after high school? You went to junior college and then college?

NELSON: Uh, huh.

RCAC: And did you go to study art?

NELSON: Yeah. I always took the fine arts curriculum. And I had to pick a major and did choose painting pretty early on.

RCAC: Were peers important to you at this point, right after high school?

NELSON: No, not really. I sort of lost contact with my best friends. They went away to school to study. One friend was interested in art but really couldn't imagine it being useful. I met Don, the man I still live with, in junior college, and he was important to me as a peer.

RCAC: How did he influence you as an artist do you think?

NELSON: He was two years older than me and was already taking it very seriously. When I first met him, I thought he was a bit silly for taking

art so seriously, for taking himself so seriously. He had exposure to the outside world, but through magazines that I had no idea existed. He sort of turned me on to them. The teachers at the junior college were very serious and also artists. It wasn't really my peers at that time that I was influenced by.

RCAC: What qualities did you feel you needed most during that period? Physical stamina? Mental discipline? Anything else?

NELSON: Well, mostly mental discipline, some sort of concentration.

RCAC: What materials were you working with when you were just out of high school?

NELSON: Well, of course there were requirements. I was doing a lot of drawing—figure drawing and figure study. There was another drawing course that wasn't figure drawing and some design courses. But mostly I was interested in drawing. And in the summer I would do a lot of drawing and a little painting. I didn't take any sculpture or anything three-dimensional.

RCAC: Do you think your training during the post–high school period adequately prepared you for your career?

NELSON: No. I don't know if it's the state of colleges, universities, but they seem to need your money so badly that they don't want to discourage you in any way. So all you have to do basically is show up, and not even that often. And I wasn't provided with an adequate studio space. It was an expensive school too. Washington University was where I went the last two years of school. I had some good instructors that were very encouraging, and would direct you and guide you to look at certain artists they felt would be good for your work at that time.

RCAC: Is your criticism that they weren't hard enough on you?

NELSON: They weren't, but I don't object to that style of education. It's just that, I think, maybe two students had that sort of self-motivation in our class. The rest of the students really would have needed more structure and some sort of push, some motivation outside of themselves.

RCAC: Did you give yourself certain benchmarks for achievement when you began your career—like I want to be X in five years or here in X years?

NELSON: No. I mean, it was just hope. I didn't have strict goals set or anything. I thought it would be fantastic if anything happened.

RCAC: What were the first organizations you joined as an artist, and which ones are you active in now?

NELSON: Organizations? I think I only joined one, the New York Artists Equity, just to get a group insurance rate. And I'm not active in it. I think they do provide other services.

RCAC: How do you feel about unionization for artists?

NELSON: I don't know. I don't know exactly what that would entail. I don't really understand the necessity of it. There probably is one for a big group of people, but I think it's sort of every man for himself. That's inherent in art. You're going to be isolated and on your own.

RCAC: Describe the period in which you think you first achieved professional recognition.

NELSON: In 1982 I was in a group show at Nature Morte, which at the time was a couple of guys out of college. They later became a really pretty respected gallery, a hip gallery. But in 1982 this was a little group show, and it got reviewed by Nicholas Moufferage, and I thought that was extremely exciting. Later on I put that in my résumé, and other people were really impressed by it. I always wanted to explain, no, it was just really this little group show. They wouldn't actually read the article; it was just like two lines. It was really funny, but that sort of impressed people in a really weird way, because it was really like a fluke. For one thing the show was a summer group show by a couple of guys with a storefront, sort of having fun. And then they became something different. I think Nicholas Moufferage became more respected, but at the time was just a guy writing reviews. I think it was reviewed in the *Voice* or something. So at the time it was no big deal, but it was enough to have them pay a little attention to my work.

RCAC: How would you describe the group you rely on now as your peers?

NELSON: Most of them are pretty serious about their work. Most of them do very mature work. Only one good friend shows with regularity in a pretty good gallery, and most of my friends have a really hard time getting shows, getting decent gallery representation. Some have never shown before.

RCAC: Is this the same group of people you have been with for a long time?

NELSON: A few friends are from college, others are just sort of from mutual acquaintances from years back, from St. Louis, I guess. Other ones I've known maybe five or six years through the art world.

RCAC: How do you think that these people have influenced your career?

NELSON: My career, or my work? They've influenced my work—we work sort of similarly. We're all interested in materials a lot, and like to look at each other's work and see what each other is doing. We talk shop—very boring. They're very influential.

RCAC: How would you describe your occupation? Is it different from the way you describe your career?

NELSON: Yeah. I think of my career as the business aspect. Maybe it's just terminology to distinguish it. I think of career as something that I didn't, and don't, have a lot of control over. I make the work, and then somehow the career part, I would say, is the gallery, the dealings with the gallery, and pretty much just what happens with them. And also what happens with media attention in publications and things like that. I mean, I can continue doing my work unchangeably; that has a life of its own.

RCAC: So what's your occupation?

NELSON: Well, just to be a painter and just to paint. I'm in the fortunate position where that's really all I have to do. Somebody else takes care of the rest—right now anyway. Knock wood.

RCAC: Describe your job history from the time you began your career.

NELSON: When I was in college, I worked in the photo industry mounting slides, and then I did photo restoration, and then in order to make money to move from St. Louis to New York, I did some little waitressing that summer, thinking that when I moved to New York, maybe I could get work as a waitress. I wasn't successful at getting a job here as a waitress, so I did housecleaning. I had also been housecleaning for my sister all through college—and my mother sometimes—to make extra money. Then I did housecleaning for four or five years. The pay was pretty good. I had to work a lot, to make ends meet. It's extremely hard work, especially if you're really good at it. I was really good at it. It ended up where I got good paying jobs where I would work three days a week and be able to paint the other four days a week. I think that's really essential, if you're going to try to do your work, to only work, maximum, three days a week, if you can really swing it.

RCAC: Describe the gatekeepers at various stages of your career—those people who you felt really let you in, and those who barred your way.

NELSON: I'm afraid I can't remember who barred my way right now. I guess lots of people. I think, typically you take your slides or send them to lots and lots of galleries, whenever you hear from somebody else that they're looking, or you just take a shot at sending to as many galleries as you can. And you get lots and lots of rejections. I can't remember who they were now, but then, I guess, I just sent slides to PPOW Gallery, and they came and looked at the work and eventually put me in a group show. After that anyone that looked at my work did it through them.

RCAC: What have been the discrepancies between your career aspirations and your actual opportunities?

NELSON: I don't know; I achieved so much more than I ever hoped for. I guess there isn't any discrepancy there. I mean, the only thing I wish

for is to show more places at once, all the time, and that's a lot to hope for. Besides, it's probably not such a good idea. A lot of people will become bored and oversaturated.

RCAC: You've had several galleries?

NELSON: Technically I've had two: PPOW, which I was with for two years, then did a show with Joe Fawbush, but was never considered his artist. Our agreement was just a one-show representation. Things happened through him, where he acted as my representative. And now there's Robert Miller, and then Michael Kohn, all along since 1986, in Los Angeles.

RCAC: What's been the major turning point in your career to this point?

NELSON: I don't know; I might find out later, but I really don't know. People suggested it was this Guggenheim show that I was in. I guess it was a good thing to be in it, a museum show, a museum in New York. I guess a lot of people ended up seeing it. But I thought the Whitney Biennial would be a real high-exposure thing. I really heard sort of nothing from it. I didn't get any feedback yet. I don't know.

RCAC: How do you feel about getting the work into large institutions?

NELSON: I like it. I think it's important. It depends on the institution, there's a lot of different reputations. But it's really exciting, because it's such a high-exposure thing, plus a museum show usually lasts longer than a gallery show, and, I guess, just a lot more people see it. I mean, the crowd that goes to galleries is a pretty sophisticated crowd. The crowd that goes to museums is much broader. I like to have as broad an audience as possible.

RCAC: What's been your relationship to money throughout your career?

NELSON: I've been lucky in that people have been willing to spend money for my work. I mean, I wouldn't like to still be cleaning houses. I've been paid well for my work. I think the first time I sold paintings, I almost felt guilty or something. I still do sometimes.

RCAC: Why do you feel guilty?

NELSON: Because I was doing the thing I liked to do most in the world and then getting paid for it on top of that. It was something I was going to do anyway. So it was like being paid twice or something.

RCAC: How has the cost of supporting your art changed over time?

NELSON: I think I use better materials, but it doesn't cost really that much more. One of the motivations for doing small work was that I only had a small space to work in, and it's a lot cheaper if you don't use as much paint. But I also liked the idea of frugality, being economically conservative. It ended up I like working in that size; it's a good size for me. I've developed small motor skills.

RCAC: How big are the average canvases or surfaces that you work on?

NELSON: Well, right now they range in size from seven inches square to thirty-six inches square, something like that.

RCAC: What have been your own criteria for success as an artist?

NELSON: To work a lot and try to maintain consistent, good quality, which means whatever I consider to be good quality. I usually have sort of high standards. At first I thought to work a lot I would have to work eight hours, hopefully seven days a week. But realistically I can't maintain whatever it takes to work that long. I run out of steam. So I'm really lucky if I can work five days a week, from three to five hours.

RCAC: Are your criteria different for other artists than for yourself, as far as success?

NELSON: I don't know. As long as they're still interested in their own work, then I guess they're successful. I don't think people have to work a lot; I don't think they have to produce much work. But if they're doing their best, and they're working very hard at it, taking it very seriously, I guess that's success.

RCAC: We were talking about supporting art, and I was wondering, have you had grants or won competitions?

NELSON: I got an NEA grant for five thousand dollars in 1985, and it came in very handy. Other things have been little bits of money for giving talks. I don't think that comes in under the awards or anything.

RCAC: Has there been a particular time when that money would have been really helpful?

NELSON: It was helpful at the time. It was a little bit before I quit housecleaning, and it made me decide to quit. It allowed me to quit my job and work full-time on painting. I was starting to sell some work, but I thought maybe it was just a fluke or something. It was nice.

RCAC: What's the importance of physical location and work space at different stages of your career?

NELSON: It's always good to have a decent space to work, and it's good to have privacy. When I was in school, my space was very un-private, too small. The reason I moved to New York was I got this Max Beckmann scholarship. It's a program where you get a studio space for a year, and you're in a class, and the big thrust of it was to visit working artists' studios and talk to them. It was really great. But that studio space was also inadequate in that it wasn't private. It was connected to a school, where they would have classes on the other side of a partition. It was something like a night school, where they had figure-painting classes with lots of retirees or something, hobbyists. After that out of necessity, I worked in my home. It was also too small. That I shared

with Don—one room we shared together, one small room. I always managed to do work anyway; one manages to do work anyway. And then later I had an actual room to myself in the house, which felt like a great luxury for a studio. I like having the studio located within my house. I don't know why. I think it's probably smarter not to, but I enjoyed having it in the house.

RCAC: What kind of control do you feel you exert over your own destiny as an artist?

NELSON: Well, in a way I have near complete control, because all I need to do is work. The only loss of control—and I think all artists have this fear, or my friends do anyway, when we talk—is each time you go in the studio, you just might not be able to work. You might go in and just not have it anymore, or be completely blocked or something. The other aspect of career—I'm in the position of having it taken care of, so I don't need control over that. All you need to do is your work. But I think actually that people—my friends and Don—don't have any control or anything. It's extremely frustrating and really disturbing. They do great work, and it gets ignored. And other people do pretty lousy work and get a lot of attention, and so personally I feel like I have a lot of control.

RCAC: Do you have a number of central ideas that you keep working on through your career?

NELSON: I do. I guess the central idea is that I'm just basically interested in painting. I'm interested in materials, and then I'm interested in what painting is, what constitutes painting, the two-dimensional aspect of it, that it is two dimensions and that you can also create illusion. My format now is landscape, but I don't think it always will be. Right now I am sort of fascinated with depicting space in landscapes. I like depicting sky, because since my painting is about painting, painting nothingness becomes profound. It's not actually nothing, but painting vapor or space or air, sky—sort of painting infinity.

RCAC: Are there particular periods of work that you feel more satisfied with than others?

NELSON: I guess so. I think I'm always a little bit funny about the work I'm doing right now. I guess I feel that's the greatest work, the work I'm doing right now, and everything else is lesser, but I don't know. The work that I did when I felt completely confident about working or when I had a nice block of concentrated time to work, I feel the most positive about it. It doesn't really have to do with the end result. If the paintings are better, it's how I felt when I was doing the painting and what I was discovering, and I guess that's really important.

RCAC: What are your feelings about critical review of your work?

NELSON: I think it's important to get it, but a lot of times I prefer not to read it, because it becomes emotional. I think a lot of critical reviews and things have so much more to do with the person writing them. And they have a lot to do with the written word, which might not have a whole lot to do with just the relationship between the viewer and the painting. On a cognitive level I think it's completely unnecessary. But then I think I enjoy getting reviews, and it's good to get attention.

RCAC: What about critical dialogue, exchange of ideas?

NELSON: Oh, well, that's really important, but it's always with my peers or someone that's already in my corner, or we're in each other's corner. That doesn't necessarily mean it has to be like cheerleading. It's important, but it doesn't really occur between a stranger and myself, unless it's maybe an interview, but then the questions are very led.

RCAC: How satisfied are you with your career as an artist?

NELSON: I'm very satisfied with it. I considered myself to sort of have early success, and there have been times when I feel like I've achieved what I set out to achieve or more, so what's left? And why continue? But that doesn't have much to do with just me and the studio, that kind of growth, continuing to learn.

RCAC: What do you think have been the major frustrations or resistances to your professional development?

NELSON: I don't know, just sort of internal things. I haven't enjoyed complete mental health, but really, I don't know what outside things. It was hard when I was cleaning houses.

RCAC: How do you think artists are perceived in this society?

NELSON: Right now I think it's considered really glamorous in one way, with the media. There's lots of ads on television and in magazines, the glamorous *Vogue* model type as an artist. I can't think of what the products are, but I think it's considered really chic, ultra-chic. Then on the other end, there's this whole other, the Jesse Helms view of artists, that they're, you know, like self-indulgent children. I don't know— weirdos basically.

RCAC: Where would you place yourself on that spectrum?

NELSON: I think generally if you meet somebody and they say, "What do you do?" and you say, "I'm an artist," that seems to really satisfy them. I've had people say, "Oh, I like that." And most people don't care. Success is almost a disappointment to them, being able to make money at it is almost considered bogus. But just to say you're an artist, most people will take you completely at your word; if you say you're an artist, you are an artist, which I agree with. And they respect you for it. I think it's considered interesting. It's not just a job.

RCAC: So if you say you're an artist, are you an artist?

NELSON: Well, if you are doing art, I suppose you are. If you're a loan officer and you say you're an artist, and you're not doing art, that's not enough. It has to do with intent, I suppose. I don't know what is the judge. I would say it would be up to oneself, the individual.

RCAC: What do you think has been the greatest satisfaction in your career?

NELSON: I've been lucky to receive a lot of exposure, and it's been good to meet people that appreciate my work. It's such a great luxury to have other people be interested in what comes out of my subconscious, have other people applaud it. It's an incredible position to be in, to have other people appreciate sort of your intuition. It's like you expose what is essentially you and then have other people say, "Yeah, it's great." Probably it's a real infantile pleasure. Besides that, meeting other artists has been really great, and other people in the art world.

RCAC: What about the greatest disappointment?

NELSON: I don't know, I guess it's just sort of a flip side. It seems like there is a lot of jealousy, and I think there are people that feel like you've got what they deserve. A lot of people are pissed; they take it personally. Your success points out their lack of success. I don't mean success, but your acclaim, your recognition was something unfairly gotten. They're not responding to your work; they're thinking more about you and what it has to do with them.

RCAC: What has been the effect of the marketplace on your work?

NELSON: I don't know, but I think I'm going to find out soon. There's a big recession coming. Really, I've heard it from all sides—to start saving, stop spending, because this huge recession is going to hit hard in the art world. And I heard that a few years ago. I'm sure it does have an effect. I don't see it in a real context the way the galleries do, and I think they try to shield the artist from it, but it slips out that they're frightened. They try to caution the artist in a gentle way. They just talk of their own fear about it in general. The people I'm thinking of, Michael Kohn, my dealer in L.A., just said that it's been very hard for him to sell work, and I think that includes everybody. And the other day I asked Robert Miller how it was going, and he said, "Well, not too well." He said, "You know, we might be heading into a war, and we have a nation that can't pay its debt, and people just aren't willing to be free with their money right now." He was just saying there's sort of general fear and belt tightening, and later he came back and said, "But there are still people that want your work, Joan." I think he was hoping I wouldn't become too nervous to work.

RCAC: Have your absolute basic requirements for being able to do your work changed since your early career, and if so, how?

NELSON: I suppose they have. I mean, I could change them back if I had to, but I've gotten used to a certain amount of luxury, like being able to structure my day. I realize I work best in the morning, and I can structure my time so that I can work in the morning. I don't have a job to interfere with that. I haven't needed to get a larger space, but I could if I wanted.

RCAC: What one major point would you like to make to young painters about pursuing a career in the arts?

NELSON: Expect it to take a long time. Only be interested in doing your work. I mean, the only area you have control over is to just keep doing your work. That's all you can do. And then the career part—I guess you have to keep up with that too unfortunately, the slide schlepping and all that.

Honors: National Endowment for the Arts Grant, 1985; Max Beckmann Memorial Scholarship, Brooklyn Museum School, 1981–82; Elliot Scholar, 1981.

Representative collections include: Private: Robert Doran Boston, Edwin Cohen, Danheisser Foundation, Douglas S. Gravier Foundation, Ruth Kaufman; Corporate: Chase Manhattan Bank (New York), Exxon Corp. (New York), McCrory Corp. (New York), Progressive Corp. (Cleveland); Public: Archer M. Huntington Art Gallery, University of Texas at Austin, Hirshhorn Museum and Sculpture Garden, Smithsonian Institution (Washington, DC), Los Angeles County Museum of Art, Minneapolis Museum of Art, Museum of Modern Art (New York), Solomon R. Guggenheim Museum (New York), Toledo Museum of Art (OH).

Professional affiliations: New York Artists Equity, New York Foundation for the Arts, adviser.

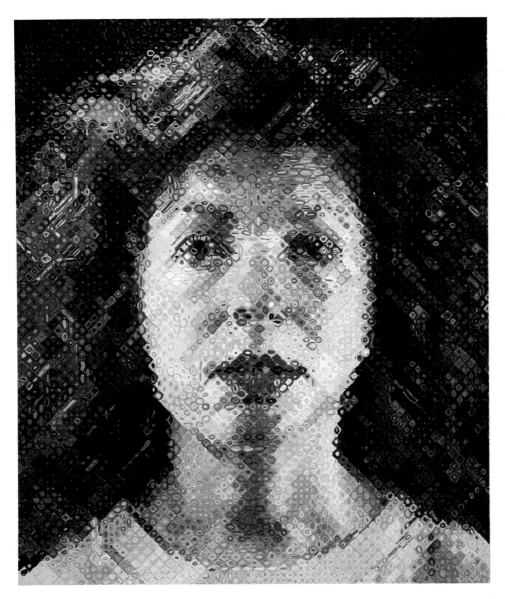

Chuck Close *April* 1990-91. Oil on canvas, 100 × 84″. Photograph by Bill Jacobson. Courtesy of The Pace Gallery.

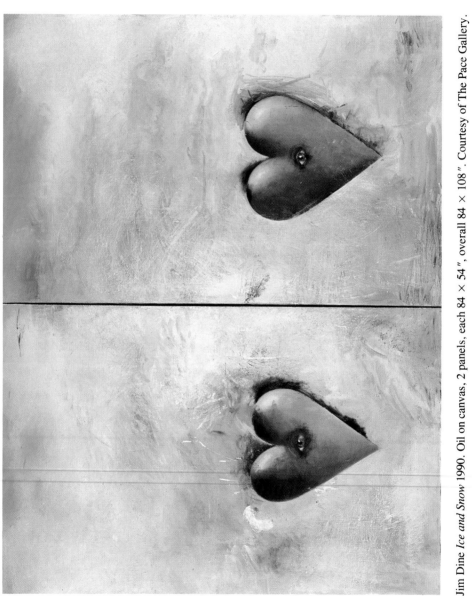

Jim Dine *Ice and Snow* 1990. Oil on canvas, 2 panels, each 84 × 54″, overall 84 × 108″. Courtesy of The Pace Gallery.

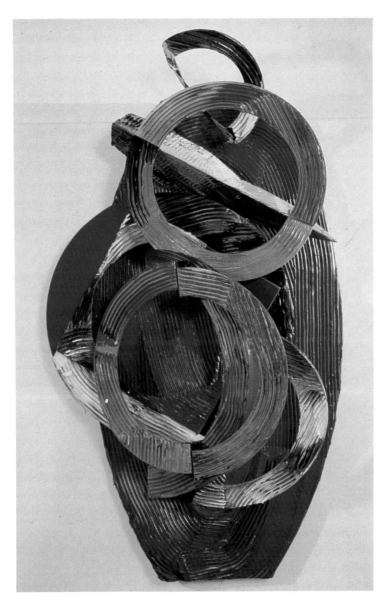

Sam Gilliam *Around a Circular Dining Room Table* 1990. 81½ × 53 × 26″. Courtesy Sam Gilliam.

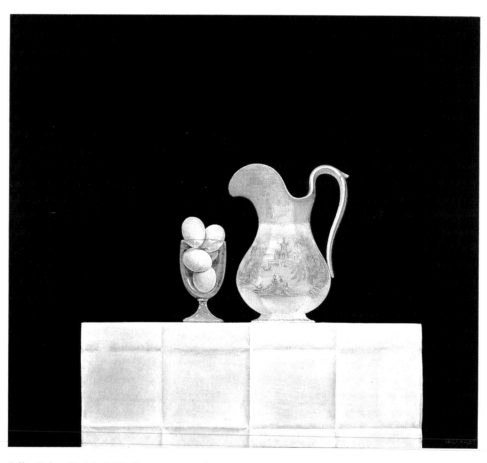

Sally Haley *Untitled (Pitcher, eggs in glass)* 1990. Acrylic on linen, 41 × 46 ″. Photograph by David L. Browne. Collection of Mr. and Mrs. John Bates. Courtesy of Sally Haley and The Laura Russo Gallery.

Al Held *Untitled B* 1992. Acrylic on canvas, 5 × 5′. Courtesy Andre Emmerich Gallery, New York.

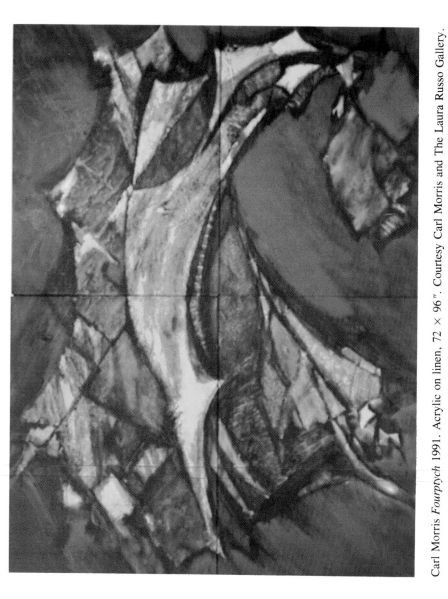

Carl Morris *Fourptych* 1991. Acrylic on linen, 72 × 96". Courtesy Carl Morris and The Laura Russo Gallery.

Joan Nelson *Untitled (After Thomas Doughty)* 1991. Gouache/paper, 2½ × 3″.
Courtesy of the Robert Miller Gallery, New York.

Barbara Noah *Reverie* 1990. Oil on photo emulsion on paper, wenge, 67 × 33⅜ × 1³⁄₁₆″. Photograph by Tom McMackin, Nance Calderwood. Collection of the Washington State Arts Commission. Copyright 1990 Barbara Noah.

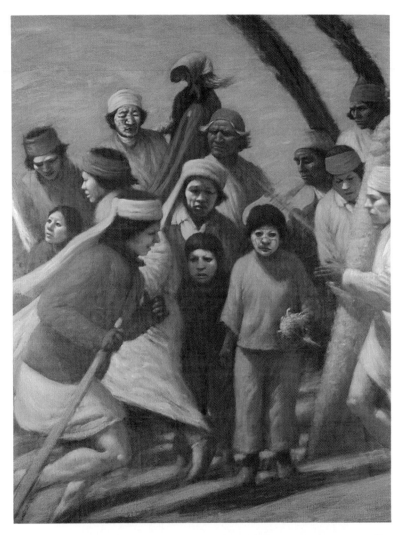

Elias Rivera *Tarahumara Dance Ritual* 1992. 5½ × 4½'. Courtesy Elias Rivera.

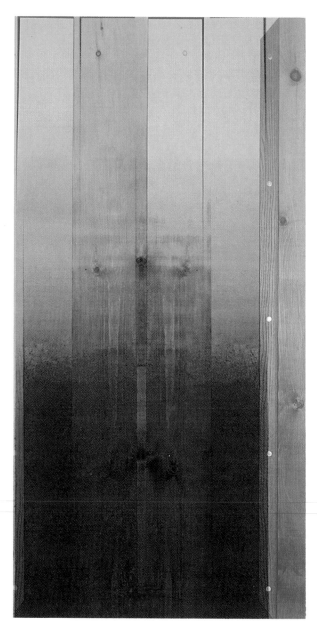

Dan Smajo-Ramirez *Contemplation Unus* 1990. Mixed media on canvas, 90 × 45¼ ″. Courtesy Dan Smajo-Ramirez.

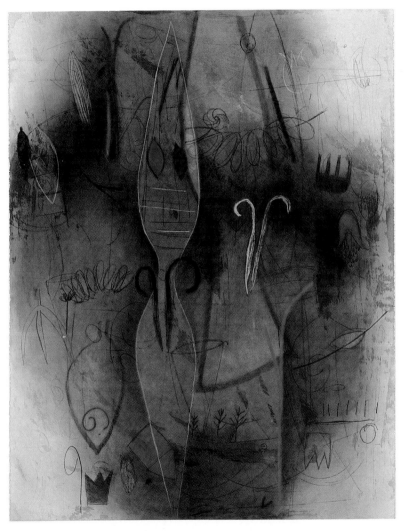

Emmi Whitehorse *Tsin Tah (Amidst Forest) I* 1992. Oil on paper on canvas, 51 × 39½ ". Courtesy Emmi Whitehorse.

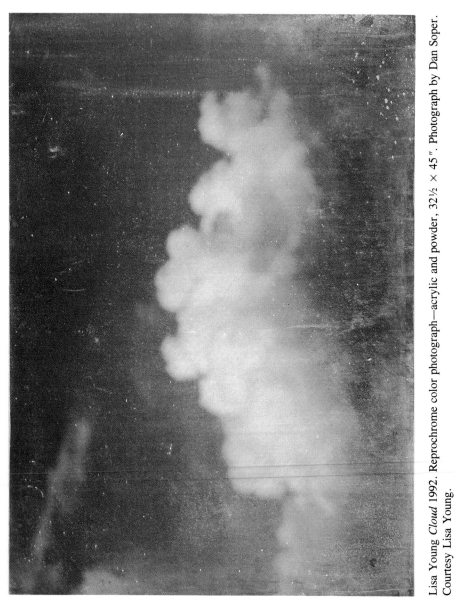

Lisa Young *Cloud* 1992. Reprochrome color photograph—acrylic and powder, 32½ × 45″. Photograph by Dan Soper. Courtesy Lisa Young.

BARBARA NOAH

B. Seattle, Washington, 1949. Attended the University of Washington, Seattle, 1969; Mills College (B.A. Honors, 1971), and Pratt Institute (M.F.A., 1975). Has taught art history, drawing, and painting since 1975. Lives and works in Seattle, Washington. Exhibits nationally.

RCAC: What were your initial experiences with art?

NOAH: Well, when I was three I painted a car that I wasn't supposed to paint. It was a neighbor's car. It was actually a neighborhood kid's father's car, and it was the kid's idea, but I did it too. We painted it with yellow house paint. I think we got half of it painted before we got caught. Other than that, as is the case with most people in the United States, I didn't have a very good art education up through school, so I was just interested in drawing on my own. I used to watch an old TV show—John Nagy's "Learn to Draw"—and I copied some of the drawings out of this book that he published. It came in a game set, and in sixth grade I knew perspective because of John Nagy, so I guess I was sort of advanced visually, but I didn't have any schooling to support that. So I just used to make pictures mostly on my own.

RCAC: How would you describe your family in early childhood?

NOAH: Mother, father, three daughters, pretty cultural in terms of music only, not visual arts. I hardly ever went to museums. I saw one art show when I was in sixth grade at the World's Fair. I remember liking an Ad Reinhardt painting there. I didn't remember the name, but I remember

liking it and that there were people making fun of it. It was one of the ones with twelve different shades of black or blue. But people in my family weren't making fun of it; other people at the exhibition were.

RCAC: Did you grow up here in Seattle?

NOAH: Yeah.

RCAC: And where did you come in the three sisters?

NOAH: Middle.

RCAC: Is either of the others involved in visual arts now?

NOAH: My older sister actually has never been involved in it formal education–wise, but she's talented that way. My younger sister's into crafts and also is very good visually. But neither of them really makes art. My younger sister does things like designing needlepoint.

RCAC: Were your parents musicians?

NOAH: No, but they both played piano. And they had us taking music lessons—outside regular school too—and used to take us to the symphony sometimes.

RCAC: Have you continued any of your music?

NOAH: I have an interest in it, but I haven't continued playing. I played viola and piano. I took piano for four years and viola for nine years, and I was pretty good, but I ended up just not having time to do it.

RCAC: How did the members of your family feel about the talent that you showed?

NOAH: They encouraged it. They were actually very nondirecting parents. They never said you shouldn't be an artist, which some people's parents do. I notice that as an art teacher now, that there are students who will say that they don't get very much support from family. I think mostly because the culture's so obsessed with making money. And most people who are artists don't make that much money—I mean, the vast majority. That's probably why. But my folks never did that. They were always very open with all three of us and said that we should just do what we really want to do. It's not necessarily the same now though. My mother particularly, every once in a while, says, "Wouldn't you like to do something else?" You know, it's after she's seeing what it takes to be an artist that she says that. She knows it's hard.

RCAC: What educational experiences provided you with early validation?

NOAH: Actually most of them really didn't.

RCAC: Were there any particular resistances?

NOAH: The one I remember the earliest was first grade, when my first grade teacher was having us draw pictures. I was drawing a picture of a house, and I was making every side of the house a different color, and

she came up to my desk and loudly said, "Houses are only two colors, and if you don't change it, you're going to fail." I clearly still remember this. People in grade school knew that I was talented at art, and so when I was in sixth grade that same teacher asked me to come back and show her first grade class at that time how to cut out Christmas trees—you know, fold a piece of green paper in half and do this. And I did it, and I don't remember now how I did it wrong, but I did it some way she thought was wrong. She did the same thing again, "No, that's not how Christmas trees are."

I actually think this kind of thing happens to most people in their art education in most primary and secondary schools. Seattle public schools are pretty good, so it's not that the public schools aren't okay. It's just that in most schools in the country, art is considered very, very secondary. It's the first thing to go with the budget cuts. You know, people take art because they want to get an easy A. It's not really taken seriously. And it seems like what they teach isn't so hot either. I can say that from having taught at three different universities. Those were experiences that I had in grade school. But I did get feedback from my teachers—generally, "Oh, well, that's a nice picture." I remember more negative things and bad things though.

RCAC: What about your classmates? Did you get any validation from them?

NOAH: I don't remember it that well, but I know I did.

RCAC: Did you spend much time drawing, painting on your own?

NOAH: I drew a lot on my own—more in grade school actually than I did in junior high. In high school I didn't have as much time.

RCAC: What art forms particularly interested you in grade school?

NOAH: Mostly drawing and coloring.

RCAC: How about in high school, did you get much better art education?

NOAH: I didn't take any art in high school. I thought I was going to be a marine biologist until I was a senior. And for some unknown reason—I honestly don't know why—I just suddenly thought one day, "I think I'll be an artist." I don't remember when it was in senior year, but it was like a bolt of lightning. No rational reason for it.

RCAC: When did you become an artist, and how did you know?

NOAH: I don't think I really became an artist until I got out of college, because I didn't get a very good art education in college either. I don't think I did. It was sort of a semi-okay one, and it's actually a school that was renowned for certain aspects of its art department, particularly its graduate school.

RCAC: Where did you go to college?

NOAH: Mills College in Oakland, California. I started out as an art major in college.

RCAC: When did you begin to specialize in your current art form?

NOAH: In graduate school. It's actually a combination of painting and photography and sometimes sculpture. In the recent past there haven't been sculptural elements.

RCAC: Where did you go to graduate school?

NOAH: At Pratt Institute in Brooklyn.

RCAC: And what other subjects in college interested you?

NOAH: I minored in biology. I still am very interested in science. I actually think art and science are very similar, in terms of how you go about making something or researching something. The practice is very similar. The research side of science, I think, is very much like art exploration. It's creative.

RCAC: Describe the importance of peers to you in this time after high school.

NOAH: Well, in college my peers were not other artists. My peers actually were the people who lived in the same building I did because of the situation. At Mills everybody lived in the dormitory until they were seniors, and then you hung out with the same people after that anyway. Friends were my peers, people that I lived near. And I don't think any of them, come to think of it, were artists. And they were important like friends are important—you know, feedback, support, communication, not about art particularly. And then after that, when I went to graduate school and since then, most of my friends are artists. I think that's just because of whatever social situation you get thrown into; that was the situation at Mills, and out in the world I spend so much time going to openings and social events that involve art, that I end up meeting mostly artists. And they're important to talk over life issues, as well as art issues. But I don't particularly depend on anyone to come to my studio and look at my work except for my younger sister; I just don't do that with other artists.

RCAC: After you finished at Pratt, did you stay on in New York?

NOAH: No, I came back here for a year and then lived in L.A. for three years. I don't actually see art in terms of media. And it's too bad that grant institutions like the NEA and schools break things down that way; I think art is art, and you do it in the medium that's appropriate. So I don't think there should be a painter ghetto or a sculpture ghetto or whatever. Part of that might be because I'm a mixed-media artist, but I think I'd think that anyway.

RCAC: Do you think your peers had any particular influence on you?

NOAH: No.

RCAC: Did you have role models or mentors?

NOAH: No. In college I think I would have had one, but one of the instructors I really liked a lot got fired. He probably would have been a mentor for me. But the instructor who was left—I didn't admire his work or anything.

RCAC: What kind of qualities do you feel you needed most during this period, say post-Pratt and the early years in L.A.—personal qualities, physical stamina, mental discipline?

NOAH: Yeah, I need all of those. The trouble with being an artist, as I'm sure you're very familiar, is that most people have to work another job. So you need physical stamina so that you can basically work two jobs. Most artists I know work as hard as corporate executives, if not harder, and get paid like newspaper carriers, or worse. You know, it's kind of insane, why we even do it. And there are, of course, people at the top of the heap who make a lot of money as artists. But that's a tiny percentage. And they're usually not in Seattle. There isn't a big enough art market here for artists to get very well supported. So yeah, you need physical stamina. And you need some sense of perseverance to keep doing it, even when it's uncomfortable. I don't think it's a sense of martyrdom, but you do have to be determined to want to do this.

RCAC: What happened after L.A.?

NOAH: I was there for three years for two teaching jobs and then came back here. They were both visiting positions, and I didn't particularly like L.A., so I came back up here, because I like Seattle. And I think my life is more important than my career as an artist. Otherwise I'd be in New York.

Actually I always thought I was going to go back to New York, because I didn't really want to leave when I left, but I ran out of money, and I was tired of living in a dump. I lived right near Pratt, not on campus but nearby, and it was a pretty rough neighborhood. I didn't feel like living there anymore, but I didn't have money to live in a better neighborhood. So I left. For quite a long time, actually maybe six or seven years, I thought I was going to move back there. And then I just changed my mind, as I matured. I decided that the place where I live was more important to me.

RCAC: What materials were you working with during this period—say, the L.A. period and the early Seattle period?

NOAH: The same ones I'm still working with actually, photography, painting and sculptural elements. I use all different kinds of materials.

RCAC: How do you describe your relationship to these materials?

NOAH: I'm not emotionally intrigued at all by my materials. In fact some of the time I think I'm more conceptually oriented that way. Some of the time I'll like what I'm doing, the process, but I'm actually more interested in the result. I hate doing darkroom work, for instance. I like some aspects of painting, but some aspects of that I don't like either. I think I'm more in tune with the concept, with the idea behind the piece, than I am with the materials—although I'm sensitive enough to them to be able to make decisions about what to use.

RCAC: Do you think your training during this post–high school period adequately prepared you for a career as an artist?

NOAH: No, but I thought graduate school was very good—particularly being in New York. I think being in New York, being able to see lots of art that I really hadn't had an opportunity to see before—I learned more from that than I did from any schooling. But graduate school was probably the best portion of my art education. I thought Pratt prepared me relative to the work itself. And maybe there was a little bit of discussion about what it was like out there in the world—business and social aspects of being an artist, that sort of thing—which I think is important. It takes you a while to find that out on your own.

I actually do that now as a teacher, in the contemporary issues class that I teach—going on studio visits and that sort of thing. We did that in graduate school. But I think it's really important to talk about business licenses and how to write grants and granting sources. And I think a lot of people, including myself, come out of school sort of dewy-eyed. You know, all you see when you're in art history classes is famous art, right? You don't see work done by the millions of people who have been artists and didn't achieve that degree of success—whether it was success during their lifetime or not. So everybody thinks, well, I'm going to be one of *those* people. I think it is sort of a slow but rude awakening that that's not how the world works. And then I think you end up discovering, like I did, that I have other priorities that are more important than that. But there was very little of that at any level of education.

RCAC: Where do you teach now?

NOAH: At Cornish College of the Arts.

RCAC: When you started, did you give yourself certain benchmarks for achievement?

NOAH: I didn't, no.

RCAC: Do you do that now?

NOAH: I remember noticing when I was in graduate school, and I don't remember now how old he was then, Brice Marden had a retrospective at the Guggenheim at a pretty young age. And I remember sort of

thinking of myself in relation to that. I also found out, at the time, that it was pretty young for someone to have a retrospective. And I realized, not too many years after that, that was an improbable benchmark. So I've compared myself to other artists at comparable ages, but no, I don't ever have a long-range plan for myself. There are galleries I'd like to show in—that's what I'm working on at the moment actually—but I don't have a plan of when that's going to happen.

RCAC: What were the first organizations you joined as an artist?

NOAH: I don't think I'm a member of any right now. I think the College Art Association when I got out of school and found out about that. That's a place where you can apply for teaching jobs and so forth. I don't think I'm a member of anything else. I'm a member of Phi Beta Kappa, but that's not an arts organization. And I'm not active; I don't send them dues or anything. There is an organization here, but it's not a matter of my being active in it, that is working on health insurance for artists. It's called Artist Trust. I think it's a good organization, so I thought I'd mention it.

RCAC: Have any institutions helped or hindered your progress particularly as an artist?

NOAH: I think and/or helped it. "And/or" was an arts service organization which doesn't exist anymore. They had exhibitions, a library, and a video facility for editing, and many organizations came out of that. I think it was early eighties that they stopped, because the person who ran it, Anne Focke, didn't want to do it anymore, because she wanted to move on to other things. And other people didn't want to do it either. That organization helped me. They cosponsored a couple of grants that I applied for, and it used to be a good place for artists to hang around and talk to each other. Nothing has replaced it.

RCAC: How do you feel about unionization for artists?

NOAH: I think it would be a good idea, but I don't have any great hopes that it's going to happen—that sort of applies both to teaching and art. There are some unions—we actually have a union at Cornish—but as for unions for artists dealing with galleries, there are so many artists and so few galleries. There are too many, what you might call, scab artists who would just take your place if you left. I don't think that artists are inherently independent, and that they therefore can't organize. But I do think that the financial pie in this country is so small that there is little sense of loyalty among artists.

The gallery system is outrageously unfair to artists, mostly how the business aspects work. Fifty percent? There isn't an agent in another kind of business like that, that takes that high a percentage. I've heard

twenty percent before, for agents for actors and writers and so forth. but fifty percent? I was amazed when that happened, when it changed from sixty/forty to fifty/fifty. I wouldn't show in a gallery that takes sixty percent. I think that's outrageous. I think the artist is responsible and deserves credit for more than forty percent—more like seventy-five percent of the cost of any works.

RCAC: Describe the period in which you first achieved professional recognition as an artist.

NOAH: Probably it happened mostly when I was in Los Angeles. I also wrote art reviews for a while, for *Art in America*. I had written for *Art Week* before that. So L.A., both in terms of writing (which I considered a side thing—it wasn't a big deal) and my work, was probably where I felt like I got some professional success. The first big exhibition in which I was included though was "In Touch: Nature Ritual and Sensuous Art in the Northwest," curated by Lucy Lippard for the Portland Center for the Visual Arts. I was getting asked to be in a lot of shows. It was easy to show in L.A.; you didn't even have to try. It's different being in Seattle; you have to seek out shows to be in, in other parts of the country particularly. You have to constantly be sending slides to curators and so forth. And in L.A., I'd be in one show, and a lot of people'd see it, and three people would invite me to be in something else. And that was actually nice. I showed eight pieces or so in a group show at the San Francisco Museum of Modern Art, after I was back in Seattle, but that happened because of people I had met when I was down there. So networking—which is a word I hate—was much easier down there. Here it practically doesn't exist.

RCAC: Do you have a representative, an agent outside the gallery?

NOAH: I did for a very short time, but not many artists do. I'd like to, but I haven't been able to find someone here who I think either has enough contacts in other parts of the country, or the world, or would be good enough at it. I used to know about Stephen Reichardt, who died a couple of years ago. He and Ann Livet had a business called Livet/Reichardt, and they were agents for artists. A friend of mine used to work for Stephen Reichardt, and he became sort of a model for the kind of person that I was looking for. And I haven't found anyone like that.

RCAC: How many galleries do you have across the country now?

NOAH: I only have a gallery in which I regularly show here. I've shown in different galleries in different cities, but I'm not a regular in any of them. So that means it's still a constant hustle. I think it's difficult for artists here to show in other cities. Because places like L.A. and New York—why would a dealer there want to show someone from here,

when there are so many artists living there or nearby that they can show, the easy access to the studio, no shipping costs? What's their motivation to do it, unless you've already established a reputation, which is next to impossible to do from here?

RCAC: How would you describe the group you rely on now as your peers? Who are they?

NOAH: Mostly artists. I actually wish that weren't the case, because I kind of get sick of art, you know. Art at school, art in my studio, art with my friends. I actually like to branch out beyond that. I'd describe them mostly as other artists, approximately the same age, a few older and a few younger, and in a variety of media.

RCAC: How have your peers influenced your career?

NOAH: Well, close friend peers have not particularly influenced my career. A few have. There are peers who I'm not close to, who may even live in other cities, who have helped me—like someone who's a curator, putting me in a significant show, that kind of thing. Or writers sometimes, art critics.

RCAC: Are you still doing much writing?

NOAH: No. I've been asked to, but I don't want to do it. I don't particularly like the whole notion of art criticism. But not just art criticism. I think this culture is obsessed with criticism, creating hierarchies, deciding what's good and bad. I don't think that's important. I think it's important to explore, not to make decisions about what's good and bad.

RCAC: How would you describe your occupation? And is this different from your career?

NOAH: Well, my occupation is both being an artist and being an art teacher. So my occupation and career, I guess, are the same. If you're talking more in terms of what's my bread and butter, that's teaching. I do make some money from art, but it varies widely from year to year, depending on whether or not I had a show.

Art is more important to me than teaching. I think even if I were able to just work on my work all the time, I'd still want to teach at least one class, because I do find it stimulating. But I'm teaching too much now—and I have to, to make the money. I've actually taught constantly since I got out of graduate school. In fact I could use a sabbatical. I taught at the Bellevue Art Museum School (which doesn't exist anymore) when I first got out of graduate school, and then I taught at Long Beach State, then I taught at U.C.L.A. I'm now at Cornish, and for one year I taught at the University of Washington as a visitor, when one of their people retired all of a sudden.

RCAC: Describe the gatekeepers at various stages of your careers—those who let you in or those who kept you out.

NOAH: Well, there have been both. But the kind of people who have been gatekeepers either way have been people like writers, curators, gallery people. You know, certain people say no to you, and others say yes. And there have been individuals in both camps. I think for most artists, there are more nos than there are yeses. I think most artists have to get used to being rejected and being told no. I think relative to the number of people who apply for grants and that sort of thing, the percentage who get them is very small. So no one can win all the time.

RCAC: Have there been particular discrepancies between your career aspirations and your actual career opportunities?

NOAH: Yes, mostly in terms of wanting to exhibit in more places—you know, have more galleries—which is difficult to do from Seattle. Oh, and the Seattle Art Museum doesn't own any of my work. They will in the future, because there is a collector in town who owns five of my pieces who's going to donate to the museum.

RCAC: Barbara, what have been the major turning points in your career up to this point?

NOAH: A turning point was going to New York and being at Pratt, but mostly being in New York City, getting exposure to a lot of art. Another turning point was going to Los Angeles and becoming involved in art down there. There are certain opportunities which I see as turning points, too, like showing at the San Francisco Museum of Modern Art. And a curator who used to be at the New Museum of Contemporary Art in New York, then at the Hirshhorn, and now the director of the High Museum of Art, Ned Rifkin. He did a show in 1983 called "Outside New York: Seattle," when he was still at the New Museum. And that was a big opportunity and turning point, as was a show in 1982 at New York's Artists' Space.

RCAC: What has been your relationship to money throughout your career?

NOAH: I've never had too much. I have an adequate amount to live okay, but I'm always on the edge. You know, no IRA, no retirement plan at Cornish. I think I worry more about the future than about now. I mean, I have enough money to pay my bills. But my sister being ill actually makes me think about this stuff, because if something like that happened to me, I would really be in trouble. So I would like to be able to make more of it than I have, in order to be able to prepare for emergencies and illness and old age. And I'm totally unprepared for any of those

three, as are most artists I know, unless they're married to someone who's got a good income or have family money.

RCAC: How have the costs of supporting your artwork changed over time?

NOAH: They're going up. A lot of things have increased dramatically— prices of materials. The costs have gone way up since I first started as a professional artist. Not just art supplies, but everything else—insurance.

RCAC: Have you received any grants or awards, competitions?

NOAH: Yeah, no big major ones, a few through "and/or," as I mentioned before. I don't know if they actually got the grant or if I did. But I wrote a grant and they applied for money from the Alvard Foundation, two different years. And I got money for my grant through that. I think they included me and some other people, in the grant that they wrote. When I was in graduate school, I got a Leopold Schepp Foundation fellowship for graduate study. Oh, one other one that was fairly recent. There's an organization called Centrum, that's up in Port Townsend, and they have residencies for artists to use their studio for a month and pay your materials costs. Well, they've obviously helped in one way or another. Either providing me with money to do something—a particular piece or a project—or given me time to work, which is very helpful. I'd like to get more grants than I've gotten, and particularly in the last couple of years, I have applied to everything I could find.

RCAC: Has there been a particular time, or is there one now, when such money would have been most helpful?

NOAH: It's helpful anytime.

RCAC: What kind of control do you exert over your own destiny as an artist?

NOAH: In general the only control is to do what I can. I can't make other people do what I want, which I discovered at a fairly young age— although I would like to be able to. I feel like I have control to a certain degree. I have to make good work, which I think I do. I have to have energy to push myself to keep doing what I have to do, such as send slides out. I mean, there's an incredible amount of paperwork. People don't really realize that. But you know, you really can't control other people's tastes, and whether someone's going to put you in a show or not, and so forth.

So I think I have control and don't have control at the same time, in terms of my destiny. There have been several times in the last ten years when I've considered not making art anymore. In fact I think it's always in the back of my head. It's not because I don't like making art; it's because I don't particularly like the way the art world works, econom-

ically or socially. So the only thing that really keeps me still being an artist is the fact that I like making art. I don't know that I'm always going to, because there are other things that attract me too. They're mostly other creative things—fiction writing, cartooning, inventing games. There are lots of things that I could do instead of doing this that I think are equally creative. But I haven't done them yet. And I think part of it is because it's hard to give art up. I don't think about this consciously. I mean, I don't really know why I keep making art, except that I like the activity. I like being in my studio making things. Everything else about it, I don't like. Also there's no guarantee that the other things that might interest me would provide me with any greater financial security or make me happier. Because they are also in a sense speculative, in the creative field. And unfortunately this culture—in spite of all the lip service, true or not, about the arts being bigger than ever and more people going to museums—is very nonsupportive of the arts in general, especially individual arts.

RCAC: How have you interacted with the public throughout your career?

NOAH: Well, many artists don't generally have much contact with the public, except at their own openings. I actually like contact with the public, including people who don't know much about art. I think part of it is because I don't think I knew much about art until I went to college. I didn't understand abstract content, for instance, until I went to school and/or had more exposure to it. In fact even into college a year or so, I hated abstract art. And it was because most of the people I was around (excluding my family) didn't like it, and so I didn't. You know, it's kind of like being influenced by your parents' politics until you leave home. So I think I understand when people say, "But what does it mean?" I can answer them something like, "Well, when you go see a beautiful sunset, you don't look at it and go, 'Gee, that's a beautiful sunset, but what does it mean?' "

I like talking to people at all levels of sophistication, but I really don't have much contact with them. I remember one incident when I had an installation at the Seattle Public Library and also at the mayor's office. While I was at the library—I was there taking pictures—I would see different people's reactions to the work. And there was a mother who came in with her son; he was probably twelve or thirteen. As they approached the piece, her eyes sort of widened, and she put her hand over his eyes and said, "Don't even look at it." And they went right up the escalator. That made me really laugh. So I don't have contact with the public much, but I like it when I do.

RCAC: What are your own criteria for success as an artist?

NOAH: Probably the same as they are for most people involved in the mainstream art community, and that is being able to exhibit and have your work received well. Although that's not always necessary—the "received well" part of it—because you can get a certain amount of notoriety and attention if people hate the work too. So it's professional recognition like that, as well as, unfortunately, whether or not you're able to make some money from it. Although living in Seattle, that's not considered by me or most other artists I know that necessary or that important as proof that you're successful. Because the financial support here is low.

RCAC: Do you have a number of central ideas you keep working on throughout your career?

NOAH: Central ideas in the work? Yes. There's this definite sensibility that runs throughout it, I think maybe, in terms of extremes. Although it may change formally, the work is about extremes—from humor to pathos—concurrent, not humor in one piece and pathos in another; microscopic, macrocosmic subject matter, the illusion of space and flatness. On a number of levels, I deal with contradictions.

RCAC: Are there particular periods of work that you feel more satisfied with than others?

NOAH: Yes, It's always the latest thing I did, which is a good sign that I'm constantly improving.

RCAC: What are your feelings about critical review of your work?

NOAH: Probably, as with most people, there are some writers who have written about it very well, and others who haven't. And that doesn't necessarily mean whether they liked it or not. But some people can look at the work and see what I mean. And I think that everyone should see that. But I think there are some writers who are rather dense or who have different agendas. But I do think a good writer is somebody who—almost all writers will deny this—is objective, in the sense that there's a difference between "what I like" and "what I recognize as good." I might recognize that something is solid work but doesn't particularly excite me. And whether it excites me or not wouldn't be important to me in terms of judging its merits.

RCAC: How satisfied are you with your career as an artist?

NOAH: I'm satisfied with the work itself. I wish I had more time to do it, I wish I could teach less, and I'm definitely not satisfied with the financial reward.

RCAC: What have been the major frustrations or resistances to your professional development?

NOAH: I've been in Seattle for the last eleven years, so for that last eleven

years, it's been frustrating not having enough access to mainstream art in this country without traveling a lot. Meaning, I can't see it very much here. The Seattle Art Museum doesn't do enough of it. The Henry Art Gallery at the University of Washington is doing more; in fact I think they do a better job. So I don't have that access to seeing other people's art. Being in an out-of-the-way place, it's also harder for me to have access to curators and so forth. They get thousands of things in the mail. And I'm frustrated by the lack of financial reward.

RCAC: How would you describe the greatest satisfaction of your career?

NOAH: I like being in the studio, making work; I really like that part. I used to make nonart things a lot, as a child; I made a great go-cart. And I like being alone in the studio too. I haven't really done any collaborating. But I just like the creative act, and it almost wouldn't matter if it was art or not.

RCAC: What has been the greatest disappointment?

NOAH: It's not necessarily the greatest disappointment, but it's that a lot of the people who buy art are just the people who have enough money to do so. I think the way art functions in culture is anachronistic—visual art, that is—relative to the Industrial Revolution. With sound recordings, a lot of people can buy the record for a little amount of money. Art multiples haven't functioned this way, and poster art is sort of pooh-poohed. Visual art is still very elite. A one-of-a-kind object or even a print is expensive because there's only one or it's a limited edition. I know people can go to museums and galleries and *see* work, that's good. And they don't have to pay to get in—well, they do in museums, but not galleries. But it really bothers me that the only people who can buy my work are people with lots of money.

RCAC: What has been the effect of the marketplace on your work?

NOAH: As far as I can tell, it hasn't had any effect on it whatsoever. I have to make what I make, and it doesn't matter whether it's going to sell or not, which is too bad. It doesn't matter if it fits in with whatever's hot currently either. In fact sometimes I wish it would fit in better, but I can't make that happen.

RCAC: Have your basic requirements for being able to do your work changed since you started?

NOAH: Yeah, it seems like I need more money. And I think it's just because of inflation. It seems like I have less time too.

RCAC: What one major point would you make to young painters about pursuing a career in painting?

NOAH: I'd say, "Don't be a painter unless there's nothing else you want to do." Lots of people go to universities who aren't that serious about

being an artist, but people who go to art school generally are. Because otherwise, why would they be spending all that money going to a private school? So they actually already kind of feel that they really want to do it, find that the financial reward won't likely be good—except for the rare instance of somebody who somehow thinks they're going to make a good living. The mental and emotional rewards though can be great, although aesthetics and snappy conversations won't necessarily put dinner on the table. My advice would be that it's a tough thing to do. And so if there's something else that attracts you too, you might want to pick that.

RCAC: Do you have any other words you'd like to add, things we haven't covered?

NOAH: I'd like to add the stumbling block to my and other women artists' careers. Women artists are not included in exhibitions and collections nearly as much as are men. We are also not as often touted as exceptional talents. This is ironic, considering the fact that the majority—probably about seventy percent of art students—are women. The sexism has of course been written about many times, but I'd like to note that I have felt and observed it in my life too, sometimes in very subtle ways.

I'd also like to note more general themes in my work, including the interconnectedness between diverse ideas or feelings, like the common-place and in the cosmic, humor and pathos, the microscopic and the macrocosmic. Recent work is based on the face-recognition reflex, developed in infancy, wherein three dots in a circle look like a face. I put diverse images together as hair, eyes, and a mouth, and the parts can be seen as memory, history, desire, et cetera. The figure, or being, is then the sum of these parts. All of my work contains an inherent sense of wonder or magic, tempered by an ironic detachment.

Relative to my education at Mills College, I'd like to note that, although in retrospect I do not feel that the art department was strong at that time (1967 to '71), I did receive an excellent liberal arts education there.

Relative to the issues of less time in my life, a contributing factor is that my work gets more complex as time goes by, so it takes longer to make.

And finally a stumbling block for artists living in Seattle, besides the isolation from major art centers and their institutions and publications, is the fact that many people here don't take artists from this area as seriously as they do artists who've established reputations out of town. The standard line is that artists here have to leave town and return (though the latter isn't necessary) to be considered good, let alone

important. This is ridiculous. There are many excellent and original artists here, regardless of geography and reputation.

Honors: Centrum Residency, Fort Worden State Park, Port Townsend, WA, 1988; King County Arts Commission Individual Artist Program Grant, 1988; Merit Award, Betty Bowen Committee, Seattle Art Museum, 1988; Sea First Faculty Excellence Award, Cornish College of the Arts, 1988; Alvord Foundation Grants, 1984, 1982; Distinguished Faculty Award, Cornish College of the Arts, 1982; U.C.L.A. Faculty Research Grant, 1979; Leopold Schepp Foundation Fellowship, 1974–75.

Representative collections include: Private: Lucinda Boone and Andrew Wilson, Anne Gerber, Helen and Max Gurvich, Cathy Hillenbrand, Camilla Nowinsky, James P. and Katherine Olson; Corporate: Hillis, Cairncross, Clark, Martin and Peterson (Seattle), Microsoft (Redmond, WA), Mudge, Rose, Guthrie, Alexander and Ferndon (Los Angeles), Seattle First National Bank; Public: California State University at Long Beach, Black Dolphin Collection, Centrum Foundation Archives (Seattle), City of Seattle, Portable Works Collection, King County, Washington, Northwest Collection, South Kitsap School District (Silverdale, WA), Sultan High School (Sultan, WA), U.C.L.A. Grunewald Print Collection.

ELIAS RIVERA

B. Bronx, New York, 1937. Attended the Art Students League, 1955–61.
Lives and works in Santa Fe, New Mexico.

RCAC: Elias, can you tell me about your initial experiences with art?

RIVERA: I was very deprived of having that experience as a child in my
home, because my parents were very simple people and they were
working. I didn't know what a museum was until I went to high school,
and then I went to the High School of Industrial Arts. Initially I had an
illness called a rheumatic heart, and I had to stay in bed. So my mother
bought some clay, and I started doing these incredible things with clay.
And from that day on, I knew what I was going to do, and it was focused
on being an artist.

But at that time I thought I was an illustrator. Norman Rockwell was
who I knew, and John Peak. So I first went to the High School of
Industrial Arts for two years, and there I just took different courses like
cartooning and illustration, but then I started going to the Art Students
League, and there I realized that there was such a world as fine arts and
music and literature and theater. And it totally encompassed me. And
my first experience of art was really in the Art Students League, and
there I educated myself to what I wanted to do and focus in my life,
essentially away from illustration into the fine arts.

RCAC: Can you tell me a little bit about your family at that point?

RIVERA: My father was a carpenter and a very simple man—not well-

read, not well traveled—and he was a bit of an alcoholic and tended to be little bit violent against my mom in jealous rage. My mom—I wouldn't say she was simple, but life experiences weren't that grand for her. And she had high ambitions for herself but never really pursued; she would have liked to educate herself more, but she didn't. She just worked odd jobs and essentially took care of my upbringing. I'm an only child, so her influence was very strong on me. It was very acceptable to her that I become an illustrator, because it was very tangible. It's a job essentially. Fine arts—there was no comprehension of what that meant, and she had no sense of judging whether I was good or not, capable or not. When I went to the Art Students League, there was an uproar. I had to fight her tooth and nail, because there was no support system. She couldn't evaluate who I was in the context of whether I had talent, but she knew it was very meaningful to me, because we had battles all the time. I never gave it up. And my dad was supportive in that he was, I think, much more sensitive to the arts. He was more of an artist soul, and he always gave me support in a certain unspoken way. And even before he died he said, "Don't give up your art."

RCAC: When did you become an artist and how did you know?

RIVERA: I entered the Art Students League in 1955, and about '56 I was taking a painting class with a very famous illustrator. His name is Frank Riley. And it didn't fit. I knew there was something wrong without knowing what it was. And the nice thing about the Art Students League is that you can wander from one class to another, month to month, and explore. So I went, and I overheard this one teacher who's an absolute genius as a teacher, and I decided he was for me. He was a bit of a Renaissance man and taught in the classical, traditional ways and was a bit of a Don Quixote. In the environment, '55, it was the New York action school that exploded the whole world, and de Kooning and Pollock and Klein were the grand heroes of art.

And I was still painting in a figurative manner. It just fit. I felt that I was somewhat out of step with what was happening. Subsequently I developed a tremendous inferiority complex about my intellectual capacities, never my capacity with my painting. Somehow I always had a tremendous facility and sensitivity, and somehow I didn't fit with the world. And to a large extent that was true for most of my life in the art world while I was in New York. Because somehow even as the pendulum is swinging back to figurative painting, I'm still out of mode. I'm not painting the right kind of figurative. You know, if I was more hard-edged or cooler, I'd probably fit. But my paintings are not as violent or

as cool. Somehow I'm in the middle somewhere, except that I feel that I'm a theatrical painter, because one of the art forms that affected me most profoundly was cinema. I'm a cinema fanatic. And fortunately, living in New York, you have access to the Thalia and all the wonderful theaters that showed Kurasawa, Eisenstein, and Bergman and Fellini, and these are the people that spoke to me. They were using the same elements that I had to deal with, and validation of the true character and exploration of the character. They essentially were my grand teachers, because in that period when I was at the Art Students League, from '55 to '61, I would go to galleries and I would go to the subways and draw in the Automats and restaurants and anywhere that people congregated— Waverly Park. And I was constantly sketching and going home and painting from my sketches.

Most of the painters that were painting at that moment were not painters that could feed me in my craft. So I would either have to go back to the Renaissance or back to Vermeer and Degas and Daumier and Brueghel, or go to the cinema, dance, anything that was theatrical, because somehow in New York at that moment you had greater access even if you were poor to what was happening artistically in New York. It wasn't outlandishly expensive, and I went to opera, I went to dance, all the time. And dance feeds my sense of rhythm within my own paintings, because I am very much involved with composition and rhythms of light and movement. And I was fed by these art forms—but very little from the art gallery, which is very strange.

RCAC: How about peers in this period? Were they important? And how did they influence you?

RIVERA: I guess peers were important, especially at that moment when you're feeling so alienated from the art world in general. It's a very necessary support system, because you feel kind of lonely, and it gives you a sense of validation. I mean, you talk about issues that are important to you and problems that you're having, and you can share excitements that you have. So peers were very important.

RCAC: And these were other art students?

RIVERA: And also my teacher. I found out now that he's only about six, seven years older than me. But I always felt having an image as my teacher was very important; he was not my peer, but he gave me strength, because the kind of commitment he had to his own art, and the relationship he has to art and what it means to him, is very akin to what it means to me. And through the years I've discovered that more so.

RCAC: Was he a role model or a mentor?

RIVERA: In his relationship to his art, he was very much a role model, a

mentor. There was a second mentor who I met after I left the Art Students League, Steve Raffo, and he complemented Frank Mason, who is more in the classical tradition. Steve Raffo was about painting the people around him and not putting them in a time warp. And both of them were very involved in the arts; both expanded my scope of listening to good music and going to theater and dance. And that was very very important to me, because all of it fed me. I'm the painter who I am now because of what I saw—and experienced—in all the art forms.

RCAC: What qualities did you need the most during this period? Physical stamina, mental discipline—anything of that nature?

RIVERA: Being young, you have physical stamina. I think it's more emotional and spiritual stamina that you need, because going to an art school, you realize that talent is abundant in our life. There are people out there that can paint and have tremendous facility and good intentions. But for me, being an artist is a total lifetime commitment, and it's a survival factor that makes an artist. It's going through all kinds of personal fires and coming out the other end and still not losing his spirit and faith in what he is supposed to be doing. I feel very strongly that I'm supposed to be doing what I'm doing, and that's why it's a total commitment. And I couldn't do anything else at this moment in my life.

RCAC: How about your training during this period? Do you think it prepared you for your career?

RIVERA: Oh, absolutely. For six years I was just painting, sculpting, and drawing. I don't have any degree. I didn't have to take all kinds of curricula like you have to do in college. The Art Students League, as you would say, may be a vocational school. It's right on 57th Street, diagonal to Carnegie Hall. It's been around since the 1800s. It's a very famous school, and it's produced a lot of good painters—Chase, Georgia O'Keeffe went there also as a young student. I think because I had the kind of training I had, it allowed me such a solid foundation that whatever I want to do, I have the capacity to do. And I feel that a lot of schools don't give that.

RCAC: Did you set any benchmarks for achievement in your career? For instance, "I'll be X in five years."

RIVERA: I think you always have ambitions of being successful, but that's always been, for me, a test in patience. And that's what I was saying before: Your commitment is one of longevity. Sometimes success happens to a person very young, and sometimes it happens not at all. I feel that for me, I always had a sense that I would make it. And what I mean by making it involves becoming well-known and earning a living through the paintings and achieving some measure of artistic

success—making a personal statement at some point in my life. But it's been a very difficult process historically. Now it's getting easier. But I am 53, so hopefully the gods are a little gentler to me. I've always been a very ambitious, focused artist.

RCAC: What were the first organizations that you joined as an artist, and are you still active in any today?

RIVERA: No, I'm not a joiner. At a certain point I went to the Educational Alliance near Delancey Street, and it was a group of figurative painters supposedly to get together and explore ideas, but it became more of a battlefield. It became a little bit like the Iraqi War sometimes—you know, just very vicious. So I felt that that was not very constructive for me, and I joined a club in the Village on Fifth Avenue near 12th Street. It's a beautiful building with a nice restaurant, but I'm not a joiner.

RCAC: Did you ever join any of these groups or institutions for medical benefits or insurance?

RIVERA: I'm very exposed. You know, it would be nice to have some medical coverage for artists, because I don't have medical coverage and people tell me it's pretty scary, and if I do get sick I could lose my house.

RCAC: Can you tell me about when you first achieved professional recognition?

RIVERA: I guess that would be out here. In New York I had many shows, and I had a lot of complimentary newspaper reviews, and I did win a CAPS grant and a few National Arts and Letters and a few prizes. I had peer recognition from other artists and people who were involved in the field; they always respected me as an artist. But I think that those are just spotty little moments which amounted to nothing as a record. But coming to Santa Fe, first of all, has allowed me not to have to do another job. I was fortunate in having a duplex that I could rent at first, and so it kept my head above water. And it allowed me to focus on just painting and also the issues of a career, which I never focused on before. For me, I just had the issue of perfecting my craft and educating myself in literature and philosophy, but those are not very practical matters. Being out here, I had enough time to say, "Hey, what else do I have to do as a professional?" And I started doing it. I did my own advertising and made sure that I was visible, because part of becoming a successful artist is not only your personal endeavors but it's also that your name becomes resonant outside to the world, and they hear your name and it denotes a certain image in their head.

RCAC: What, then, is your definition of success, and do you apply the same definition to other artists?

RIVERA: Well, my personal definition of success is essentially the most

important definition: what I do in that studio alone and how I conduct my life, because I feel the kind of art that I'm doing is a totality of my life experience. So who I am in every sense of the word is who I am as a painter. That's the primary issue.

Another very practical issue is how can I live a life on this planet, pay my bills, have circumstances that allow me to paint, because in the past I've always had to do other things—to allow me to live and pay my rent and possibly to squeeze some time to paint. That's not a very successful life; it's very frustrating, it's very schizophrenic. And I wanted to create an environment for myself where I could do both at the same time—have my art, pay for my life—and also allow it to be a process of growth. It's a very difficult question, because sometimes a lot of people are out there and they're very successful financially. They know how to market, they know how to image, and they create a product. And I'm not interested in that. I'm interested in producing something that is on a lot of different levels—more than just an image. It's an experience. It speaks of what life is about, which is different levels of experience, not only the format of the painting, how the painting is put down and composition, but the theater of it, the psychology of it, the emotion, the spirit of it. So it's all those different layers, because I'll be successful if I feel that I can create the same experiences that I've had when I go to museums and I see the same painting for twenty years and it always says something to me, and I'll hear music for twenty years and it'll always say something to me. Or a good film of Kurasawa—for me, a genius of our time. And if I can be in that company, I'm successful.

RCAC: You talked a little bit about always having to do other things. Can you give me a brief history of what your job history's been?

RIVERA: I started doing everything from delivery boy to department stores to work on the waterfront, on the docks. That was too harsh to me. And I'm a pretty good dancer, so I taught dancing at Fred Astaire and schools like that, and that was an awful experience, because it's like a real con game there. So it destroyed the fun of it. And I worked in coffeehouses, which were real fun because in the late fifties and early sixties, I worked in Café Wha, Café Bazaar, and I heard some wonderful music. Rich Haven and Bill Cosby used to play there, and steel bands, and there was one coffeehouse that had one-act plays—Ionesco plays and *Waiting for Godot* and *The Lesson* and *The Overcoat*. And it was really wonderful. After that I was good with my hands, so I started doing some woodworking, and that gradually got me into cabinetmaking. And when I finally moved to Brooklyn, I started cabinetmaking full-time, with painting, and then I got really fed up with that after seven years

because I never made money—or hardly any—and I decided to become a framer. And I had a framing business for seven years. And that was an education, because it allowed me to get behind the scenes in the gallery world, which is such an inner sanctum. And it allowed me to listen to the machinations of how those institutions work. So it deflated the ominousness of what the gallery world is about. It gave me a pretty clear perspective that it has nothing to do with your painting process. It's just an institution that some people are privy to get in—if they're political, they'll do anything to get in, and it creates a lot of emperors with no clothes, you know. It allowed me to frame some beautiful shows, a whole Whistler lithography show. I was very good friends with the curator of the Arthur M. Sackler wing at the Met and did a whole exhibition for the Columbia Piranesi collection that they have there. So that was a plus. The negative is that I also had to frame Leroy Neimans.

RCAC: Can you tell me if you have any people who you rely on now as peers, and who they are?

RIVERA: I have a friend of mine who I didn't know very well at the time but went to my high school and also studied with my same teacher. He's from Brooklyn, and through the years we've become pretty good friends; he was instrumental in my moving to Brooklyn—Park Slope— because he lived there at the time. He's also instrumental in my coming out here, because he was coming out and the timing was just perfect. We're both figurative painters with the same background. We paint different images—he's more of a landscape painter, a different kind of world, different kind of statement—but we still speak the same language, so we can give each other feedback that is very direct and very respected. We know what we're doing, and we know each other's language. We don't have to be long-winded. That's always a real plus.

RCAC: How would you describe your occupation, and is this different from your career?

RIVERA: Well, my occupation is now my career, fortunately, and I hope it continues.

RCAC: Describe the gatekeepers at various stages in your career, those who let you in or barred the way for you as an artist?

RIVERA: Well, my mother tried to be a gatekeeper, keeping me away from art. I guess my teachers were the ones who created the excitement that fed my energy and commitment, that allowed me to gain perspective and also to strengthen me.

RCAC: What have been the discrepancies between your career aspirations and your actual opportunities?

RIVERA: I have two different phases. One is in New York, which is the

larger part of my life. There I felt totally frustrated. It was more that a door was closed to the kind of art that I was doing, not being a political person. And I think that helps a lot, if it's that important to you, because the standard-bearers of New York art are very powerful, and if you happen to fit what they want, then you're in. But if you don't, you're definitely out—without a doubt. And so that's a closed inner sanctum, from my point of view.

The best thing I did was to come to an environment which is involved in the art world but is more on a human scale. It's smaller, it's more approachable, it's certainly a more beautiful environment to live in, and all of that has allowed me more access to becoming a professional artist, where in New York I don't think I would have survived emotionally. It would have killed me somehow, because it's so confrontational, and I don't think I would have been allowed the time to do what I needed to do.

RCAC: What has been the major turning point in your career?

RIVERA: Coming out here.

RCAC: What's been your relationship to money throughout your career?

RIVERA: Very difficult. It's one of my biggest, biggest, biggest tests, and it's something that has always been very difficult for me to make, even doing cabinetmaking, framing—I was never a good businessman. So I could never bid it properly, get the right price so that I could make a living. But I also have a theory about that. I also think that on an unconscious level, I produced a situation for myself that was totally intolerable so that I could eventually leave it. You know, I had choices to become an illustrator in New York, and for a lot of different reasons, I didn't want to buy into a comfortable format. And I could have, with the kind of skills that I had. That would have been an avenue that would have allowed me a very comfortable life-style. But I wanted to protect myself from that kind of environment, because for me, painting is a gift that is to be protected and nurtured, and when I put the service of my art to a magazine or cog in a corporate machine, that's not servicing and protecting my art. Yeah, money's always been very difficult. I think now, finally, I am doing what I am supposed to be doing, and what I want to do, and it's produced much more money than I ever experienced when I was doing it in New York. Now I'm commanding decent prices. I still have to get 'em up there, but I'm at least commanding some healthy prices and see my future in a very positive way.

RCAC: How has the cost of supporting your art changed over time?

RIVERA: The cost of living is immeasurably higher now. I also own a house and the car and have had a very difficult background financially

that has made my debt service very high. So I'm paying for my history of being poor, and life is more expensive. And also I have incurred a lot of expenses in framing bills and also in advertising.

RCAC: How have grants, awards, competitions, emergency funds affected your career, and has there been a specific time that you can think of that they would have been the most important?

RIVERA: All the time while I was in New York, that's for sure. I've only gotten one grant in my life and a few prizes. And they certainly would have been very, very, very meaningful. I think on many levels—not only monetarily but also professionally. They're the accolades that you need to be validated.

Essentially the issue of money is always a problem. And I think the less concern about money that I have, the more I can produce, because the money has been an enormous battle, emotional stress, and drain, and what it's done to me is it's created a lot of strength within me to trust that somehow I'll survive. The forces have been very abundant in that they've allowed me to survive up to now in the most improbable times. You know, there are times that I felt that I would never make it. Sometimes I think I'm crises-oriented, but it's just the reality of most people, especially in the arts, unless they have family money or a gift of making money.

RCAC: What's been the importance of physical location and work space at different stages of your career?

RIVERA: I think it was very important, because when I was in New York it was feeding me—being in that location, being in the subways, in the Automats—and that feeling of the energy of the people that I was painting was a very, very important issue.

The space was never an issue, because at each point of my history, it was always adequate. Before I left New York I bought half a brownstone and I had an enormous parlor, a Victorian parlor, so my studio had very high ceilings and very good light. But as I changed and as New York changed, I lost my connection to New York. And that was the most painful, because New York had become, from my point, too paranoid. I'd lost my subways—too violent, everybody was too concerned. I couldn't feel comfortable sketching people in New York. I'd lost the Automats. So in a certain way I had lost my people.

And so when I came out here, the environment was much more conducive, first of all, for healing myself emotionally and spiritually. And having experienced Mexico—Oaxaca and Tanamara—opened up a whole other world. I painted the plaza in Santa Fe, and my girlfriend used to work for the racetrack, and I did a series of paintings of the

racetrack. So I've had a lot of different avenues I've explored. I've explored some of the Indians in the pueblo, doing their dances, and the Tanamara here, the Lachini dancers. So it's provided a new world of people. It's always people that I'm concerned about. And eventually I hope that my career allows me to travel more and to explore even more of the world of people, wherever they are—whatever touches me, moves me. I also want to go back to painting the urban part of my life, which is not being expressed right now with these Mexican paintings, and I want to go back to my restaurants here and paint the people that I know—the theater that I know because I understand my people much more. I can give more input psychologically and emotionally than I can with the Tanamara. As much as I love them and I'm moved by them, I don't understand them. So I'm a voyeur. Here I can make a statement, and I want to eventually explore that avenue again.

RCAC: What kind of control do you exert over your own destiny as an artist?

RIVERA: I think the most important aspect of control and controlling your destiny is, for me, the spirit of the person. My spirit, my inner spirit, is the most important issue, because without that, whatever I touch is going to vibrate with whatever place I am emotionally and spiritually. There is so much capitalist stuff outside being done under the auspices of art; for me, it's junk art. There's enough contamination with this mediocrity and television nonsense, soap opera stuff, that I don't want to be a part of that. And the more I can nurture myself, the richer I am in my life experiences, inevitably that's going to affect my art. And that's my primary concern always, and increasingly so because, for me, art has become more of just letting it happen than intending it to happen, though there's a strange marriage there.

RCAC: I want to move on now to your interaction with the public. Could you describe that? What was it like throughout your career?

RIVERA: In New York I guess it would be through friends who knew me as a painter, who bought my paintings, and the kind of responses I had in openings and shows that I had in New York. And generally it was always favorable, but not always financially, because the kind of images that I was dealing with in New York were not necessarily happy-go-lucky and, generally, the most successful paintings sometimes are the most pleasing. Unless you're in a high-powered New York gallery, then they can make it anything. When you're doing something too emotional or disturbing—which was not my intent, but it just happened that my paintings were like that—they had a harder time selling. So I wasn't always having successful shows. They all eventually

sold; I always received very complimentary reviews on my show and compliments of me as an artist. But it didn't always pay my rent. So in New York it was a very strange phenomenon. It was like a catch-22 there.

But when I came out here, I slowly—and I say that very significantly, slowly—started to create a reputation and slowly have developed a following where people are buying my paintings and there are collectors waiting for my paintings, which is a very nice feeling.

RCAC: Do you have a number of central ideas you keep working on throughout your career, and if so, what are they?

RIVERA: The central idea is essentially the theater of people, where they congregate, and it's mostly gathering places where they are, whether alone in an environment or together, and it's just around people in an emotional state. I mean, I want you to feel their sense, their presence.

RCAC: Are there particular periods of your work that you're more satisfied with than others?

RIVERA: Yes, you go through different phases, when you feel you're cooking and when you're not. And when you're cooking, I guess it means that everything is going right—your emotional state and your physical energy, which is a very important issue, your physical stamina. For me, painting is a very demanding process emotionally. And it's not necessarily a physical thing, but because it's so strenuous emotionally, you need to be a healthy person physically. And because I'm exhausted a lot of times just because every time I go to my studio I face a lot of my fears, I'm always fighting through that. And it's not necessarily battling it but, you know, confronting it, dealing with it, dealing with painting through the fears, just painting through the anxiety.

RCAC: You talked a little bit before about critics being kind to you. How do you feel about critical review and critical dialogue about your work?

RIVERA: I generally don't read too many art reviews. Sometimes I'll read a review of mine two years after the fact. But I somehow get impatient with reviews that are so long-winded and about the people who write it more than the experience. And I have subscriptions to both *Art News* and *Art in America*, just because I need to be a part of what's happening in the world, but I'm really astounded by the diarrhea that happens in those magazines.

RCAC: How satisfied are you with your career as an artist?

RIVERA: Finally, fairly satisfied, if it keeps on going, which I feel it will, in the way I want it to go. Now I'm very satisfied because I'm also happy with where I live, with my life and my environment, and that people are starting to know who I am, because I always had a sense of who I was

and what I saw saying in art and my place in it. And a lot of times in New York I felt like an invisible man, that I didn't exist and had no credibility. But here, slowly, I'm developing a sense of, you know, people do know who I am, and in that I'm happy because I feel it's warranted. I feel I'm a good painter, and I'm an artist, and I have something to say, and people should acknowledge that, and also people should buy my paintings.

RCAC: Can you describe major frustrations in your professional development?

RIVERA: It's mostly been about money. And I also have to say that there's an issue of what you feel about yourself, and that almost stops the flow of money coming to you. You know, I'm sure that there's a lot of not feeling worthy of a successful career, so you sabotage whatever little successes that come your way. That's been a very strong issue for me too, because I've always felt somehow, on a gut level, that my career successes would come later in my life. And so it's coming to pass, because it's starting to surface now, and it's getting stronger and stronger, and I'm developing as an artist and becoming stronger as a painter. I deserve a successful career; I want a successful career. I want a more graceful life. There's enough drama and junk that comes anyway. As a youth I used to read O'Neill and Dostoyevsky so much that I became part of that melodrama—a lot of angst. I feel that I'm more in sync with creating a more successful career, because my mind and my emotions are more together and focused in one direction—one is not going left, one is not going right, which is what I used to do before.

RCAC: How about your greatest satisfactions in your career?

RIVERA: I guess those would be in specific paintings I've accomplished, I've done, and the kind of responses I've gotten from paintings. I mean, a sale is a sale is a sale; I need the money and I'm glad to make the sale, but when I feel that I'm successful is when I'm painting well. I know when I have a good painting, but I also love the validating responses of people that I respect, or even people that are just lay people because I feel that I'm painting about people. Everybody knows about people; everybody has a response. And so I always welcome anybody responding to my work.

RCAC: How about the greatest disappointments?

RIVERA: Career wise? Well that has to do with expectations in applications to grants that have never come through, trying to get into galleries in New York and being totally pushed away. And just the difficulties of penetrating that capital A, Art world, that possibly allows you to earn a living in New York that was never allowed to me. And I guess that

my greatest bitter feelings are about that time in New York when I tried to get into a New York gallery that I respected and was ignored or snubbed. I mean, the arrogance of some of the dealers is just totally obscene. And not being able to get some grants that would have allowed me some grace in New York. And money that I got was through hard effort in other fields of endeavor which took away time from painting.

RCAC: What's been the effect of the marketplace on your work?

RIVERA: Profound. Going back again to New York, what was viewed as art that was valid, purchasable, art that was allowed to go into the Whitney Annuals and such places—I was at crosscurrents. So that created a lot of similar frustrations, because most of those institutions are ism oriented. It fits a slot. It fits an ism, or it creates an ism like Pop—Warhol—and it's a very specific marketing device that is easy for the marketplace to deal with. And since my art never quite and still doesn't quite fit into any of these slots, it's always been a very difficult process for me to earn a living at. So yes, attitudes are very, very lethal to me in my history.

RCAC: How has your relationship to your materials changed from your early training?

RIVERA: Not much. I just hope I use the materials with greater power and greater artistry. But essentially I'm using the same materials.

RCAC: How have your absolute basic requirements for being able to do your work changed since your early career?

RIVERA: I guess the older I get the more creature comforts I want. I like to have a warm studio and a spacious studio. And, in fact, as lovely as you see this studio, the scale of my paintings that I would like to do is increasing, and I'm going to expand when I can. So my requirements have increased because I feel that my career will allow me to upgrade, so to speak.

RCAC: What one major point would you make to young painters about pursuing a career in the arts?

RIVERA: Develop a personal relationship to your craft and find that relationship that means something to you and excites you and makes you feel the inevitability of doing what you have to do. It has to be something that you need to do and you must do. Find the space to develop enough power in your craft that will give you enough options to do whatever explorations you need to do to develop your personal statement. That comes from long, long living and hard work and commitment and patience, having an honest life.

And society doesn't make it easy at all, so you need a lot of stamina and a lot of personal clarity. If it's money you want, you might start

doing things just for the money. If you have a sense of what you want to do, what kind of statement you want to make, you could certainly get into art and create products and have a nice life-style too, a very successful lifestyle. Or if you want to make a personal artistic statement, then give yourself every option for that to happen. And also having the language. Too many people don't have the language, and so they're cripples. At the time that I was going to the Art Students League, there was a big no-no about having a classical background, because that's going to hamper your emotions and pigeonhole you, cripple you, stop your creativity, et cetera, et cetera. And what you had to explore at that time was just your unconscious and all these fantastic openings that were happening at the moment in Freud, in psychology—not that I'm pooh-poohing that, but it's just the emphasis.

All the painters that we look at now—de Kooning and Pollock and all of those guys—had a tremendous talent and a tremendous training. And in that they had a lot of options. Kandinsky could do paintings à la Sargent, in a classical, flamboyant manner, and he developed his own vision. Mondrian—straight down all the painters that you respect came from a source of history, and they were able to use the language and know what it was firsthand. And too many of the schools at the time that I was going to school started their history and their training from Matisse and Cézanne and Picasso, which is absurd.

So the scope of training you have is ultimately one of the most important gifts you give to yourself—for your future. What art is, is such a personal, complete statement of who you are. And to know that—I mean, to know that everything you do and think is part and parcel of the kind of statement you want to make. Through the doing you always develop in the craft. But it's also how you marry that craft with the spirit, because what makes Kurasawa is his vision. It's the totality of a man. And if you look at Kurasawa, every frame is an exquisite frame. It's just beautiful. And so he had a sensibility that was just totally his. It's not just painting. It's also how truthful I am about myself, how truthful I am about everything, because if I'm going to lie to myself, I'm going to lie on my canvas. You know, what do I want to do? I want to create more light to the world, however that might sound. I really mean it. You know, light being joy, something that's positive, not that I can't paint sadness, but it's how I look at sadness and what I feel about sadness.

Honors: State Capitol Commission, Santa Fe, NM, 1992; Albuquerque Airport Commission, 1988; Best Painter Award, De Puerto Rico Institute, 1972;

Rockefeller Plaza mural: Banco de Ponce, 1972; Channel 13, One-Year Anniversary: Attica Riots; Fortunoff family, five commissions, including one bronze plaque for Dowling College, Oakdale, NY, 1971–75.

Representative collections include: Private: Edgar Davies, Alan Fortunoff, Amy Greenberg, Lois Katz, Jordon Kronenworth. Public: Albuquerque Airport, Albuquerque Museum of Fine Arts, Amherst College Museum (Amherst, MA), Georgia Museum of Fine Arts (Athens), New Mexico State Capitol (Santa Fe), Santa Fe Museum of Fine Arts (NM).

Professional affiliation: Member, National Academy of Mural Painters, 1992.

DAN SMAJO-RAMIREZ

B. Chicago, Illinois, 1941. Attended Chicago City College, Olive-Harvey, 1972; University of Illinois, Chicago, 1972–75 (B.A. 1975); Art Institute of Chicago, 1975; University of Chicago, 1975–77 (M.F.A. 1977). Professor of art at the University of Wisconsin–Madison, 1988–present. Lives and works in Madison, Wisconsin. Exhibits internationally.

RCAC: Dan, what were your initial experiences with art?

SMAJO-RAMIREZ: As a young child, I can recall many occasions to see a lot of my uncles and aunts on my father's side of the family who could always draw cartoon characters, or draw something from a comic book that always looked very real, so I think I was always kind of possessed by a certain magical thing I saw about the ability to make something look real, even though they were taking something from something that wasn't real to begin with anyway. I was encouraged a lot by my mother, who was also a singer and sang a little bit on the radio in Chicago when she was a young person. And my father, who could also draw and make things look very real, to me anyway. I think that kind of got me interested also. There were always drawing pencils, big drawing tablets that were always kind of strange and wonderful to have. I should tell you that I'm half Mexican and half Yugoslavian. And my father was born in San Francisco del Rincón in the county of Guanajuato, Mexico; my mother, although she was born in the United States, her mother was born off the coast of Yugoslavia. She was involved in music from her

particular area, and my father could draw. And my father's sister and brother, they were always drawing. I remember when I was in grammar school, I believe it was about third grade, and there was a drawing contest. I asked my father for this tablet, and he brought me this really big tablet, around thirty by forty. I remember taking my pencils and drawing these octopuses under water, characters, this scene that I was going to enter into the contest. We lived in an apartment building; it was half Mexican and half Yugoslavian. My grandmother had all the money; she came over from Yugoslavia, and she brought some money with her. The rest of my family were factory workers and pretty much like most people at the time—struggling to get along. My father came over with his parents, and his parents, when they came over, lived in a boxcar at the Santa Fe Railroad on Clark Street, just off of Archer Avenue in Chicago. And they lived in a boxcar while my grandfather (who's now dead) cleaned the inside of cars. They came for work I think, primarily, and a better standard of living, I guess, than what they had in Mexico at the time. He came down with them, and he lived in what's called the Chinatown area of Chicago, 24th and Wentworth. There were not so many Mexican people living in the area as there were Italian and Chinese. He was a baseball player. My mother, she lived not too far away from there, and I guess she met him one time playing baseball, and one thing led to another, and their lives got together. After that it was myself and my brother and sister!

RCAC: How many siblings do you have?

SMAJO-RAMIREZ: I have a younger sister. I'll be fifty this year; she'll be thirty-five. I have a brother who is forty-four.

RCAC: Are they involved in the art world at all?

SMAJO-RAMIREZ: No, not really. Back to this thing about the drawing and the tablet: I drew this scene and took it into school to have it evaluated. In this apartment building where all of us were living together, I had an uncle from my mother's side of the family, who was Yugoslavian. He weighed about four hundred and sixty-five pounds, and he had these wonderful features in terms of wrinkles and saggy skin and things like that, plus he was also a very jovial kind of guy. I mention that because when I presented this drawing of mine for this contest, later in the day it was announced that I had won this contest. So everybody then filed into this room where these drawings were set up, and there was mine. And I looked, and it was this wonderful picture of my uncle. Well, I knew immediately who did it. My father had done this drawing when I had laid this tablet down. Sometime during the night he went in there and sketched my uncle, and so of course I had to fess up that it

wasn't my drawing. And it wasn't one of the greatest experiences of my life; I was kind of deflated. What happened was I put in the tablet, not realizing the other drawing was even in there. They just kind of looked through it, figured, "Oh, he's entering all these drawings," and chose the drawing of my uncle! Which made sense; it was a nice drawing.

RCAC: And you had lots of relatives living around you?

SMAJO-RAMIREZ: I believe there were six apartments, and there were uncles and aunts from both sides of the family. I had an aunt, my mother's sister, who lived directly across from us, who sent me to the Art Institute as a young person. She knew how much I liked to draw, and she was very much an influence on me as a young child, very supportive. She was married to a young Mexican man; his name was Emilio, and he and my father were very good friends. They got along quite well as brothers-in-law. He was a pitcher in the White Sox farm system at one time, and he also played baseball with my father, so I suppose they had that in common.

RCAC: So the members of your family seem to have been fairly positive about the talent you exhibited as an artist.

SMAJO-RAMIREZ: I have gotten nothing but the most positive feedback and support from my family in anything I did. It didn't matter whether it was art or anything else. They had a way of making me feel very liberated and free to do whatever I wanted to do.

RCAC: Were there any other educational experiences that gave you validation or resistance to your art work?

SMAJO-RAMIREZ: At the high school level, I wasn't much of a student. I had a class once in high school, an art class. I remember having a confrontation with one of my teachers about what complementary colors were. She really was thrashing me around about what I didn't understand about art. I got confused and infuriated about it and kind of felt maybe I didn't know as much as I thought I knew.

I think for a little while after that, I turned to other kinds of things. I never graduated from high school. I was in a Catholic high school in my first year, and got into some trouble there and was asked to leave, and went to a public high school, where I wanted to play football more than anything else, which was basically almost all I did, other than this one art class I was just talking about.

I ended up going into the marine corps at a very young age. Oh, one of the experiences I had in the marine corps was when our drill instructor asked if anyone could draw. I raised my hand, said I could. So I had to draw this big platoon flag of this big globe with the wings and "Semper Fi" and all this kind of stuff that marines thrive on as mottos, which are

kind of wonderful, I suppose. But I didn't last long in the marine corps either. The only art classes that I can really feel comfortable saying that were art classes would have been the ones that my aunt paid for at the Art Institute, which were life drawing classes. I was probably twelve, thirteen, something like that. And at the American Academy of Fine Arts in Chicago, where they taught these very classic approaches to tone and composition. For my part, that's really what art was about. I knew nothing. Art history was not in my life at all at that time.

I remember liking the smell; I remember walking in, you could smell oil paints. That aura of making art was just magic for me. I don't work in oils; I did when I was younger, so I recall the smell. I deal with acrylics now, so there's not that much of a smell really. So through school and my education, there really wasn't that much formal training. Right after the marine corps, when I came back to Chicago, I wanted a job. Most of my family were truck drivers, and truck drivers back in the sixties made pretty good money. I think it was 1959 when I got my first truck driving job, and I drove a truck and I was a steel hauler until I was twenty-nine years old, so that was ten or eleven years of hauling steel.

I was making money, spending it as fast as I was making it, having a good time. I was making a lot more money than most kids my age. I ended up getting married and drove a truck while I was married. Finally it was getting rather hard. I was working twelve hours, fourteen hours a day, seven days a week. And as you get older you start to kind of think, is this the way it's going to be the rest of your life? You want better things. So there was kind of a glamour still about art.

RCAC: When you think back, were there any particular art forms that interested you as a child? The drawing you talked about. Anything else?

SMAJO-RAMIREZ: I think more than anything else it was simply to be able to take a pencil and draw something that looked real. Remember the pencil with one side red, one side blue? Of course tatoos are red and blue. I have a tatoo here, a beautiful Mexican girl with a sombrero, on my arm. So I would be the one asked to draw these tatoos on everyone's arm. I'd draw these wonderful things, and they'd look just like these things should look. I can only look back on that and say it was one of those reinforcement things that happened in my life that made me feel special in ways I didn't feel otherwise.

It's an interesting question, actually, that you're asking. Now that I think back, one of the things that really frustrated me more than anything else was that the neighborhood I grew up in was primarily Irish-Polish Catholic. I was the only Mexican—half Mexican actually. Most of the kids that I went to school with, that I knew, finished high school. They

went on, finished college. They're lawyers, they're doctors, they just really performed quite marvelously. I never did. I was always the truck driver. I was the kid who had the money first, but in the end I didn't really have it. So I've always had a certain kind of embarrassment about a lack of education. As I got older, after I got married and was feeling the frustrations of a dead-end thing, I said, "Well, you know, there is one thing I can do. I can draw and render things kind of realistically. Maybe being a commercial artist might be an interesting thing to do."

Again I saw a certain kind of glamour in coming and sitting in an office and drawing, and I assumed you got paid a lot for that. I think at age twenty-seven, probably with a lot of naïveté, I decided I would go to school part-time. So I took the GED and passed. That gave me the credentials to enter the city college. And so then I went into a city college in Chicago called Olive Harvey and took the academic courses. And lo and behold, when you go to school when you're twenty-nine years old, you have a lot more to say than when you're in school when you're fifteen, sixteen, seventeen, or eighteen. So things went quite well.

I enjoyed the classes I had, the classes in psychology, classes in social sciences, philosophy. I loved philosophy. I was able to draw on some experiences of my own that allowed me to see life in ways I never saw it before. That had an incredible effect on me. It was part-time. Through a long period of my life, of growing up, I was always trying to find ways of getting around things so I wouldn't have to do it the hard way! But I figured, well, I'd go to city college, I wouldn't go to a large university, because then you'd have to take all those courses that are so hard, and I'm going to fail and I don't want to fail, I want to feel good, I don't want to feel bad! So I figured city college. I don't mean to infer that a city college has a less demanding program, but in my eyes, given my naïveté, that's the way I was looking at it. So I went there, and for the two years I got almost straight As, and everything was wonderful. So I figured, okay, then I'll take these academic courses, transfer them into the university, and then I'll take the art courses that I need. I went to the University of Illinois at Chicago, and this is where everything really changed for me, because I went to the school with the idea of doing commercial art. Well, I didn't do a very good job of screening their program to see just what it was they taught, but it wasn't commercial art. Primarily it had a reputation at that time of being an extension of Bauhausian ideas. So there was the strong, rigid foundation program that one took in space—positive, negative space. I said, "Okay, I'll take the foundation program." I took the first class, and my teacher was a man by the name of Bob Nickel. I keep his picture around because he

had probably the greatest influence on my life. Now, I don't recall exactly whether he was actually personal friends with Piet Mondrian or whether he just knew him through another intermediary, but he would tell us a lot of stories about times when Piet Mondrian would work, and how he would do these things with the lines, and it would take forever moving them back and forth.

Anyway this man, Bob Nickel, was not only a teacher in the foundation program, he was a collagist. He was an artist who did collage work with found papers and things in the streets. He was also, I guess, what one might refer to as a transcendentalist, a spiritualist. But he had an incredible effect on me, because he would look at the things that I would draw—I would draw things, bowling balls, that would look real—and he would just kind of shake his head, like, "You know, you're never going to make it, but that's okay, this is what you want to do." I started listening to him, and he showed me that there was something about abstraction, which was what he was dealing with, even though he was using found materials, which aren't very abstract. But I guess that through this process of abstraction you could touch things inside of you in ways that were dictated differently than through working representationally. That really intrigued me, so I started working.

First I took an art history course. They have a sequence in our school where you start with the ancient and move through different periods. Somehow I ended up taking the contemporary one first, the modern one. I took the courses out of sequence; I think it was okay to do that. One of the first people introduced to me was Barnett Newman. He really intrigued me with the way he thought, about the way you make a painting and what it meant. I wasn't sure I saw that in the work, but it interested me. This was a real factor in why I work the way I work, which is primarily with linear elements and light and abstract architectural components. What I could do was, as I found out, make the most incredible masked taped straight lines with paint and build these kind of light surfaces. So I figured, well, I've got that. That kind of looks like Barnett Newman. And when I think about Barnett Newman, what he feels, and I find that it's really so compatible to the way I feel about how art should function, and how a visual thing could function, to really reach in and talk about things and feel things, I said, "This is what I want to pursue." So I was in the right place! Because it wasn't just a question of Bob Nickel but a number of members of the faculty who were incredibly supportive of me, and really helped me, and things just really came together.

I had the really good fortune of meeting people—Dennis Adrian, who

over the years I've become very, very close to. He just visited our campus here in Madison. But as a young student, as good fortune would have it, one of my instructors mentioned to Dennis Adrian that he might want to look at my work. Dennis was an art critic, a curator, putting shows together at the time. Dennis looked at the work and said, "Well, there's a spot at a restaurant, the Black Hawk Restaurant, in Chicago. You can put up all the work you want." I probably put up sixty pieces all over the place. It was my first venture into being public somehow with something I believed in. In this particular instance there wasn't any feedback, there wasn't a review, but it was one more of those really positive things that happened in my life. This was 1973, and I graduated in 1974, so it was right about my third year. Dennis had done this for a number of artists, not only in Chicago, in other places, but especially in Chicago, where if he sees a young person that he likes, he'll support. That's just one of many good things that happened to me.

When I was in graduate school at the University of Chicago, as I moved through the rest of the programs, again I found the right school to be in. I was the kind of person who liked to think a lot. Sometimes I would be criticized that you can't make art thinking, that you really have to come from inside. I was always confused by that. I've never seen the difference. I don't know how anyone can really make those distinctions. You can talk about them that way, but I just think they function too closely together to make a distinction like that.

RCAC: When did you become an artist, and how did you know?

SMAJO-RAMIREZ: I don't know that I ever thought about becoming an artist right away, because I think I thought in terms of being a painter, being a sculptor. Maybe that's part of the education that I have in that I sensed in going through some of the classes that I took that there was painting and sculpture, and the classes were set up that way. It wasn't till later that I came to realize that what they were really talking about was making art. I think you really find that out when people like Rauschenberg and a lot of other people began to do multimedia things, incorporate all aspects of life into something in a very specific way. That happened to me probably as I came into graduate school. But being an artist was still kind of a strange idea. Even to this day when I talk to my students, I try to get across that I can't teach them to be artists; all I can do is educate them, which simply means to expose them to different kinds of experiences, different kinds of options, ways of looking at the world, through either my eyes, their eyes, or other people's eyes. Making art is something that they either will do or they won't do, and I just don't know if there's a period at which one can start to really say

it's that. I have to be very honest with you: As the years have gone by, I've seen how much bad art I can make, as well as good things that maybe I'd find more significant. I'm not sure, maybe you're an artist sometimes, and maybe you're not an artist sometimes. I'm more comfortable with saying I'm an artist in terms of the things artists generally do to make art.

RCAC: Describe the importance of peers to you in the time after high school, in your truck-driving days and then at art school.

SMAJO-RAMIREZ: In terms of peers one of the things I've had to confront is being half Mexican and half Yugoslavian—as an artist especially—because oftentimes with the last name that I have, there are certain expectations on the part of certain people that my art look a particular way. There's kind of a stereotype about what Mexican art looks like. With a lot of the Mexican artists I know—and I think I'm probably more paranoid about this than anything else, because I really don't think that it's what they're thinking as much as what I'm think-ing—it's as if I don't fit, but I should because I'm Mexican.

I remember a show at the Museum of Contemporary Art called "New Roots, New Visions." I remember how different my work looked than the rest of the Latino artists that were in the show. I like being different, but what I had to have understood was that being Latin American was all I had in common with everyone who was there. But that in fact as a person who lived in the world I was an American who really was influenced by minimalist art. That's why my work looked so different. I understand the Spanish language fairly well, enough to get by. I don't speak it very well at all. I'm greatly inhibited in my relationship to other Mexican people because of that. I want to speak Spanish, but I don't; I always end up speaking English. So it affected my art experience in the sense that I embrace being Mexican so much—I mean, I cook Mexican food, my Mexican grandmother raised me along with my Yugoslavian grandmother, because my parents were working most of the time. So I'm very close to both. This is a very uncomfortable position I have found myself in quite often, and along with that is the fact I'm here at the University of Wisconsin, Madison, on what's called the Madison Plan, which is a mechanism that's been put together by the university to recruit minority faculty members into the program. That's been a very difficult thing for me to deal with, because when I come into a situation like this, I don't want to be thought of as a minority. I don't think any of us who are considered minority really want that. So, I suppose you tend to work harder, to prove yourself. I think everyone tries to work hard. But there is, nevertheless, at least that thought in your mind about

how you're perceived. So luckily, because of all the good things that have happened to me, I have enough of a background and accomplishments that I think at least I'm on a par with those who might try to judge me.

And I think as I listen to myself talk, I sense a certain kind of paranoia, in a way that I probably never would have admitted years ago. As I'm growing older, I'm beginning to think more about that. And so I guess what I meant was there's that negative kind of ambience about my relationship with my Mexican peers, but on the other hand there isn't, because I know I'm so much like them, and I love what they do, and, you know, we talk when we get the opportunity. But I am always fearful of having shows like that, that are Latin American or American minority, Mexican. They really make me uncomfortable.

RCAC: Do you think your training during your art school period adequately prepared you for a career as an artist?

SMAJO-RAMIREZ: I think it has. It doesn't stop, of course, because I still see a lot of these people, and they're struggling. All of us are kind of in this together, and we have questions that we put forth to one another in terms of not only our art but our teaching also.

RCAC: After you finished art school, did you give yourself certain benchmarks for achievement?

SMAJO-RAMIREZ: Yeah, I think I did. I was working with and having little shows, you know, exhibitions. I think one of the things all of us wanted was something like some review in a major magazine. That was like a benchmark of a kind! The first time that ever happened for me, that was again one of those reinforcing factors that said, "Well, maybe there's something here that's good."

The word "benchmark" is interesting, because there was a benchmark other than art. There was also a benchmark in terms of a level at which my life with my former wife and our marriage was going to be fulfilled, to the extent that we could live a little more harmoniously than we were because of my working as much as I was. And we didn't have children and things like that. So that was another of the things I was striving for; that was a goal. And I did give myself a couple of years for that to happen. As things turned out, my life changed so much. I became such a different kind of person, where my wife, who was so supportive of my doing what I was going to do, was not growing while I was growing, which led ultimately to my getting a divorce.

RCAC: What were the first organizations you joined as an artist?

SMAJO-RAMIREZ: I try very hard to stay away from organizations. I have this incredible pretension about being unique, by myself, so I try

to stay away from organizations. We had a Wednesday evening group of artists that would get together and talk, but I was getting uncomfortable with it, because people started asking, "What is your philosophy? You ought to have a philosophy." There were a few that said let's write a manifesto. I started really getting frightened then. Then it got down to a case where one art dealer decided to put together a series of drawings by all of us, into a box, and sell them. And that's when I said, "That's it for me!"

RCAC: Do you belong to any artist organizations now, other than the galleries where you show?

SMAJO-RAMIREZ: No, I don't. I've worked with a place called Metropolitan Structures, which was an organization in Chicago that had an art advisory board that I would sit on, and I, along with a few other artists, would recommend different kinds of shows they could do. I don't apply for a lot of grants and things like that. I've always been able to support myself with my art, and I find it real cumbersome going through the process. By the same token, I am aware of the necessity for those things to exist, because there's a great need for a lot of artists to have that accessible to them.

RCAC: How do you feel about unionization for artists?

SMAJO-RAMIREZ: Well, I was a union man for a long time—Local 705 and 710 of the International Brotherhood of Teamsters—and I wouldn't give you a nickel for a union. But I will say this: There was a time when they were necessary, when they first came in. There's no question about it. But there's just too many things that have taken place over the years that have led me to believe that there are powers involved in unions that don't have the welfare of their constituency at hand. Not all, but some.

RCAC: Describe the period in which you first achieved professional recognition as an artist.

SMAJO-RAMIREZ: Well, I guess that would have been while I was in undergrad school. I had mentioned that I was asked to do a show in the Black Hawk Restaurant. But if you mean the first time I sold something, that would probably have been about 1976, when I had my second one-person show, at a place called Chicago Gallery.

RCAC: Did critical reviews follow?

SMAJO-RAMIREZ: Yes, it did. There were two of them, both by Chicago art critics, one named Alan Artner and the other Dennis Adrian, the person I mentioned to you earlier. And both reviews were very positive.

RCAC: How would you describe the group you rely on now as your peers?

SMAJO-RAMIREZ: I suppose in some instances they haven't changed an awful lot. I still see and talk about conditions of life that are part of making art with many of the people, the faculty at the University of Illinois at Chicago who have since become my friends and colleagues and coworkers. I have an additional group of newer peers, who are my colleagues here at the University of Wisconsin–Madison, and there are again a few people here who I confide in and talk to. Some are visual artists, some are writers, whom I consider, I guess, now that I understand the word "artist" a little bit better, also artists. Some are curators, gallery dealers.

My present in-laws are in some ways an influence. They have a way of looking at the world, both of them, that kind of intrigues me and that in a lot of ways has influenced my own thinking in some respects about how I approach the things I do as an artist.

RCAC: How would you describe your occupation? Is this different from your career?

SMAJO-RAMIREZ: My occupation, I guess, is really as a teacher. I don't consider painting and doing these other things that I do as really an occupation so much as something that I wouldn't want to live without doing. Teaching is something I love very, very much and, of course, what I do, in that my own work as an artist comes very much into play with what I teach and how I teach and how I perceive the things that I teach. I don't see either one as a career. It just isn't. There are too many things involved. The word "career" does have a connotation to me that equates with, or is synonymous with, the idea of success. It's as if there's a certain level of success that one must kind of meet almost, or attain, to have had a good career. And I just don't see that kind of thinking as having any place in being a teacher or in being an artist.

RCAC: How long have you been teaching?

SMAJO-RAMIREZ: I've been teaching ten, twelve years.

RCAC: So did you come here after your truck driving and then school and then painting? Did you stay in Chicago?

SMAJO-RAMIREZ: After I graduated from the University of Chicago (I did my graduate work there, which is, by the way, where I met my present-day wife, Linda, who is also an artist), I went back to driving a truck for about six months, because I needed some money to support myself and to rent this loft in Chicago. And then I went to work for about a year at the University of Chicago in the admissions department. And while I was there, I would sit in my office when I wasn't doing interviews and read. I read philosophy a lot; it interests me a great deal. And I got this idea that maybe it might be interesting if I could apply to

the graduate program to work toward a doctorate in some field that would be directly related to what I was doing in my artwork, feeling also that I'd accomplish a number of things: getting the research done that would interest me while I was making my art, which I would also be selling to support me, and then I would get a higher degree which might enable me to get a teaching job. So I applied and was accepted. I was given a really nice fellowship, and I started working on this thing. All of a sudden what began as an adventure into thinking about art turned into a very structured academic idea about writing about art. It wasn't feeling right at all. So I gave the fellowship back and took a teaching job at the University of Illinois in Chicago that came up on an adjunct basis, which meant that I would just be teaching part-time. Eventually it led into my teaching full-time, going on a tenure track. Then I received tenure while I was there.

Then while I was there, this position here at the University of Wisconsin opened up on the Madison Plan, and I was asked to come down and interview for this job. The conditions were appealing, because the main consideration that I had was time. I wanted more time to do my work, because teaching does tend to be very demanding in terms of time away from your studio. And we worked something out here where it was very good. It's just an incredible salary. That, coupled with the fact that our children, our two boys, who were in school in Chicago, were having a tough time. There was also an opportunity here at Madison where things, as they were explained to me, were at a crossroads, where it looked like things could really start to blossom, and there were certain aspects of the program that I could make some contribution to. There are a number of faculty here I find very proficient. I never realized how much I would miss Chicago though. I lived there for forty-seven years. I was born there. Here it's a totally different atmosphere. I'm having a lot of trouble with it. I am a concrete-and-steel person; I have been all of my life. This is incredibly beautiful here; it can almost lull you to sleep. And I'm not used to seeing mallard ducks walk across my lawn. As beautiful as it is, it kind of jars me all the time. I do remember kind of worrying whether or not I could still make art up here. I don't think that's a problem. In fact I think the newest body of work that I've done is maybe the best work I've ever done.

RCAC: Do you see any pattern or progression in your career or the work that you have been doing?

SMAJO-RAMIREZ: The pattern I think is that I'm still dealing with those concerns of minimalism. They never seem to alter themselves any. I teach a number of seminars in postmodern theory, and I really enjoy the

young ideas. I don't agree with hardly any of them—I don't know if I'm too conservative or too much a traditionalist—but I find them actually very thought-provoking. I don't find the artwork real provoking, but I find the ideas quite provoking.

RCAC: Describe the gatekeepers at various stages in your career.

SMAJO-RAMIREZ: We were talking a little earlier in our conversation about the peer-pressure thing. And I mentioned about being half Mexican and being half Yugoslavian, I was in an Irish-Polish Catholic neighborhood, and everything was just perfect. I'm looking back now and finding out that I don't think it was all that perfect. I think that in fact there were some times when being the good old Mexican kid on the block bothered me quite a bit—not so much then, but now—that I was always considered as Mexican and not Mexican-Yugoslavian, and that maybe I was just kind of a mascot or something. In some of my recent experiences teaching, there has been some prejudice—against the fact, for example, that I could come into a situation here as a minority and be given a reward of a kind that a lot of other people who aren't considered minorities are somewhat envious of. And it's something that I understand; I have great empathy for that. On the other hand I can't apologize for the fact that I live in the times that I live in and have accomplished the things that I have accomplished parallel with those times. I'll never apologize for those things, but it's uncomfortable.

RCAC: What have been the major turning points in your career?

SMAJO-RAMIREZ: Certainly when I was given a one-person exhibition of a suite of prints in the prints and drawing section of the Art Institute of Chicago. From what I understand, I was the first Chicagoan ever to be given a one-person exhibition in this particular department. I think that had a lot to do with a certain kind of significance accorded to my work, which, I suppose, reflects on me as being maybe a significant kind of artist, at least at a particular time, because first of all you're being legitimized, if you will, by a major institution. It solidified not only those things in the art community, or the art mainstream, but again it was one more of those very positive things in my life that made me feel as if I do things that are worthwhile looking at or thinking about.

RCAC: What has been your relationship to money throughout your career?

SMAJO-RAMIREZ: Very good as far as the sales of works are concerned. People collect my work, and I've had this good fortune. I think I've had eighteen one-person shows in Chicago, and I would say probably fourteen or fifteen of them were sold out when I had the exhibition, and others would be sold out later when the exhibition was

over. But the point is that people have been very supportive, and not just in Chicago. I mean, people on the West Coast have collected my work, and museums in different parts of the country.

RCAC: How have the costs of supporting your art changed over time?

SMAJO-RAMIREZ: The costs have never been really prohibitive, because when you're selling work you can put the money back into the artwork. My most recent show, I didn't sell anything, nothing at all. And, you know, what does one attribute that to? Well, I've been told by my dealer that things are really hard, money is tight, and all of that. But, you know, dealers are going to be nice to you too!

But getting back to the situation I'm in here at the University of Wisconsin, one of the other attractive things about this university, which is an incredible university as a research institution, is that we have research grants here, and faculty can apply.

RCAC: For the artists?

SMAJO-RAMIREZ: Yes, faculty apply for the research grants, and they're quite generous with the amount of money they'll give you to support you as an artist.

RCAC: Have grants, awards, competitions, or emergency funds affected your career?

SMAJO-RAMIREZ: As I said earlier, I don't apply for many grants. I've never felt a need to, because I've always had the money, and it just takes so much time to put all that stuff together. Since the money's there, I don't do it. I still think they're worthwhile having. I'm always a little bit uncomfortable with the idea of the government having anything to do with funding artists.

RCAC: What has been the importance of physical location and work space at different stages of your career?

SMAJO-RAMIREZ: Very, very important, if for no other reason than convenience. I had a loft in Chicago back in 1978 that was about fifty-two hundred square feet. It was quite large. And then I moved to a home on the far South Side of Chicago and worked out of a garage, which I turned into a studio, which was about four hundred square feet. I do very large-scale work, and I still continued to do large-scale work, and fortunately I work primarily in panels, but I could never see the whole thing up at one time. Coming here I have this studio which is about fourteen hundred square feet, which accommodates my needs. It still is not as large as I'd like it, but it's certainly very good. So it hasn't affected my work in terms of aesthetics, because I still manage to make the large-scale work even in a small environment.

A question I was asked by a number of people in Chicago at this most

recent exhibition was, "How much has being in Wisconsin affected what you are doing?" My response to that was, "Not at all," but I really don't know that. I don't think it has, but I don't really know.

RCAC: What kind of control do you exert over your own destiny as an artist?

SMAJO-RAMIREZ: In terms of some notion of success, really none at all. In terms of enjoying what I do, I have total control over that. There are times when I hate being in here. I mean, I just don't like it, it's no fun, it's not interesting. Maybe it's because I don't have any ideas, or it might be because I'd rather go play golf, which I love to do. Or I'd rather do something with my family. But that's the way it is!

RCAC: How have you interacted with the public throughout your career?

SMAJO-RAMIREZ: Well, I've always tried to make myself available to people who wanted to speak with me, about my art for example. If I'm asked to lecture on my art, I can only think in very rare instances where I have refused to do that. I think you're kind of obligated to really, it's almost a responsibility, especially with the good fortune that I've had, where people have been so supportive. I think you have to give things back. As difficult as it is to try to articulate verbally what your work's about, I think it's still something that you should do.

RCAC: What are your own criteria for success as an artist?

SMAJO-RAMIREZ: I guess my own criterion is that I have focused on this issue of reality in the way that I've experienced it through minimalism—minimalist ideas and other kinds of art ideas. There's an element of the notion of truth. One comes to find out we're talking about so many different shades of truth and aspects of it. I'm not talking now about an absolute truth, because I think that's one of those leaps one makes. But I have been in pursuit of a kind of truth for me, and it's still coming into play for me. It's still there; I'm still seeking it. That is the one thing that I don't deviate from, and if I'm successful at all, it's not in finding it, but it's in being as honest as I think I possibly can through this process, in that pursuit. It's very pretentious to think you don't deviate from that; I'm sure one does. I mean, there are certain other things that we start to fit in. But I guess ideally, if there's a success factor, it's that somewhere along the line, hopefully there's at least one thing that I have "made," not thought about, that somehow will reflect that pursuit of the kind of truth that I've been focusing on for some time. I guess the other element of that would be that understanding or that expression communicated would have some value, that it could actually make something in the world better. And I'm not going to say, because I think it's a cliché, even if it means just for one person, because I don't

really mean that. I would like to have a larger impact than that; that's important to me. So in terms of success, ideally that would be it.

RCAC: Do you hold these same criteria for other artists as well as for yourself?

SMAJO-RAMIREZ: No, I don't.

RCAC: Are there particular periods of work that you feel more satisfied with than others?

SMAJO-RAMIREZ: Oh, definitely. There have certainly been times when I've worked on a series and have felt, "Well, this is just wonderful, it's great," and I'll stop and I'll look back on it, and say, "Gee, you know what? It just isn't so great." And so usually I can find one or two things in different periods of my work that I think are the strongest, that line up with this element of truth that I was talking about, this thing that I pursue as an artist that is there. But I think ultimately one leaves that to others. I think you really have to.

RCAC: What are your feelings about critical review of your work?

SMAJO-RAMIREZ: You want as much as you can get, especially from those who spend a lot of time investigating the nature of art, because I think it's helpful and gives you feedback in terms of how you're progressing in the field. The downside of that, I suppose, could be how much one is affected by the kind of criticism one gets. Does one begin to work for critics or oneself?

RCAC: How satisfied are you with your career as an artist?

SMAJO-RAMIREZ: It's so easy for me to say I'm really satisfied, because I've had limited successes of one kind or another.

RCAC: What have been your major frustrations?

SMAJO-RAMIREZ: When one makes art and talks about some kind of relationship of art to life, you're really hit over the head when you are married to another artist, which I am. I am married to a woman who I love deeply, and who is an absolutely tremendous individual, who I have learned so much from, who is so bright, so intelligent, and I think also a wonderful artist. But the confrontation of trying to deal with time—who watches the kids, who doesn't watch the kids, especially in an era of women's liberation, which I strongly embrace, teach in my classes—that is an incredible frustration, because I want for her everything I want for myself, and it can't be done! She has to steal, like I have to steal. And that is a reality, at least in my experience.

RCAC: How would your describe the greatest satisfaction in your career?

SMAJO-RAMIREZ: I can't help still feeling that the show I had at the Art Institute was incredibly satisfying because I think the work was solid. I think the work was good. In terms of what I've been trying to

accomplish over the years, I think that the pieces that I've just finished are really strong. In particular, the dirt pieces—and I hate to single out works like that, because usually someone will come along and say, "You're wrong, it's the other ones." I really do feel that these earthworks that I've just finished are good. I'm very satisfied with that. I'm also very satisfied with some things that are happening in my teaching right now. In some of the seminars, there are some young individuals to whom good things are happening, and they tell me that in some respects some of the things that we were able to discuss in the seminars we've had have made their life genuine for them in ways that weren't before.

RCAC: What has been the effect of the marketplace on your work?

SMAJO-RAMIREZ: As I said, I didn't sell any work from this show, although I understand there's a bunch of things on hold. And my dealer said that the economy is such that no one will spend over four thousand dollars, and over the years my work has gotten to a price where I couldn't buy my own. So, I guess, it's having an effect!

RCAC: What one major point do you make to your students, or would you make to a young painter, about pursuing a career in the arts?

SMAJO-RAMIREZ: Really going into your studio and loving it when you're there is an indication that in some way there's a sense of self that is going to be embraced through this activity. If that means something to you, then do it forever. Just keep challenging yourself, permit yourself to be good to yourself, to go do it. It's too easy to look at making art as being some kind of situation that you need to struggle, to bring every bad thing or good thing into a work. You never know what it is. It usually tells you who you are if you let it. And you have to play. That's the biggest factor: play. Be willing to play when you're making your art or thinking about it.

Honors: Wisconsin Arts Board Fellowship, 1992; University of Wisconsin–Madison Research Grant, 1992, 1990, 1989; State of Illinois Commission, Chicago Technology Park, 1988; Commission, Frito-Lay, Dallas, 1985; Commission, New Art Examiner Benefit, 1984; Commission, State of Illinois Center Building, 1983; Commission, Illinois Governor's Award, 1982; Mr. and Mrs. Frank G Logan Medal, Art Institute of Chicago, 1978; CIC (Committee on Institutional Cooperation) Fellowship, University of Chicago, 1978; Fairweather-Hardin Gallery Prize for Excellence in the Fine Arts, University of Chicago, 1977.

Representative collections include: Corporate: AT&T (New York), Borg-Warner (Chicago), Continental Bank (Chicago), Illinois Bell Telephone (Chicago), Kemper Group Insurance (Chicago), Standard Oil (Chicago); Public: Art Institute of Chicago, David and Alfred Smart Gallery, University of Chicago, Illinois State

Museum (Springfield), Indianapolis Museum of Art, Museum of Contemporary Art (Chicago).

Professional affiliations: Advisory Committee Member, *Per Cent for the Arts*, Wisconsin Arts Board, 1992; Steering Committee Member, Mid America College Art Association, 1991; Member, Associate Editorial Board, *Journal Twenty-One: A Journal of Art and Culture*, 1987–91; Member, Metropolitan Structures Advisory Committee, 1987.

EMMI WHITEHORSE

B. Crown Point, New Mexico, 1959. Attended the University of New Mexico, 1976–82 (B.A. 1980; M.A. 1982). Lives and works in Santa Fe, New Mexico. Exhibits internationally.

RCAC: What were your initial experiences with art?

WHITEHORSE: I don't know, but somehow innately I just knew that that's what I was born to do—to draw. The only thing that I could do. I never excelled in anything else. I was terrible. I was really inept at everything, except for the fact that I could draw. I could always draw better than most of the other kids, so I always felt that I had a special gift, and that's what I clung to and that's what kept me going, I guess, through the most difficult times. You know, just knowing that I had that one special gift that I could do better than most people. Very young I decided that this was what I was going to do, made up my mind that this was going to be my life and this is what I was going to make my life, living as an artist. I must have been five, six years old when I made up my mind that this was what I was going to do. About five years old, I was put in a government boarding school, but I spent some time at home and half the year in a boarding school situation, where I didn't have any visitors. It was a very lonely existence, and you were herded around with other children from the other parts of the reservation. It was very lonely, but then again, during the summertime, it was like Christmas, it was the happiest time of our lives, because that was the time we spent

with our family, and we got to do what we wanted to do. Got up when we wanted to, dressed the way we wanted to, and ate the kind of food that we wanted to. So it was always half and half. You always got something that you always wished you had most of the time, and then half the time you were deprived and forced to adapt to a new way of living and thinking.

RCAC: How do you think the members of your family felt about your interest in art?

WHITEHORSE: I was the baby of the family, so I don't think they took me seriously at first. Oh, you know, "She has to be taken care of," that sort of thing. I really didn't have much clout. And then when I was a teenager, I guess I was just thought of as an oddball. My siblings did everything that parents get nightmares over. They would run away, or once in a while they'd run off and do stuff that just put more gray hairs on my parents' heads. But I never did. I never did anything like that; I was a very quiet, introspective kid at the time, so I think I really was just regarded as an oddball. I guess my parents just were waiting to see what I was going to do. They never pushed me into anything, although they wanted me to be something like a lawyer or a doctor of course. But they never really pushed me in one direction. Most of the time major decisions were left up to me. My parents would always say, "Well, it's going to be your decision. And it's going to be what you're going to have to live with. And you're going to have to do what you want to do." And I always felt like, jeez, I wish I would get a little bit of direction, but they never interfered. Sometimes I wished they had, just so that I had a sense of guidance.

I was pretty much responsible for where I wanted to go to get my education. And then when I got to the university, my parents and my other brothers and sisters just assumed that I was there at the university learning a profession such as a lawyer. So they were very supportive, verbally, about that. But nobody ever came to visit me at the university. It was the same thing like back in boarding school, you know? You wanted your parents to come see you, and you wanted so much to have contact with family, but nobody ever came to visit me. And Albuquerque is not too far from where I live, but nobody ever came to see how I was doing at school. So I found myself again basically just struggling for myself. Everybody just assumed I was preparing myself for a major career of some sort, but they didn't know what I was doing. They didn't even know that I was in the art department.

RCAC: Do you think being an artist in a way isolated you from your

family? Is it the art that isolated you, or were you just different from your family?

WHITEHORSE: Probably a mix of both, I think. My siblings were pretty artistic; they were very gifted also. One was very athletic; he got all the awards in high school for basketball or football or whatever. My sister was like that too. As far as athletics were concerned, she was very good in those. And then another sister of mine was an honor student all the time. But, yes, I think that set me apart from the rest of my family. I was different. I do look very different, too. You know, I'm much, much taller than all my other siblings, and I really don't look like part of the family at all. I don't know what it was, but I always felt very different. From the very beginning when I was a child, I always sensed that I was very different.

RCAC: What educational experiences do you think provided you with early validation or resistance to your art?

WHITEHORSE: Well, the validation was when I was in high school. One teacher there encouraged me to enter a contest. I entered and it turned out that my art won over all in the whole state. I ended up getting a scholarship because of that, and that just sort of surprised me, and I thought that I could do something important. And I was very grateful to her, urging me to do something like that, because I never would have done something like that on my own. I didn't have that fierce achievement sort of attitude either. And I guess also, when I was a child, I refused to learn anything else in school. So what I would do is turn inward and end up just drawing. I would draw, draw, draw, to a point where I wasn't even allowed to have paper or pencil. So it just made me think, "I'm doing something they hate, and I want to do it anyhow."

RCAC: So when you were a child, you were mostly drawing?

WHITEHORSE: I was mostly drawing. I still do that. Most of my work is still a lot of drawing right now. You know, it's really not painting. I can't paint like other people paint, because I don't use paintbrushes. I hate paintbrushes. I use my hands to apply all the pigment and spread it out with my hands.

RCAC: When did you become an artist? And how did you know?

WHITEHORSE: I started showing when I was at the University of New Mexico, when I was in my last or second year of a B.A. program. And I guess that's when I decided, "Yes, I am a real, bona fide artist now, and it's a business also." In the last year of my master's program, I was very lucky, I got picked up by a gallery that had a very good name. In '78, '79, is when my career as an artist really did take off.

RCAC: When did you specialize in your current art form? When did you start doing the kind of work that you're doing now?

WHITEHORSE: I think that maybe in the last half of '79 and 1980 is when I finally just figured out what it is I wanted to do, because before that I was just sort of floundering around, playing around with all sorts of materials and things, and not really having a core, an idea. And then, in 1980, I hit upon something, and things sort of fell together. The way of working and what I wanted to express all sort of came together. I had to make up my own way of working, and I still use that today. I think that's what makes me unique in a way too, the fact that I had to invent the way that I work.

RCAC: So after high school you went on to college and you studied art. Were you interested in any other subject?

WHITEHORSE: I did go straight from high school to the university. The transition for me was like, oh, this is just part of the boarding school system again. So I really wasn't terrified, except that the university was so huge that it terrified me a bit, but, you know, it was like, well, if you don't do it, you'll never find out what you're missing. So I just sort of went in; it was like jumping off a cliff. When I landed at the university, I said, "Okay, I'm here. I've got to learn how to deal with the situation, even if it kills me." That was my attitude when I got to the university. And I found that it wasn't really that different. And it wasn't as scary as I thought it was going to be, so I said, "I can live with it." And I think that's why I ended up surviving the whole six years that it took me to get my degree. I was also very interested in writing, so I did take a lot of writing courses. I just sort of roamed around in the art department too. I took up ceramics, I took up sculpture, I started making steel sculptures and some motorized sculptures. I still want to go back to that, because I did have a whole series of works that were very much like Richard Serra pieces, and they were huge things, but at the time I just couldn't afford the material or the storage space. I had to give it up. I sold all my welding gear, and I ended up working in the photography department. (Because of my love for black and white, the sculpture was also black and white pieces.) I took some photography, and I ended up back in the drawing department, and I did get my degree in printmaking, not in painting, which is more graphic-oriented, more drawing-oriented.

RCAC: Describe the importance of peers to you in this time right after high school, and talk about who they were and how they influenced you.

WHITEHORSE: I don't think that I had any, because when I went to high school, that was so far away from my home and it was a very temporary sort of setting. And I never saw anybody again from that high school,

because it was in Arizona, and I lived in New Mexico. I was born in New Mexico, and I grew up in New Mexico. But my brother had gotten a temporary job in Arizona, so I ended up spending the last two years with his family there, because they needed sort of like a housekeeper–baby-sitter, cheap. So I was available. I never saw anybody again from there, and when I got to the university, I didn't know anybody there either, and I didn't have any friends. But I do remember some of the classmates that I had. For some reason when it came my turn to talk about my work, I mean it was just student work, people would get very upset. Sometimes it was a very hostile atmosphere. I didn't have anybody to look up to, or help me, when I was fending for myself.

RCAC: You didn't have any role models or mentors?

WHITEHORSE: No.

RCAC: What qualities do you think you needed the most in that period—physical stamina, mental discipline, anything like that?

WHITEHORSE: I was introduced to a lot of European artists, but somehow I always felt like I had no alliance with them. I admired a lot of artists, admired a lot of their art, the architecture and things like that, but I always felt like it was not mine. Somehow I always had that very strong sense of myself. I know where I was from, and I knew what I was capable of and from what background I came. Somehow I had a very nice sense of comfortableness with who I was. So I always felt like I had to look to myself, to invent things myself. And I think some of the same way with the American artists. I can borrow theories and ideas and techniques from the modernist painters. And I can reinvent it and reuse it in my own way so that there is a fresh approach, or it looks new, I guess.

RCAC: During this period what materials were you working with, and what was your relationship to those materials?

WHITEHORSE: I worked with paper then. I worked with a lot of colored oils, pastels. And then with photography I worked with a lot of the graphic-making materials and a lot of etching inks. I still work with those same things. I still work with the oil sticks, and I still work on paper. I work on canvas now and then, but I still put paper on the canvas. And I somehow felt very comfortable using steel too, so I want to go back into steel.

RCAC: What materials do you use now?

WHITEHORSE: I work with a lot of chalk now and with oil pastels and maybe sometimes rice paper. And then some stains—oil stains, turpentine stains. And sometimes I work with dyes. Earlier I was working a lot

with rice paper; I would dye the rice paper and collage that onto my works.

RCAC: Do you think your training during this post–high school period prepared you for your career as an artist?

WHITEHORSE: I don't think so. I think it started at five years old, when I was taken away to boarding school and knew that there was a distant system I had to work with and live with, and how to maneuver through that. Somehow I always think my preparation started when I was five years old.

RCAC: Did you ever give yourself benchmarks for progress, like, "In five years I want to be X?"

WHITEHORSE: Oh, no, I don't ever do that. It's every day, one day at a time. I'm much too modest when it comes to trying to plot out a career or ambitions.

RCAC: What were the first organizations that you joined as an artist—and if you did, which ones are you still active in?

WHITEHORSE: I was always one that was never a joiner. But we did have a little group that grew out of the university atmosphere, the environment there at UNM, and it was a group consisting of all Native American students that were in the art department, so it was like our own little Indian art club. There was one guy from the sculpture department who joined us, and there was me and there was another woman who was also in the painting classes. That forced us to come together, because we were always being dumped on, so we came together as a support group and we called ourselves the Gray Canyon. And it turned out that the Gray Canyon group turned out to be a very popular thing at the time, because all of a sudden we had a big color videotape done on us, and we had catalogs out, and we had traveling shows through a lot of the museums across the U.S. It was like overnight success, and that was sort of overwhelming too. But it also prepared us a lot, in the business dealings and what we wanted to pursue and do in the art world, I guess. And that was the first one.

After a year or so that group disintegrated, and each artist in that group just got so busy, or we moved away from each other out of state. But every single one of those people is still in the art world. Some have bigger names; some have taken other turns. They're more in the political field, as far as when it comes to tribal government. Some of them don't paint anymore, but they're teachers, I guess, or something like that.

Two of them turned out to be teachers. The second one founded an art society called the Albuquerque United Artists. It was a group of artists, and it was a co-op gallery. They had a space, and you paid your

membership, and you could book shows if you wanted to. I joined that and I was with them, but I didn't really take a lot of active part in it. I was just sort of one of the members who mailed in their membership dues every now and then and maybe donated to their fund-raising auction every year. And that was it. I was never really a part of it. But then I dropped out of that one when it got to a ridiculous size and started demanding ridiculous amounts of time from their members. So right now I don't belong to any organization. I'm one of those people who absolutely refuses to get involved with anything, and I'm always complaining, "Leave me alone, I don't want to know. Don't include me. Don't call me." I'm very much a loner. I've always been a loner.

RCAC: So you don't believe in anything like unionization for artists?

WHITEHORSE: Well, that probably I might. There should be some things done, because the artists are always the ones that are losing out on a lot of deals. There should be more legislation that would help the artist and protect the artist.

RCAC: Describe the period when you feel you first achieved professional recognition as an artist.

WHITEHORSE: That might be the show that I had with a gallery called Marilyn Butler Gallery. This was the first time that a major gallery had picked me up and gave me a show, but it was a very funny way that it came about. Someone had canceled the show that she had scheduled only two weeks before the opening, and she was tearing her hair out, going, "Oh, my God, what am I doing to do? I've got this empty slot here." Invitations had been printed, but they hadn't been mailed out yet. So she was left with a gap there and didn't know what to do. It turned out that she called a friend of mine, who turned around and suggested that she call me, to see what she thought of my work. I got this call in the evening and ended up having to Federal Express slides out the next day, and she liked the work, and all of a sudden I had a show. It was like a major show I had to do in two weeks' time, and she wanted twenty works of art overnight. So it was like, "Well, if I'm going to do it, if I'm going to be a part of this, I am going to have to pull this off. And I'm going to have to be able to pull this off all the time." So I said, "I'm going to do it," and I went ahead and did it. Got the work done, delivered, had the show and went for the opening, and that was probably the beginning of what would be my professional career.

RCAC: How would you describe your occupation? Is this different from your career?

WHITEHORSE: My life is painting, and that's what I do. I live it every day. It's just so much life for me that I can't separate the artist part of

me from the career part of me. It's hard for me to do that. It's all one thing for me.

RCAC: Describe your general job history from the time you began your career, and tell me if you think there's any sort of pattern or progression.

WHITEHORSE: I never ever had a job, to tell you the truth. I always felt like I was on the outskirts of society. I've never had a teaching job either. So far I've been lucky enough to be at a point where I am able to spend twenty-four hours a day just at home, painting, and be able to support myself totally from the sale of my artwork. I am very lucky. I have to have this concentration, total concentration, that I need.

RCAC: Can you describe the gatekeepers at various stages of your career, meaning those who let you in or people who barred the way for you as an artist?

WHITEHORSE: There were two people at the university that were very supportive and some others that were just horrendous teachers, to a point where they told me that I came from a primitive background, that I would never learn how to paint, and I should just forget the art world, get out of the painting department, and go enroll over in the art education department or something like that. One teacher was like that, just flat outright told me. That was probably one of the people who discouraged me, and I think also some of the museums in the earlier times. When we were doing the Gray Canyon group shows, a lot of the museums— they all happened to be museums that had something to do with Native Americans—and a lot of the museum board members were very disappointed, not happy with what the Gray Canyon group show contained. The artwork was not what they expected. Some of the museum board members were also people that were very set against seeing something contemporary or something new grow out of the old. And then there were some gallery people that were like Marilyn—the one gallery that picked me up. The Marilyn Butler Gallery was one that was very encouraging. She never demanded anything. She always wanted me to paint what I wanted to paint and at my own pace. And two lithographic teachers that I had at UNM—one was John Summers, who was the technical director at Tamarind Institute, who is now dead. He was a very supportive teacher. And then also Garo Antreasian, who was the one responsible for sort of reviving the lithographic process here in the states, just as it was dying out. He was also a very supportive teacher, and I dearly appreciate them to this day for that.

RCAC: Do you define yourself as a Native American painter or as a painter? And how would you rather be defined?

WHITEHORSE: I guess I would just rather be known as Emmi Whitehorse, the painter. I always had a very hard time saying that I was a Native American artist, because I don't want to really stress the fact that I am who I am. I already know I am a Native American. I am a Navaho person; my name screams it out. So I always introduced myself as Emmi Whitehorse, I am a painter. Or just Emmi. For a while I had a very hard time, trying to hide the fact that I was a Native American, to the point that I wanted to change my name to Brown so that nobody would know. But the Native American part of me is what was the interest for a lot of people, and I think that's responsible for most of my success, whether I want to admit it or not.

RCAC: What have been the discrepancies between your career aspirations and your actual opportunities?

WHITEHORSE: The opportunities that arose and came my way were far beyond what my dreams were, or what I had wished for. So when they did come, I was shocked that these things happened.

RCAC: What do you think the major turning point has been in your career up to this point?

WHITEHORSE: I think returning to the Southwest, for one thing, has really helped. I ended up living on the East Coast for five years, in Connecticut, and I literally lost my sense of direction and sense of self. I just was floundering; I had no idea what I was painting. So I came here, just to reorient myself for six months. And then I realized that I really didn't want to go back, so I stayed and ended up meeting another person that I had known back in my university days. Somehow meeting this person again and being back here in the Southwest was a major turning point for me.

I always had a very hard time not being able to really accept myself for who I was or who I am. There's this problem that I carried around with me from the boarding school days, where the matrons there would always treat us like dirty little Indians, and they would try to scrub the dark color off our skin with these big brushes, and that was so demeaning and just always stuck in my head. And somehow I always carried with me the fact that there was something wrong with me, that I was not accepted. I was different from society; I would never be accepted by society. I was always somehow reminded that I was a primitive person that would never succeed; I would only get as far as having a custodial job or something like that because that's what they stressed, vocational things like learning how to be a mechanic. People never said, "You could be a doctor, too." We were never ever told that. We were

always told that we could be secretaries. You could go to this business college, and all my sisters were all shipped out to these god-awful business colleges.

So somehow I always carried that negativeness with me, and it affected me. I never truly really accepted myself for who I was, was never comfortable with myself. I always wanted blond hair and blue eyes and lighter skin. So when I came back to the Southwest, I met this person.

RCAC: This person was also Native American?

WHITEHORSE: No, he was not. But he pointed out the facts: "Look at your culture. This is what your culture is famous for. Your culture is known for this. They're ingenious people. Your culture is just ingenious for using contemporary things. And using that tool or whatever to reinvent it and to make it their own." And he pointed out all the things, and I started looking at the things. I thought, "My God, these things are very contemporary if you look at them, you know?" That quilt looks like a Frank Stella, and that was done hundreds of years before Frank Stella even got around to painting—it's the weaving. But it's so contemporary. And then the jewelry that the Navahos did was just unbelievable. And he pointed out all these things to me. And then I started thinking, "You know, I do have something here to be proud of."

The return to the Southwest made me think I am who I am, and I like who I am. I am different, yes, but I can certainly use that. And I am different in a unique way. I am very lucky, and I am a very special person because of that. So it just brought a whole new wave of energy.

And I started doing this new series of work, which I am very excited about. There's a lot of possibilities with it. Plus the Wheelwright Museum has sort of given me a ten-year retrospective show, which I don't really want to call a retrospective, but it's a survey. I even had the clout to put my own show together. I designed the whole show—the walls, even picking out the color of the paint on the walls. The videotape, the catalog were all designed and laid out by me. So that was a real major turning point for me. I used to think everyone would be very critical about my work. I used to worry about that a lot. Now I feel like I can do anything I want. I will do whatever I want, as I please. That feeling, that coming to terms with myself and accepting myself, who I am, was really a major turning point for me.

RCAC: What's been your relationship to money throughout your career?

WHITEHORSE: Of course I'm a terrible business person. I should actually have a person manage my money for me, because I am really a terrible manager with money. I make enough that I can live comfortably,

but most of it goes back into the artwork, into the supplies and into traveling to different shows, overseas. It goes into hiring people to do photography for me and sometimes hiring people to have my canvas stretched for me, so I don't have to do that myself.

My only wish is that I had more, so that it would allow me to do the things that I'm only dreaming or wishing for now. I want to do some glass casting now, and it's going to cost so much money. It's going to take forever to do, but it would be very nice if the money was there just to go to the foundry and order it and have it done. That would be very nice. Other than that, of course it controls my life to a point, because sometimes I don't have any, and I can't go buy paper or paint sticks to work with, and sometimes somebody will want a painting and I can't make it. So it's always feast or famine. I think it's like that with everybody.

RCAC: Has the cost of supporting the art itself changed over time?

WHITEHORSE: I think it has, because a lot has to do with the hype involved in it. It drives up the prices, and everybody assumes if you're an artist you have a lot of money, so they charge you an arm and a leg for framing, for your materials. Just the whole industry surrounding that too.

RCAC: How have grants, awards, competitions, or emergency funds affected your career, and has there been a particular time in your career that money like that would have been the most helpful?

WHITEHORSE: I never ever applied for a grant of whatever kind in my life until this year. I have just applied for the NEA grant, and I probably won't get it. I have always stayed away from competitions or things of that nature, because it's like a lottery. You never get it. The little people never get it. What the hell, I'll do it myself. You know, that was always my attitude. I'll always do it myself; nobody will help me. I have no one to turn to. Yes, emergency grants I would have used when I was living in Connecticut, because the cost of living was just extremely high. And for someone who, as an artist, just couldn't survive, you just didn't have the money to go buy your materials. I would have loved to have had something available, or been given something like that then.

I think in places like New York or on the East Coast where the living conditions are higher than other places, maybe there should be more in those areas. Here you can certainly use a grant; out here we don't have a lot of support from the state. But then again our living conditions are very cheap, and you can get away with living on less than eighteen thousand a year.

RCAC: What has been the importance of physical location and work space at different stages of your career?

WHITEHORSE: That has always affected me tremendously. I love where I am now because of the light. You can't beat the light here. It's just unbelievable, plus the scenery is just tremendous. That openness that we have here is just unbelievable. You don't have that anywhere else.

I liked living on the East Coast for a while, but then it felt so claustrophobic to me. For some reason I felt like it choked me. I think I end up painting what I see, you know, what is around me. I ended up painting the leaves and the trees when I lived there. When I began here, I painted the landscape, but it was an abstracted landscape where, when you looked into the distance, you saw the land and the land and sky just sort of meet together somewhere way off in the distance. I guess I was fascinated by that, so I ended up painting works that merged the two, the land and sky together. So all the works had this feeling that you were falling into space or down from space onto the ground. I guess for some people it doesn't matter where they live; they'll paint anywhere. I would love to go to India and live there and paint too and see what happens. I'm very much influenced by my surroundings, yes.

RCAC: What kind of control do you exert over your own destiny as an artist?

WHITEHORSE: A lot, I think. I'm at a point now where I can steer; I can get what I want and turn away what I don't need. At the beginning you have to put up with a lot of things that you have no control over just to get recognition or to get ahead. But now it's comfortable, and I'm at a point where I can pretty much decide what I want.

RCAC: How do you feel about the marketplace? What's your relationship to it?

WHITEHORSE: Horrible. Here in America it has always been that big, open frontier attitude. People put so much emphasis on advertising and hype that things get ridiculously overpriced and overblown. But that's my problem with the art market; I feel that it shouldn't have to be that way here. Another problem is that you don't really get a lot of support from the state or the government. So we always have to fend for ourselves, and I think that invites that free-for-all, you-make-your-name-yourself attitude. And then you invite the hype.

RCAC: How have you interacted with the public throughout your career?

WHITEHORSE: This has been the year that I've really been interacting a lot more with my art public. I've always avoided meeting the people. (Not at my openings—I would go to my openings and meet people.) I always hide out; I always stay away. I have a very hard time trying to

socialize with people, so I end up staying home most of the time. The first year I ended up having to have a lot of people come through the studio, which I never allowed people to do. Now I've had people come through the studio, and I've gone and given little lectures and slide presentations. I'm sort of thinking, "Well, it's not so bad, and I could certainly use it as training and maybe use it in a positive way." So far they haven't been disastrous, but I am also able to not deal with it too, if I choose to. I can just say, you know, the gallery will take care of all that. But I think that the people who are the buying public really do enjoy meeting the artists and talking to the artists, and a lot of their comments are very genuine. And some people will bring out comments that are really real, and it makes you sort of confront something that you'd never recognize in yourself or didn't know.

RCAC: What are your criteria for success as an artist, and are these the same for other people as they are for you?

WHITEHORSE: I would hope so. One of the biggest things that I gripe about is that you should never put a price tag on it—that is, a ridiculous price—unless you yourself really think that the work is worth it. And one of my biggest concerns has always been that what I put out has to be reasonably priced, and it has to match the work: Is the work good enough? The work should be good, and then I can ask this much for it.

You go into painting because you are an oddball and this is what you want to do and you don't expect to make money at it. I think that's the best attitude to have when you go into this business. And one of the criteria probably is to keep working all the time. You've got to have a consistency too. You can't be flipping around. You've got to have a basic direction or a point of view that you want to present. You've got to have this one statement you want to say. You've got to have a clear idea of what you want to say and how you want to say it. Most people are very confused when they paint, and they don't know what they're saying or what they're doing. I always stress that you really have to have a specific direction where you're going. And I guess one thing would be that, you know, what it is you do, it has to come from you. It has to come from your own determination. Your personal stamp somehow has to come out, I think.

RCAC: Are there certain ideas that you have been working on throughout your career? And if so, are there particular periods of your work that you're more pleased with than other periods?

WHITEHORSE: I think I'm very happy with the 1990 series that I'm doing, and there was a series that I did in '88 of this very linear sort of work. It was very abstract. And then also the "Kin Nah Zin" series that

I did very early in the 1980s. "Kin Nah Zin" was one of the things that I really appreciate now. So I'm sort of aiming to get back to the 1980 series when things were very non-representational, very abstracted. I feel like I'm going around in a circle.

RCAC: What are your feelings about critical dialogue about your work?

WHITEHORSE: Some people seem to have an inner eye and have been able to hit the nail right on the head when it comes to my work. Most times they are really off—off! It's the problem with Native American art. People are assuming it's about storytelling; it's people going into the Egyptian tombs and trying to decipher the symbols. It's hieroglyphic. A lot of the criticisms are written like people are describing the painting to a blind person. You know, that's not clear for them. And that's the only kind that I get, and I hate that! We don't have a serious art critic here in Santa Fe. We don't have very good critics. They all try not to step on anybody's toes at all. They make everybody sound like a great artist, you know. And I hate that!

RCAC: How satisfied are you with your career as an artist?

WHITEHORSE: I guess I am pretty happy now. Before I wasn't really happy in a way, not really satisfied because I always felt that I was not taken seriously. My problem there was that being a Native American person, I was not taken on the same level; my work was not taken on the same level as a white person who painted in New York. I always felt they got the different treatment—and I got the different treatment! I still think that happens even today, because I sense it.

RCAC: Has that been the major frustration and resistance in your career, and have there been other frustrations you've felt?

WHITEHORSE: When I first started out, being a woman artist was a disadvantage because the major artists here in the Southwest were all Native American *male* artists, and the Native American female artists were not taken seriously. Now that has changed. You know, now it's the women that are the major artists and the most important ones. And I never could understand that, because my upbringing was always that the woman does everything, that the woman ran everything. I had a very hard time accepting that the males dominated the world because of my upbringing. That was one of the frustrations, in the beginning.

And then the second one was the one I just brought out recently: the fact that I was known only because of the fact that I was Native American. I was a novelty item. But I look at my work and, yes, there is some Native American mysticism or cultural baggage that seeps out in the paintings, but it's not so blatant. It's not meant just for Native American eyes. It's very universal. So now I'm again very comfortable

with the fact that the work itself doesn't say that it's painted by a Native American artist, that the work says that it's contemporary. It could have been painted by anybody, from anywhere in the world. But my frustration with that has changed, and I see it differently now. I see it differently, and I paint differently too, and I use that to my advantage now, I think. Plus the fact that there is sort of a new awakening of ethnicity in the art world now. A lot of Hispanic artists are now being featured, and a lot of black artists are now being featured. Now there is a door opening and acceptance of the minorities.

RCAC: What would you say is the greatest satisfaction of your career?

WHITEHORSE: I guess my stubbornness has helped me be the person that I am and made me put out the kind of work that I do. And one of the satisfactions is that my work is different. My work is unique in a way, and I see myself now as a unique person, so I'm very satisfied with that. Plus the fact that it's accessible to people.

RCAC: And how about the greatest disappointment?

WHITEHORSE: I guess that problem I mentioned before, that my acceptance in the art world would not have been possible only for the fact that I was Native American. I was accepted only because I was a novelty item. And realizing that I still was not taken seriously as most major artists would be taken seriously—that was probably a very disappointing realization for me. But I'm happy with myself now, so I don't have a need to feel that I have to be accepted anymore. If that side of the world doesn't like my work, fine. Probably one of my disappointments now, too, is the fact that the tide is changing. People are so conservative! I'm very disappointed in the situations where artists and photographers are being hounded like they're criminals! I think that's very disappointing. That says a lot about our society. I'm very afraid of what this place is going to be like in the next five years because of the conservative view, you know.

RCAC: How has the marketplace affected your career, your work?

WHITEHORSE: I've always tried not to let that dictate what I paint. It's always very easy to fall into that trap where you start to produce what sells the best. I never allow myself to do that; I always refuse to paint what's popular. I always paint what it is that I love doing the most. I don't care if nobody buys it or if anybody else likes it. Fine! I'll give it away.

RCAC: How has your relationship to your materials changed from early training until now?

WHITEHORSE: After formal training I think each artist finds out that what they learned in school does not apply in the real world or fit their

needs. So I ended up trying to unlearn a lot of what I was taught. I now do all the "don'ts" and mix media and paint with whatever gets the effects I want. I have ended up employing very unorthodox methods to get my message across or to achieve my paint surface. I think it makes for a much better working relationship with my materials now than back then.

RCAC: How have your absolute requirements for being able to do the work changed since your early career?

WHITEHORSE: Oh, I don't think they have much. I still have a lot of the same guidelines, I guess—the fact that back then I always had this attitude that, you know, this work is not good enough. I have to do it over again. I started with that attitude, and I still have that attitude. Plus the fact that I was a stubborn person, and I'm still really stubborn now.

RCAC: What major point would you make to young painters about pursuing a career in the arts?

WHITEHORSE: You don't get into this just to make money. If you do, become a lawyer or be a jeweler, something like that. I mean, people treat this like everybody's an expert in this. When it comes to artists, everybody looks over our shoulder and says, "Well, you should paint like this, paint like that! This is what you should paint!" Everybody's an expert all of a sudden; everybody thinks that it's glamorous, but it really isn't. There are more people in the visual arts world than there are in any other profession, you know. There are more artists than there are lawyers, I think. If someone wants to become an artist, I think somehow they have to have shaped that as a child or at a very young age that that's what they wanted to do—not just because of the hype involved in it.

I think whatever it is that they do, it should be real. I mean, it should be genuine. I always have a very hard time calling myself an artist too for some reason! I always refer to myself as a painter, because I think that the term "art" conjures up all sorts of other things too. I don't know. I think you have to be stubborn if you want to make it as an artist. There has to be some sort of stubborn streak, and you have to have a lot of patience, and you have to have a lot of perseverance, because it doesn't happen overnight, you know.

Representative collections include: Corporate: Hughes Aircraft Co. (Los Angeles), IBM Corp. (Tucson, AZ), Merchants National Bank (Cedar Rapids, IA), Mountain Bell (Denver), Paine Webber (Reno, NV), Phelps Dodge Corp. (Phoenix), Prudential Insurance Co. of America (Newark, NJ); Public: Albuquerque Museum of Fine Arts, Art Bank/Art in Embassies, U.S. Department of State

(Washington, DC), Heard Museum (Phoenix), Museum of New Mexico (Santa Fe), St. Louis Museum of Art.

Professional affiliations: Bentley-Tomlinson Gallery (Scottsdale, AZ), Hartje Gallery (Frankfurt, Germany), Jan Cicero Gallery (Chicago), Lew Allen Gallery (Santa Fe, NM), Lowe Gallery (Atlanta), Will Thompson Gallery (Telluride, CO).

LISA YOUNG

B. Mt. Prospect, Illinois, 1964. Attended the Art Institute of Chicago, 1980; the University of Illinois (B.F.A. Honors, 1986); Tufts University (M.F.A., 1991). Lives in Boston and works at the Fogg Art Museum, Harvard University.

RCAC: Lisa, can you tell me about your initial experiences with art?

YOUNG: I can remember getting praise as a child very early. I can remember other kids in class coming up and asking me to draw things for them, and I guess it was at that point that I became cognizant that I did well in art, in comparison to, say, math, in which I did really poorly. I think that it's only natural to keep doing something that you're praised for and to lose interest in something that doesn't seem that rewarding. I didn't have very many friends when I was a little girl, and I think that art was something I could do by myself that never got boring, and art was something that I could do privately that no one else could be critical of; I could hide it away.

When I was in high school, when I got a little bit older, I became more involved: I studied dance (I have actually studied dance since I was four) and studied the flute for four or five years, but all those things eventually came to an end. I tried to sit down and think about why I stopped doing those expressive forms and why I kept making things visually. I think it was because when I played my flute I knew that everyone in the house could hear me, and they would comment. They'd say "Oh, you played

that very well!" or "Oh, you screwed up that section!" And when I danced, I had to go to class and be with other people, and of course there was the performance aspect. It's not that I didn't enjoy performing, but I think that I felt I had the most control and the most freedom when I could go to my room and do whatever I wanted and no one else needed to know.

RCAC: Can you tell me about your family during that time?

YOUNG: My family has a very odd relationship to the arts. Both of my grandfathers were artists or artisans; they were both very talented. Both of my parents have a fairly good knowledge of art history. They appreciate the arts; they support the arts. I think that's very different from a lot of other people's parents that I know. My parents were both elementary school teachers, and I think that the elementary school system, the way that art (and other subjects) are taught to children, places an emphasis on a singular viewpoint, a linear approach to learning and a right and a wrong answer. My parents were invested in that system and in the way that I looked on paper—that I got all As, that I didn't get into any trouble at the principal's office. They liked my artwork because I was good at drawings things realistically. Through junior high and into high school, my parents were both better at rendering than I was, so they could still correct my work. I think that the educational system was a world my parents felt comfortable in, but I think that sometimes that system stifles creativity: It places an emphasis on a product instead of a process, and that's something that I've come to spend a lot of time thinking about in the studio now. So in a way my parents were very supportive, but in a way they were very stifling, and when I would come home from college and show them my report card, if I got a B in one of the art classes, they would say, "Maybe you should quit. Maybe you're just not good enough."

I think they had a lack of sensitivity for the fact that studio work cycles, and that there are highs and lows. I've discovered that sometimes it doesn't look like you're getting very far very quickly, and then you'll make a lot of quick progress. I have a brother; he is three years younger than I am. He's gone on in architecture, although he really likes sculpture; he's done a lot of sculpture, and I feel very close with him. I feel somewhat alienated from my parents, but I speak with my brother about all my ideas in their complexity. When I speak to my parents I speak more superficially: I say, "I'm doing an image of Lake Michigan," or "I'm using photographic images in my work." My brother really has the capacity to understand. He's involved in looking at contemporary art, so he's really a good person for me.

RCAC: What educational experiences provided you with early resistance or validation for your work?

YOUNG: On the one hand I was praised for my art as a child. I also think that there was resistance to my being good in art in that other kids would say I was "stuck-up" because I could draw things really well, and would ask me, "Why do you take art so seriously?"

I think that from a very early age kids grow to realize that art is not valued, and to do well in art isn't the same as doing well in social studies or math. I can remember, we were doing a social studies project about different historical periods; we were in the Middle Ages, and I made this full-scale castle with papier-mâché. It was very complex; things moved—for example, the drawbridge went up and down—and the instructor said, "Oh, you shouldn't have put in all that time and effort. You should have saved that for the Renaissance." And I look back on that, and I think, "You know, there's a perpetual privileging of certain periods in history, certain artists, certain kinds of artwork, and in a larger sense, a devaluing of art as a whole and within the value system of our society." Of course I wasn't cognizant of those things at the time, but that's what I think back on.

In a way I got affirmation through good grades, but there was a lot of resistance that was less overt and harder to pinpoint. I believe that is why I didn't really feel great about what I was doing.

RCAC: What art forms interested you in your early education?

YOUNG: Well, they've been pretty similar throughout my development. I've mostly worked with two-dimensional things; I did as a kid. I think that in elementary school that's what you do first: you paint, you draw with crayons, and clay is like a once-a-year thing.

When I was in college the program was fairly traditional. Most people used oil paint on canvas; that's what I used. I didn't really like it, but it was only after I left that institution and went to graduate school somewhere else that I realized the materials I chose to use were up to me. Also in my college, sculpture was on one floor, and painting was on another floor, and photo was on another floor, and there was not a whole lot of interdepartmental integration.

It was in graduate school that I really began to develop, to locate what was interesting to me and what materials I liked and what materials I didn't. I really like working on paper. I don't ever paint on canvas, and I don't use oil paint anymore either. The slow realization that I enjoyed using some materials more than others developed in tandem with the realization that there's no one form of art that's more equal than others, that you have the power to choose. So I use water-based paints; I use

paper; I use mechanically reproduced images, color plates, Xeroxes, some photographic imagery. I've done some sculpture; I've done an installation. But three-dimensional work is not really what appeals to me.

RCAC: When did you become an artist, and how did you know?

YOUNG: That's a really hard question, because it's just now that I've graduated (I received my master's last month) that I have had this realization that, in fact, there's really nothing other than art that I feel inclined to do, that I really have zero interest in any other professional career. At that point I realized, "Well, that means that I'm going to do work in the studio." I always knew that I wanted to do something involved in the arts, but when I entered college that could have been as an art historian, an illustrator, teaching art. I did not go to an art school, which I think my parents would have forbade. I went to the University of Illinois, which satisfied them, because it is a very well-known, "Big Ten" college. My parents told me I had to double-major; they suggested that I major in art education so that I could have a job and I could paint on the weekends. I went through the bulk of the certification program, but I felt it was lousy. I felt the way I was being trained to teach children, to sort of "start up" the next group of artists within the whole society, was really awful! And I realized I had two choices: I could either go into teaching in the public schools and really try to make changes for the better or say, "You know, I'm just not inclined to do that, and I'm going to get out of the system because it's going to kill me." I really saw the educational system take its toll on my parents.

So I really got out, and somehow I graduated, and as I was doing my last year, I became really panicked—I didn't really see myself as an artist at all! I saw myself as a student, and not even an art student, but just a student! I thought, "Well, my God, the only thing I'm capable of doing is going to school! I better go to school some more!" So I applied to some graduate programs, and amazingly enough I got into four of them, and so I picked one, and my parents said, "Well, why are you going?" And I said, "Well, I could teach on the college level. That interests me a lot more than teaching children." They said, "Okay, that sounds fine. We can provide some funding for that." However most of the way through graduate school was a real struggle: What am I really doing here? What am I going to do when I graduate? Will I keep working? And there were these sorts of slow realizations for my parents: that I had no real intention of becoming a professor as soon as I graduated either. My parents would cry and say, "You're going to end up on welfare," or they would make suggestions like, "You could

become a salesman for Winsor and Newton and paint on the weekends."
And it was just really slowly that I realized that I had a lot of skills, but
they just weren't "marketable" skills, that I really wasn't very interested
in developing those "marketable" skills. I began to recognize that I had
bona fide skills as an artist, and working in the studio was what I loved,
and speaking with people about art and being involved in that community
was what I really wanted.

I realized it was a choice of a life-style as well as a profession, to
choose to develop a creative force in my life that I think I'd be really
bored without. I know some people say that they knew they were artists
as soon as they were conscious, but I think that for a long time I have
been struggling with my parents and social conventions: feeling that I
was a person who would teach or have a real profession and, of course
get married. It was always in the near future that I was supposed to get
married to someone, and then I could paint and do whatever I wanted
to, along with being a wife. I realize that this is not the option for me;
that's not the way I see myself.

RCAC: Were there people during your undergraduate years or your
graduate school years who you considered your peers, and what was
their importance to you?

YOUNG: I keep in touch with one person from undergraduate. I don't
know what happened to the rest of them; I don't think that they went
into the arts. I think that my friend is very ambitious, she's my age, and
when she does things and tries things, it gives me the incentive to go
out and try them. When I entered graduate school I was five to ten years
younger than most everybody else, and in a way they were more like
mentors. Being the youngest in the program had its positive and
negative sides to it. The value of my relationship with my friend from
undergraduate was that I could hear her talking about first experiences
in all their imperfection, as opposed to speaking with someone who was
ten years older than me and having it explained to me how things worked
out for them.

When my friend from undergraduate and I went down to the College
Art Association (CAA) conference together for the first time, we made
a lot of mistakes, but it was very validating to have someone like me
there, as opposed to being in the position of being a child prodigy in a
graduate program.

I think that in a lot of ways the other graduate students were mentors.
I observed them. I watched how they handled things—not so much in
terms of artwork (none of them really influenced me very heavily in
terms of my work), but more in terms of how to deal with an art

consultant; how to market your work; how to prepare a slide sheet properly. Those were things that I learned from them. What I learned about my own painting was a more internal process.

RCAC: Were there teachers or other people who you consider mentors?

YOUNG: Yes. There were three people in graduate school that really helped me enormously. The one who helped me the most of all helped me to see my work more developmentally and to see myself as a person making that work, in a more whole sense. I know my first year in graduate school, I was very dissatisfied with my work. I thought it was terrible, and I can remember he gave me an A, and I went to him, and I said, "I don't understand; my work is terrible! I don't see why you aren't flunking me out of the program—my work is so bad! It's the worst work!" And he responded, "You just cannot see that progress that you're making now, and we will take this work out a year from now, and you'll see all the ways you were growing that you couldn't identify." And he was right. A year later I looked at that work, and it was still horrible! But it contained all the elements that showed up in later work that was a lot more successful, so something had been happening. And I think that realization was a really important thing. Because my work was poor that first year. I was really down, and people usually just responded formally, which wasn't very useful to me, like "Well, it looks kind of dark," or "You should have used a different brown." He was the one person that came into my studio and said, "You know, I think those comments are irrelevant. I think the real issue for you is that you're not operating out of your strongest base of power, and it's making work difficult for you." That's what I needed to hear! That's what made sense to me! That's what provided me with the impetus to move on. The best teaching that I ever received was someone telling me to go to a particular show or to look someone up in a book, because you have to put everything else together yourself. I think that the personal support meant as much to me as the critical support of my work.

RCAC: Do you feel you needed any particular qualities during that time—physical stamina, mental discipline?

YOUNG: Yes, definitely. I think that you need them all the time—forever—especially the ability to be disciplined, the ability to concentrate. I do believe that work comes very smoothly sometimes, and it's really tough at other times. I also know that when it's been very difficult to work, and I've worked anyway, even though I hated it, even though I thought the things I did were horrible, it's always better than not doing anything at all. It's so hard to do at the end of the day, to come in and say, "Boy, that painting is really horrible; I don't want to work on it,

but I'm going to work on it anyway." Many times when things were very difficult, I would create time limits, and I would say, "You will spend three hours a day in your studio, and it doesn't matter if you go in there and read art magazines or novels or if you just go in there and talk on the phone. It doesn't make any difference what you do, because somehow you're making progress." If you don't go into the studio at all because you don't feel like it, then nothing happens. The physical stuff, I think, that's pretty much tied in with the mental stuff.

The question of physical stamina is a funny question. I was always very, very thin in undergraduate, and then in graduate school I gained weight, and I wasn't exercising as much; I didn't ride my bike around campus because I lived in a city and I took the public transportation. I began to feel I had to make a commitment to becoming more fit, and it was mostly for self-esteem. I felt fat, felt ugly, and controlling that somehow increased my powers of concentration. I think that exercise increased my ability to follow through on things in the studio. And you have to move things around; you have to lift things up; you have to use a drill. I mean, I've done a lot of physical work because I'm an artist, not because my work is very physical; my work is basically painting. For example, when I moved into this space, I had to help build a wall that was thirty feet long and sixteen feet high, and I had to build furniture, and I had to put things together. I had to try to figure out how plumbing works. I think that you do need physical ability to do stuff like that, but that's not the most important thing.

RCAC: Do you think that this undergraduate and graduate training prepared you for your career as an artist?

YOUNG: I don't know! I mean, what is a career as an artist? Sometimes I see being an artist as being very separate from school. I feel like being in the educational system educated me; it educated me in a particular way. It gave me a certain groundwork. Individual teachers looked at things very formally; others looked at things more metaphorically; others tried to be more socially or theoretically contextual in the readings of work. All these readings work around in your mind and then come out in you and in your work, in whatever form it eventually evolves into. The one thing that you get from school—you get all this information. You get basic things like color theory and composition and you get people who are saying, "Read this; look at that." But in terms of being prepared, I guess what school does is that it gives you a lot of different people to interact with, because no particular program taught me, for example, how to write a cover letter or what to do on a studio visit. It was my going to an individual teacher that I had a good

relationship with and saying, "Listen, so-and-so's paying a studio visit. What do I do?" And him telling me, "Well, this is what I would do." And then my doing that, that's what prepared me, but that has to do with people, not a particular class. School provided me with a lot more people to interact with than if I had not been in school at all. I probably wouldn't have known a quarter of that number of people.

RCAC: I realize that you're still young, but have you set benchmarks for yourself? At a certain point do you want to be at a certain place?

YOUNG: I guess in a way, yes. I think about that a lot. I think I'm pretty ambitious. I also think goals are always changing too. They're changing very quickly now! I don't think it's a particular benchmark, but rather I don't want to see myself caught, stuck, in the position that I see a lot of other people stuck in—people in their early forties who are teaching at local universities, who may have representation at a local gallery, who are somewhat regionally known, and who are basically set up and no longer moving forward. I think the other thing about having a mentor is that I saw the faculty who were really pushing to continue to grow every day and to really move on with their work, and those who were not; those who had reached a point where they either burned themselves out or they just said, "This is a reasonable amount of success. I feel comfortable. I feel reasonably happy; things could be a lot worse, and this is where I'm gonna get off the train."

I know I'm really young, and it's really easy to say those things when you're young, but I guess that I realize that I don't want to get off the train anytime soon. I see people who are represented by galleries and set that as a goal; but I also see other people, a lot of young people especially (whose work is often more provocative than people who are represented), and I think a lot of them don't have any interest in becoming represented, they don't have that goal. I'm in the process of figuring out what it is that's going to be most satisfying to me, and it might not necessarily be going the gallery route, but just to keep working.

I want to find representation, but I'm not sure ultimately, once I get that, how meaningful it's really going to be. I mean I really wanted to be in an outside juried show, and I got in; I spoke in a symposium; I'm represented by a couple of art consultants; I've been in some other shows; I'm having a one-person show in the fall. But it doesn't make your work better, and it doesn't make it easier to work. And it doesn't really make you any happier. So I think that it's one thing to have these kind of benchmarks, and it's another thing to realize their real significance in the overall scheme of things.

RCAC: How you joined any artist organizations?

YOUNG: No, and I feel like I should.

RCAC: Do you have any feelings about unionization for artists?

YOUNG: I have such a vague concept of what that really means. One thing that I'm slightly involved in is the Arts Community Organization in my neighborhood here in Boston. I've gone to a few meetings to find out what's going on. One of the first things that I realized is that everyone in that room was an artist, and everyone in that room wanted something different. As a result these meetings were just intolerable! The solution for one person was the most irresponsible and ineffectual idea for another. We got stuck on these points and went around and around and around, and that's one of the reasons why I have a tendency to avoid those organizations, although I know that is no solution. I'm certainly not advocating, or very proud of, that decision, but I just can't take it. So to unionize what, for what, to what end, to the benefit of whom? It just seems totally impossible.

RCAC: Can you tell me when you first achieved professional recognition as an artist?

YOUNG: Probably I was twenty-three or twenty-four. Now I am twenty-six. And when I was twenty-four, I was included in a show that was curated by Kathy Halbreich; she's the director of the Walker Arts Center now, and at the time she was the curator of contemporary art at the Boston Museum of Fine Arts. I was juried into that show, spoke on a panel. The moderator was David Ross, who's now the director at the Whitney. At that point I was also approached by an art consultant who saw my work and who sold a piece for me, and I was also hired by the Boston Museum School as instructor in continuing ed. for that year. And I realized that several of my instructors at the Museum School had submitted work to that show and had not been accepted, that I was hired by the same institution that they were, even though they were hired for the long run and I was only hired for one year. I realized that I was essentially vying for the same goals that they had, and that I had the ability to achieve them (not that I would necessarily get into every show), and that's when I first felt a sense of professional recognition.

I thought, "I could very easily create more work in this vein and set myself up here and really cement myself in," and the consultant was very clear about what I needed to do: I needed to work smaller; I needed to introduce more color. And I thought, "I could figure this out; I could situate myself here in Boston permanently. I might even be able to make a living from my work." And I thought, "There's just no way I'm going to do that. I would consider that to be a failure." Yet when I felt like I

had professional outside recognition, I thought, "My god! But I'm not a professional! You know? I'm twenty-four! I'm as concerned with wanting to date someone as I am with feeling like some important professional." I didn't feel like a professional woman, basically; I didn't feel like a professional anything, and I couldn't believe that this had happened.

RCAC: How would you describe the people you rely on, as your peers?

YOUNG: They're probably people who are newly out of school or some of my instructors at the Museum School. I think that my relationship with my instructors has gone from being teacher and student to being peers, where we are in the same shows or that we meet for lunch. I know people who I see more professionally and people who I see more personally.

RCAC: Did they influence your career?

YOUNG: Definitely! In emotional and in real, overt, factual ways. I have friends who call me up whenever they see a show that would be good for me and tell me to apply, and I think that's a strong influence, when you get handed things that way, and also when you know that people are looking out for you and that they're interested in your work. And I think they influenced me professionally because I could go to them with questions, or I would just watch them and then do what they did. It was mostly through watching.

RCAC: How would you describe your occupation, and is this different from your career?

YOUNG: Yes. My occupation is a secretary. I really don't mind being a secretary; I really don't mind working in the office. It allows me to use my brain in a different way. I did some work as a graphic designer, and I have to admit, I think when you use your eyes and your hands in a visual way at work, sometimes you don't want to do more visual work when you come home. However I know some people like to work that way all the time. I don't mind the typing and filing; I actually kind of like it. I like organizing things. But I also feel isolated at this job; I think that I'd like to be a secretary in an arts organization; right now I'm not. It's somewhat alienating, and it is very hard to slip in and out of that mode. It's hard to be really present there when they're busy and I'm preoccupied with studio work.

RCAC: Tell me about your job history from sort of the beginning of your painting career to now.

YOUNG: There is none. It's this series of low-paying, work-study, student-type jobs, and I think that there are two reasons for that. I think that, one, I wasn't receiving any training; I wasn't an accounting major

who got a job at a bank to develop skills and a résumé, because no job that I found really helped me become a better painter in the studio. So there is a real gap in between those two things. Also (I don't want to generalize too much) I think for myself and for a lot of other artists that I know, there's a perception on our *own* part that we're incapable, that we're unskilled, that somehow to operate in the corporate world is just too sleazy. I think the reason that I have a history of low-paying, work-study jobs is that on a certain level I don't feel like I'm capable of doing more than that. And I think that that's a real mistake. That's the other thing: If you get really involved in something else, you have to make choices, and you have to find a balance between the studio and other aspects of your life. There's a good reason why a lot of artists I know are waitresses, but I think that it also raises an issue about taking yourself seriously, of deciding how much of the rest of the world you see yourself as being a part of. I think that's a real issue for artists. I basically worked my way up the secretary ladder. On the one hand I think, "What am I doing? I'm getting all these skills. I'm actually becoming a high-paid secretary!" And on the other hand, I think, "Well, you know, I could take those skills to an organization that meant something more to me."

RCAC: Lisa, were there gatekeepers at various stages of your career? People who either let you in or barred your way?

YOUNG: I think so. I think there were a lot more people who let me in; there were a lot more people who said, "Let me help you with this; let me mention your name to this gallery; I think your work is very good." And I think that not so much in graduate school, but especially in undergraduate, there were gatekeepers to personal and artistic power that barred my way—in a very insidious sense—because I was a woman. I can't say that I've been the recipient of any overt or really vile chauvinism or sexism, but it was definitely present. In my first painting class I can remember painting series of works that depicted a young girl in her bedroom; she was surrounded by many different hats and clothes and mirrors and makeup and all that kind of stuff. I didn't get a lot of support for that work, and so I began painting in a more expressionistic kind of Chicago school mode. One instructor came to me and said, "I am so glad you stopped doing those other paintings which were just an idyllic fantasy of girlhood." And I thought, "You know, that's not what they were really about." He had no ability to relate my artistic development to my personal development as a woman. And there was no role model to really talk to. Somehow I felt denied access to a privileged core because I was a woman. Those are things that I

notice. I notice the way that I'm treated by people, and when I think of gatekeepers, that's what I think about. I see it too in terms of who gets hired, and I think, "You know, once again they hired another man." It's very insidious, but it's really rampant!

RCAC: Have there been discrepancies between your aspirations and your opportunities so far?

YOUNG: No, not really.

RCAC: What do you think has been the major turning point in your career up to this point?

YOUNG: I guess the major turning point was getting juried into my first outside show. Even though I was still in school, it gave me a taste of what the future would be like, and the kind of work that I would have to do, and the way that I would have to present myself. It forced me to do things like write my first cover letter, my first artist's statement, my first résumé, my first bio.

You asked earlier, "When did you know that you achieved professional recognition?" And it was at the same time I realized, "Wait a minute. I'm putting the same effort, energy, and professionalism into this that the people who got a business degree put into their work and into what they do," and I realized, "I am a professional just like they are." I want to qualify this statement because I do not see commercial success as related to professionalism. Unlike people who equate professionalism with sales or with commercial success, I equate professionalism with the way that you handle yourself and the extent to which you take yourself seriously, having interactions with people that are meaningful and that help you learn, and becoming involved on a higher level in a larger community. That's what I mean by professionalism.

RCAC: What's been your relationship to money throughout your career?

YOUNG: Well, I'm probably not a very good person to ask that of, because although I've always had a job, and I worked as hard as I could, I've essentially always been in school until a month ago, and my parents picked up the tab for whatever I couldn't cover. But I've been selling a few things, and I recently won an endowed award, and it made me realize, "That's my money. That's my money that I earned, because of what I do, because I submitted a body of work and I was awarded this."

I'm still at a point where I solve my financial problems entirely by being a secretary; any extra money that I make is a perk. But I've seen people who are a little older than I am slowly shift from that into supporting themselves through completely arts-related money—grants, sales—and slowly cut down on their hours at their day job, you know, whatever bogus job they have, until it's just gone. So my relationship

to money is that I'd like to do really good work and get another endowment.

RCAC: Have you won any other awards or grants or fellowships?

YOUNG: No. I mean most of those things aren't really available to you when you're in school, so I just applied for things that I could get through school: That's how I received my endowed award.

RCAC: How about the importance of physical location and work space? How important are they?

YOUNG: I think that's really important. I've lived in four places in the last five years, and each place has been really different, and the place that I live in now is a loft space; it's a live/work space, and it's in an arts community downtown. Before that I lived in apartments and commuted to my studio, and I really did not like that. For me, getting a live/work space was a way of saying, "This is what I do, and I cannot avoid it." And I cannot blow off going to the studio for a week because I'm chicken, and rationalize it by pretending the studio doesn't exist because it's completely separate from my apartment. And I think that once you have a live/work space and once you're in a community with a whole bunch of other people who are doing the same thing, it fuels your fire; it validates what you're doing; it makes you want to keep doing it.

And location, I guess I take that to mean urban versus rural. For me right now it's really important to be in the city. I was raised in the white-bread suburbs, and the University of Illinois is located in Champaign-Urbana, which is in central Illinois, and it is essentially in the middle of a cornfield. It's a wonderful institution, but it was like living in the country, and when I graduated from there, I said, "I am living in a vacuum, and this is really bad." I know a lot of the graduate students who came to Champaign-Urbana to do their graduate program. They thought it was a great way to spend two years in the middle of nowhere and really concentrate. It depends on what you want. I think that it's a lot harder to network yourself into a position of getting shown if you're out in the middle of nowhere. A lot of people I know aren't interested in that, and they're perfectly content to live a more monastic life. But I like the active community.

RCAC: What kind of control do you feel you exert over your destiny as an artist?

YOUNG: I think there are two levels. Ultimately I exert all the control in terms of whether or not I keep working in that studio and whether or not I grow in a way that is going to make my life meaningful in a whole sense. But in terms of opportunity, I think I've been really, really lucky.

I've basically been able to do everything that I set out to do. I haven't received a lot of rejection; I've received a lot of affirmation. I don't think that that's going to last forever or be very consistent. I can see a lot of people who do good work who, for whatever reason, just aren't where they think that they should be. They don't have the skills or the interest to go to the openings and talk to the people, to take their slides around, to really bust their butt to promote themselves. And then they feel really bummed out and isolated as a consequence. I can't really be very critical of them, because it takes a lot of time and energy. In fact I see a lot of people who spend most of their time doing that, and I think their work suffers as a consequence.

I began to draw as a little girl because it gave me a lot of freedom, not because I wanted to market myself in the world. So I think that, as an artist, you're forced into a position of having to deal with the rest of the world and the way that it operates, whether you like it or not, if you want to be a part of that world. I think that a lot of artists end up being really bitter, and they say, "Well, we don't want to play the game." At a certain point I think you just have to say, "Well, which rotten apple is worse to bite into, the art market or isolation?" And you have to just make a choice or try to make the best compromise you can.

RCAC: What are your criteria for success as an artist? And are they the same for other people as for yourself?

YOUNG: No, they're definitely different for every single person. I think that people's criteria for success change all the time, depending on where they are in their lives. I think that my criterion for success is not to become complacent and not to stop taking risks at this point.

RCAC: Do you have a number of central ideas you keep working on throughout your work, and what are they?

YOUNG: Yes, I think that I do. I think that, if anything, my pieces are linked conceptually more than through a particular image or a material or a way of working. I think that my works have a tendency to center around the mechanics of desire, for instance the gap between a state of lack and a state of fulfillment that we experience as desire or yearning. I definitely see my work as relating back to that disparity that was set up in early childhood and I think compounded by the fact that I'm a woman. I see my work as an expression of the ideal versus the reality of a situation, in its varied forms. I even think back to those paintings when I was very young of the girl in her room with many hats, and I realize it wasn't that I was creating an idyllic scene; in retrospect I see that the driving force for those works was the gap between the fantasy

of being fulfilled with that environment and the fact that I found it totally unfulfilling and one which deprived me of any sense of self.

I think that a lot of my works have to do with a sense of self, or position of self, in relation to desire, which I explore through landscape. Someone came to my studio recently and said that I used the landscape as a means to create a kind of psychological expectation more than a straightforward depiction of the natural world. I think that comes across too in the gap between something that's mechanically reproduced and something that's actually real, a real leaf as opposed to an image of a leaf. So those things keep coming up.

RCAC: How satisfied do you feel so far with your career as an artist?

YOUNG: I feel really satisfied. I feel really kind of terrified by it frankly. I feel that my problem, strangely enough, is not a lack of critical attention; not a lack of success; it's not a lack of anything, but rather a real awareness of the constant struggle to create your best work, and that it's really, really hard, and it doesn't get easier! That challenge is what makes work interesting; I think less about the external things, although I also worry that I'm not getting somewhere fast enough.

RCAC: Have you had major frustrations or resistances so far?

YOUNG: I've had major frustrations and resistances in terms of work in the studio, not so much externally but internally. I think that coming to a graduate program and spending your first year doing work that you think is really horrible is very frightening, because you think, "My God, I'm supposed to be at an advanced level, and I feel so unadvanced, and I feel that my work is so unsuccessful." I think that it's things like that difficult year that you have to continue to work through that are really hard.

RCAC: What's your greatest disappointment or greatest satisfaction?

YOUNG: I don't know. Every time I finish a piece that I think, "Wow! This is the best one yet!"—that's sort of the most intense feeling of satisfaction. The greatest disappointments probably consistently don't even have to do with other people; they have to do with ways in which I was sort of my own worst enemy or my own undoing. They usually have to do with not feeling confident enough to enjoy the moment or to see things more developmentally.

I remember when I graduated from undergraduate, I didn't attend the ceremony; I didn't want any celebration. I can remember feeling so bad about the work that I'd done, that it was really unsuccessful, that at one point I said, "All this commemorates is four years of failure as an artist and a person!" And when I look back I think, "Oh, my God!" You know,

I had so much ahead of me, and I'd just been accepted by four different graduate schools. Yet I remember feeling an intense sense of disappointment. I think the disappointment that I feel now is that I just couldn't see far enough beyond my nose to realize that there was a lot that was coming after. I'm really young, and I do that to myself often. I think I have very high critical standards; a lot of times when I disappoint myself, I'm the only one in the room that is really disappointed.

RCAC: Does the marketplace affect your work?

YOUNG: I'm sure it does; I know it does. And by marketplace I mean what I see at galleries and what I see in magazines. I think it can't help but affect you, and in some ways that is good and fine, just like anything you see that gets stored away; you never know when it'll come back and manifest itself in some form.

A lot of times I'll be making a painting, and I'll think back to some image that I'd torn out of an art magazine of someone's work, maybe someone famous or maybe someone unknown, and I think, "Wow! The way that they used that color or that image really affected me, and I didn't really think about this until now." I know the other way that the market affects you is that you see the style of work or the kind of work that's being applauded, that's being supported.

Right now I think that magazines show a lot of diverse kinds of work. For example there's definitely a strong political bent to a lot of it; there's definitely theoretical divisions in terms of people who confront critical issues as opposed to those who are really heavily embedded in a modernist kind of de Kooning paint handling, and I think that in a way it makes you have to take responsibility for everything that you do. And sometimes it becomes really paralyzing. I think if I use this piece of paper, and it's torn in this way, and I put this color on, it's derivative of artist X; it makes a reference to art-historical movement Y; it puts me in political camp "thus"—and it's really easy to lose track of your initial conception.

If I want to make a piece about a particular idea, I feel I need to give myself permission to use whatever vocabulary I want to best get that idea across. I feel strongly that you cannot operate from a position of ignorance, I think that's really stupid; you have to have enough momentum to try things, and you can't paralyze yourself. So that's a constant potential problem.

RCAC: What advice would you give to other young painters entering the art world?

YOUNG: I don't know how to advise exactly. Let me relate some experience: I had the strangest experience after I won this award at

school. I approached an instructor who was sitting down. There were a few students sitting around him, he was someone who had been pretty supportive of me, so I went and I shook his hand and said, "By the way, I just won this award, and I wanted to share that with you—I feel really good." He said, "Oh, sit down! Let's talk about it." When I looked up, there must have been fifteen students sitting around us all of a sudden, and someone asked, "How did you do it?" I started explaining to them how I made the painting, but what they really wanted to know is how I'd won the award: Did I politic, did I talk to people ahead of time, how did I make my selection for the jurying committee? And I just thought, "My God! These are young art students, and they're not even interested in my painting! All they want to know is how I won the award!" I told them I submitted my best work. Period.

I'll also say that one time I was entering a show that was "a drawing show." And I said, "Well, how do I know if one of my pieces is a drawing?" And my instructor said, "You can never second-guess a juror, so you should always submit your best work, and if you don't get in, you won't have to sit around thinking, 'Well, God, I really liked that other piece better, but I didn't enter it, because I didn't think that they'd like it.' "

So I would say that you can't waste your time second-guessing and figuring out how you can get somewhere. If you present your best work—and you can identify what you think is your best work, even though that may shift from month to month or day to day or hour to hour—you will know why you made the decision you did. You can't really give someone advice as to how to make a good work. You have to know what your standards are, and you have to know what your criteria are, and then you won't be dependent on someone else to define what is a good and a bad piece of work for you, because that's when you lose all your power.

Honors: National Endowment for the Arts/New England Foundation for the Arts Regional Fellowship, 1992. Dana Pond Award in Painting, School of the Museum of Fine Arts, Boston, 1991; Tufts University Scholarship, "Documenta 8" Art Festival, Kassel, Germany, 1987; Summer Session Scholarship, Art Institute of Chicago, 1980.
Representative exhibitions include: One-person exhibitions: "Recent Work," Simmons College, Trustman Gallery, Boston, 1991, Tufts University, Gallery Eleven, Medford, MA, 1990, "Earth Day," Harvard School of Public Health, Harvard University, Boston, 1990, University of Illinois, Arts Coalition Gallery, Champaign-Urbana, 1986, Group exhibitions: "Distinct Voices, Massachusetts Women Artists," Federal Reserve Bank of Boston, 1992, Annual Exhibit, Dana

Pond Award for Painting, Grossman Gallery, School of the Museum of Fine Arts, Boston, 1991, "Dual Vision," Montserrat College of Art, Beverly, MA, 1990, Tenth Annual Boston Drawing Show, Boston Center for the Arts, 1989, Selections from the Tenth Annual Boston Drawing Show, Bank of Boston, 1989.

Professional affiliation: College Art Association.

BIBLIOGRAPHY

Compiled by Judith M. Burton

This bibliography is not intended to be comprehensive. Most of the publications cited below provide extensive bibliographies that can guide the reader to additional insights and information.

Bradbury, Malcolm, and James McFarlane, eds. *Modernism 1890–1930*. London: Penguin Books, 1978.

Crane, Diane. *The Transformation of The Avant Garde*. Chicago: University of Chicago Press, 1987.

Czestochowski, Joseph S. *The American Landscape Tradition*. New York: E. P. Dutton, 1982.

Efland, Arthur. *A History of Art Education: Intellectual and Social Currents in Teaching the Visual Arts*. New York: Teachers College Press, 1990.

Egbert, Donald D. *Social Radicalism and the Arts*. London: Duckworth, 1972.

Flexner, James T. *History of American Painting*. Vol. 1, *First Flowers of Our Wilderness*; vol. 2, *The Light of Distant Skies*; vol. 3, *That Wilder Image*. New York: Dover Publications, 1969.

Geldzahler, Henry. *New York Painting and Sculpture: 1940–1970*. New York: Metropolitan Museum of Art, 1969.

Goodrich, Lloyd. *What Is American in American Art*. New York: M. Knoedler and Co., 1971.

———. *Three Centuries of American Art*. Catalogue for exhibition sponsored by the Whitney Museum of American Art. New York: 1966.

Greenberg, Clement. *Art and Culture*. Boston: Beacon Press, 1961.

Harris, Neil. *The Artist in American Society: The Formative Years 1790–1860*. Rev. ed. New York: Simon and Schuster, 1970.

Henri, Robert. *The Art Spirit*. 1927. Reprint. New York: Harper and Row, 1984.

Heron, Patrick. *The Changing Forms of Art*. London: Routledge, 1955.

Hess, Thomas, and John Ashbery, eds. *Avant-Garde Art*. New York: Macmillan, 1968.

Hobbs, R. C., and Gail Levin. *Abstract Expressionism: The Formative Years*. New York: Whitney Museum of American Art, 1978.

Hughes, Robert. *Shock of the New*. New York: Alfred A. Knopf, 1981.

Kandinsky, Wassily, and Franz Marc, eds. *The Blaue Reiter Almanac*. London: Thames and Hudson, 1974.

Kozloff, Max. *Renderings: Critical Essays on a Century of Modern Art*. New York: Simon and Schuster, 1969.

Kramer, Hilton. *The Age of the Avant-Garde*. New York: Farrar, Straus, 1973.

Lippard, Lucy. *Mixed Blessings*. New York: Pantheon, 1990.

————. *Pop Art*. London: Thames and Hudson, 1974.

Lowry, W. McNeil, ed. *The Arts and Public Policy in the United States*. American Assembly, Columbia University. New York: Prentice-Hall, 1984.

McKinzie, Richard D. *The New Deal for Artists*. Princeton, NJ: Princeton University Press, 1973.

Melosh, Barbara. *Engendering Culture*. Washington, DC: Smithsonian Institution Press, 1991.

Motherwell, Robert. *The Dada Painters and Poets: An Anthology*. New York: Wittenborn, 1951.

Norman, Dorothy. *Alfred Stieglitz: An American Seer*. New York: Random House, 1973.

Novak, Barbara. *Nature and Culture: American Landscape and Paintings, 1825–1875*. London: Oxford University Press, 1980.

O'Doherty, Brian, ed. *Museums in Crisis*. New York: Braziller, 1972.

Orvell, Miles. *The Real Thing: Imitation and Authenticity in American Culture, 1880–1940*. Chapel Hill: The University of North Carolina Press, 1989.

Porter, James. *Modern Negro Art*. New York: Arno Press, 1969.

Rose, Barbara, ed. *American Art Since 1900: A Critical History*. Rev. ed. London: Thames and Hudson, 1975.

Rosenberg, Harold. *Discovering the Present: Three Decades in Art culture and Politics*. Chicago: University of Chicago Press, 1973.

————. *The Re-definition of Art*. New York: Macmillan, 1972.

Russell, John, and Suzy Gablick. *Pop Art Redefined*. London: Thames and Hudson, 1969.

Schapiro, Meyer. *Modern Art, 19th and 20th Centuries: Selected Papers*. New York: George Braziller, 1978.

Shattuck, Roger. *The Banquet Years: The Origins of the Avant-Garde in France, 1885 to World War I*. New York: Random House, 1968.

————. *The Innocent Eye: On Modern Literature and the Arts*. New York: Washington Square Press, 1960.

Steinberg, Leo. *Other Criteria: Confrontations with Twentieth Century Art*. New York: Oxford University Press, 1972.

Williams, Raymond. *The Politics of Modernism: Against the New Conformism*. New York: Verso, 1989.

Wilmerding, John, ed. *The Genius of American Painting*. New York: William Morrow, 1973.

ADDITIONAL BIBLIOGRAPHY ON ISSUES OF CONTEMPORARY PAINTERS

Ashton, Dore. *The New York School: A Cultural Reckoning*. New York: Viking, 1973.

Becker, Howard S. *Art Worlds*. Berkeley: University of California Press, 1982.

Burnham, Sophy. *The Art Crowd*. New York: David McKay, 1973.

Guilbaut, Serge. *How New York Stole the Idea of Modern Art: Abstract Expressionism, Freedom, and the Cold War*. Translated by Arthur Goldhammer. Chicago: University of Chicago Press, 1983.

Jeffri, Joan. "The Artist in an Integrated Society." In Stephen Benedict, ed., *Public Money and the Muse: Essays on Government Funding for the Arts*. New York: W. W. Norton, 1991.

———, Robert Greenblatt, Zoe Friedman, and Mary Greeley, eds. *The Artists Training and Career Project: Painters*. New York: Columbia University, Research Center for Arts and Culture, 1991.

———, ed. *Information on Artists*. 12 vols. New York: Columbia University, Research Center for Arts and Culture, 1989.

Jones, Alan, and Laura de Coppet. *The Art Dealers: The Powers Behind the Scene Tell How the Art World Really Works*. New York: Clarkson N. Potter, 1984.

Rosenberg, Bernard, and Norris Fliegel. *The Vanguard Artist: Portrait and Self-Portrait*. New York: Quadrangle, 1965.

Simpson, Charles. *SoHo: The Artist in the City*. Chicago: University of Chicago Press, 1981.

YBarra-Frausto, Tomas. "The Chicano Movement/The Movement of Chicano Art." In Ivan Karp and Steven Lavine, eds., *Exhibiting Cultures: The Poetics and Politics of Museum Display*. Washington, DC: Smithsonian Institution Press, 1991.

Zolberg, Vera L. "Art Museums and Living Artists." In Ivan Karp, Christine Mullen Kreasner, and Steven D. Lavine, eds., *Museums and Communities: The Politics of Culture*. Washington, DC: Smithsonian Institution Press, 1992.

Zukin, Sharon. *Loft Living: Culture and Capital in Urban Change*. New Brunswick, NJ: Rutgers University Press, 1989.

INDEX

About the Research Center for Arts and Culture

The Research Center for Arts and Culture is both a service and a resource for arts institutions, policy and decision makers, funders, scholars, individual artists, and managers. Committed to applied research in the disciplines of arts management and arts law, the Center provides the academic auspice so important for exploration, education, policy making, and action.

In addition to the vast resources of Columbia University, including the considerable cooperation and participation of the faculty, an advisory board of artists, administrators, and members of the legal and business professions offers continuous support to the Center, helping it to provide services and expertise. Collaboration and cooperation with service organizations, trade publishers, and arts institutions strengthen the Center's unique position and enable it to translate its findings into useful, practical forms.

About the Editor

JOAN JEFFRI is Director of the Research Center for Arts and Culture, which she founded in 1985 at Columbia University, Director of Columbia's Master's Degree Program in Arts Administration at Teachers College, and former Executive Editor of *The Journal of Arts Management and Law*. Her books include *Arts Money: Raising It, Saving It, and Earning It*; *ARTISTHELP: The Artist's Guide to Work-Related Human and Social Services*; *The Emerging Arts*: *Management, Survival, and Growth*; and *The Craftsperson Speaks*: *Artists in Varied Media Discuss Their Crafts* (Greenwood, 1992).